The New Formal
INTERIORS BY JAMES AMAN

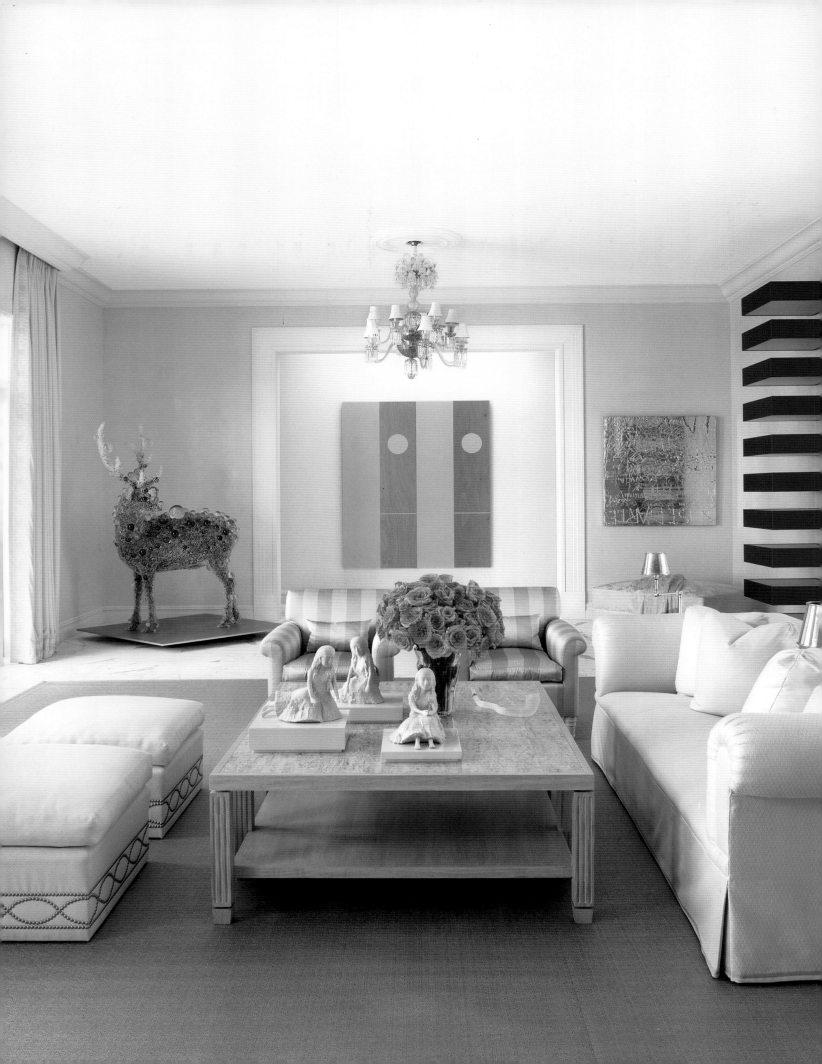

The New Formal
INTERIORS BY JAMES AMAN

JAMES AMAN FOREWORD BY EMILY FISHER LANDAU
Written with Mark Stephen Archer **Photographs by Karen Fuchs**

The Monacelli Press

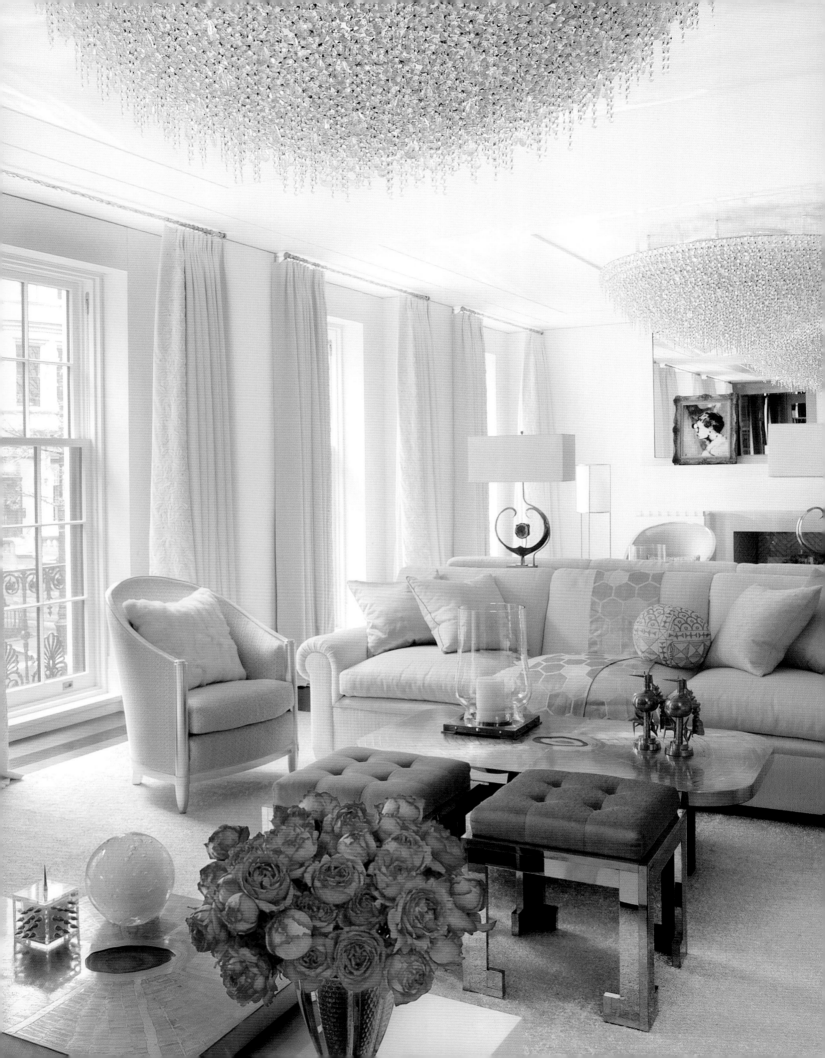

Contents

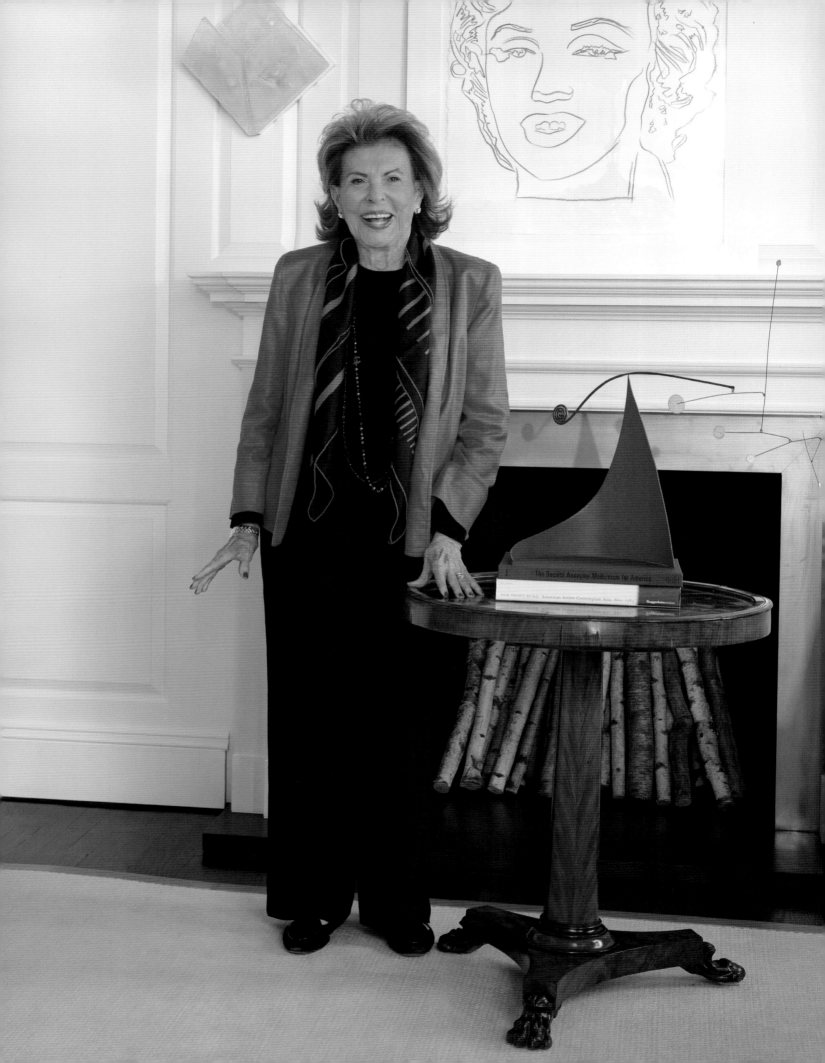

Foreword

Emily Fisher Landau

I met Jim Aman in the mid-1990s when I was thinking about ways to enhance the environment for my personal art collection at my apartment in Manhattan. I knew there had to be a better way to organize and display my paintings, sculpture, photographs, and Asian pottery, and I felt it was important to bring in new ideas and refresh the minimalist aesthetic from the 1970s. I had recently opened a new Center for Art in Long Island City, but I hadn't focused attention on my own needs. A friend of mine suggested Jim after seeing my reaction to his work. "Jim is very talented," she told me. "I think you'll like him." She was so right.

From the start, Jim impressed me as a person with a clear vision and a "we can do it" spirit that is always the mark of a great collaborator. His designs succeeded in combining the traditional with the modern and glamorous in a kind of "simpatico" relationship. At the same time, I felt Jim had some of the important qualities of artists whose works I've admired and collected over the years: knowing how to edit and not overwhelm the work and knowing when to stop and let it breathe.

Jim also had a special talent for highlighting the furniture in my collection. In those days, furniture-as-art pieces by the likes of Alberto Giacometti and Claude Lalanne were not as appreciated as they are today. Art Deco styling was fading in popularity, and Chinese furniture was rarely seen in the best homes. Jim managed to blend these design approaches in a new formal way that I think is as timeless as it is sophisticated and elegant.

His approach is straightforward. Jim exercises the same kind of rigorous selection in choosing quality furnishings as I do in choosing new additions to my collections. For him, the art doesn't begin and end with the paintings on the wall; he treats the entire environment as a work of art. Jim's eye for detail is extremely sharp. He knows how to add just the right touch—and impact—with a small, fanciful piece, and he's adept at editing the overdone and extraneous. I also like his willingness to take risks and not rely on simple solutions or tried-and-true formulas.

Jim is very persuasive. He makes me think about some of my own choices—and, believe me, that's saying something—and he's not about to sacrifice comfort or style by turning an art-filled home into a stark, sterile museum. Jim is also not one to override or control the design collaboration.

At the same time, I was drawn to Jim's unassuming attitude and his wry sense of humor. We take joy in talking about the things we love and cherish in our homes. My children and grandchildren enjoy the surroundings as much as I do, and we all are happier for being in such welcoming yet still visually exciting spaces.

Interestingly enough, among all the elements I like to think we share, Jim and I grew up with a similar problem: we both had trouble reading in school. For years, I coped as well as I could with this affliction, and it wasn't until I was fifty-six years old that I was diagnosed as dyslexic. Jim found out about his own condition much earlier and, fortunately, received the support and treatment to overcome this all-too-common learning disability.

But I suppose dyslexia may have led us down a similar path. Our difficulty in dealing with the printed word may explain to some extent our lifelong fascination with the visual arts—a world with limitless boundaries for the imagination and none of the constraints associated with sentences and paragraphs.

Truthfully, I can't think of a better kind of relationship to have with someone who's helping to shape your world and make it more inviting and beautiful. What started as a professional partnership has grown into a valuable friendship—and that makes me very happy indeed.

Over the years, I've introduced Jim to my family and friends, many of whose lovely properties and spectacular art collections are featured in this book. If you aren't familiar with his work, let me share a bit of information that I never hesitate to tell anyone who's looking for a new interior designer: "Jim is very talented. I think you'll like him."

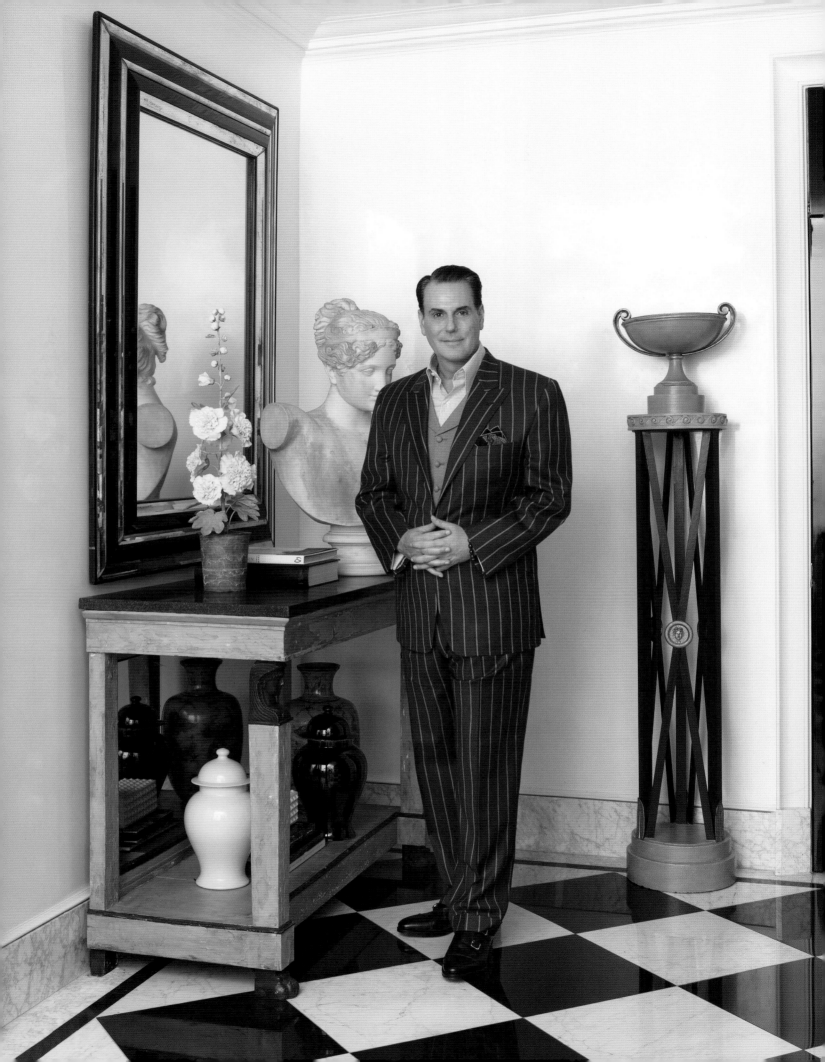

Preface

If you could say it in words, there would be no reason to paint.

—Edward Hopper

The written word has always presented a challenge to me. Growing up with dyslexia, I looked on reading and writing as chores, and I always felt there had to be better ways to communicate my thoughts and feelings. Lacking the skills of most painters, musicians, and performing artists, I suppose I turned to the decorative arts as a way to express myself, to give life some shape and meaning, and to bring beauty, elegance, and harmony into my world. In the simplest sense, I guess I always felt the need to express something that, to paraphrase Hopper, was beyond words—and I found that expression in interior design.

The New Formal is a reflection of my passion for decorating. It's a visual representation of my thought process in creating interiors and making art the focal point of those spaces. Early on I realized that my client base represented a new generation of collectors. They respected classic traditions but savored the beauty and drama of cutting-edge art. Their vision of "formal" living replaced the Old Masters, heavy tapestries, and ornate furnishings of previous generations with contemporary, often provocative works of art that inspire and delight in brighter, more open spaces.

Of course, when I began my own business twenty years ago, I never thought about creating a book. Back then, my focus was on finding clients, making sure projects were moving along smoothly, lining up my next job, meeting budgets, and managing expenses. And, if I ever had any free time—which still often eludes me— I would try to enjoy all that New York City had to offer.

In many ways, that focus has not changed much over the years. I still worry. I still juggle projects. I still try to balance my work and social life. But at least now I have a much greater sense of confidence and accomplishment than I did back in the last century, and I have colleagues and associates to help with the follow-up and follow-through. Plus, I now have enough stories to tell and pictures to share—along with some hard-won advice—to actually fill the pages of a book.

That feeling of satisfaction or general contentment hasn't always been part of my nature. As a restless kid growing up in Short Hills, New Jersey, there was always something better on the horizon, one gleaming light in the distance, the place I wanted to be more than any other in the world: New York City.

Not surprisingly, my strongest memories from childhood were making the forty-five-minute drive with my parents to see Broadway shows and being fascinated by the ways in which furniture and scenery would transform the stage. For me, those stage sets, those worlds in which the characters lived, were every bit as interesting as their stories and dialogue. It was something I thought about all the time. I would put my new-found theatrical knowledge to good use at home, rearranging the living room furniture and moving artwork and mirrors from one wall to another.

Since I had so much trouble with printed words and numbers, my grades were poor and they didn't really improve until middle school, when I had the opportunity to take arts classes and experiment with painting and life drawing. That's when I also had the chance to participate in theater productions, usually as a member of the stage crew, and go on field trips to museums in New York and Philadelphia.

One of the few books I remember is *From the Mixed-Up Files of Mrs. Basil E. Frankweiler,* a children's "classic" of sorts that was adapted into a film in the 1970s with Ingrid Bergman and again in the 1990s with Lauren Bacall. It tells the story of Claudia, a twelve-year-old girl, and Jamie, her nine-year-old brother, who run away from home and choose to live—of all places—in the Metropolitan Museum of Art in New York. Most of my friends thought the book was ridiculous, but I thought it made perfect sense.

What better place to live than one of the most magnificent structures in the world—on no less than Fifth Avenue—in the heart of New York City? And what better surroundings than the most beautiful paintings and sculptures on earth? I can't remember what Claudia and Jamie's parents did to make them want to run away in the first place. But can anyone think of a better hiding place than the Met? Seriously, kudos to those kids!

I may not have completely understood at the time, but I think that's when the notion of living with art began to appeal to me. I filled the walls of my room with posters and magazine clippings and tried to create spaces that were beautiful and inspiring. Although I was fascinated with art, I had to admit at a relatively early age that I didn't have the inherent talent to be an artist. The interest may have been there, but I just didn't seem to have the inclination or perhaps the patience to succeed as a painter or sculptor. That's probably why I chose to attend the Pratt Institute in Brooklyn and major in advertising and graphic design, a field that I thought would eventually help me in my true passion: interior design.

Most of the professors at Pratt taught only a few classes and spent most of their time not as academics but as real business people. They managed payrolls. They built client bases. They kept customers satisfied. That's where I learned a lesson that applies as much to interior decorating as it does to advertising or virtually any creative enterprise: the importance of salesmanship.

I realized that to succeed in the design business meant developing an essential skill: the ability to ask clients to understand your vision, to take a huge leap of faith and commit a great deal of time and money on little more than a promise, a few fabric samples, some paint swatches and floor plans, and perhaps a furniture rendering or two. I also realized that a testimonial from a satisfied client could go a long way in opening doors to new clients and in building the trust and confidence that are so important in the collaborative design process.

These business and life lessons continued when I had the opportunity to put my freshly minted degree to work as part of the Creative Services Team at Polo Ralph Lauren. I may not have realized it when I first came on board, but my time with Ralph Lauren was literally a "master class" in merchandising. I discovered firsthand how critical the aesthetics of the environment were to the overall selling process. I learned how to give a residential feel to magnificent buildings, like the Rhinelander Mansion on Madison Avenue, and transport buyers to a very special and inviting space. I saw how to incorporate simple solutions such as home-like seating areas into luxurious interiors where, lo and behold, there was beautiful, quality merchandise just waiting to be purchased. And I learned how to highlight artwork and special collections to enhance any setting and add a touch of history, fantasy, drama, or glamour.

Of course, as part of the Ralph Lauren team, I also learned that trends come and go, but quality endures. I refined my own aesthetic to incorporate respect for tradition and timeless elegance with an eye for the unusual or quirky, combining traditional and contemporary elements—what, for lack of a better word, is often called the "transitional" style. I also came to realize how much the decorative arts share with the visual or performing arts, with fabrics, furniture, pictures, and furnishings substituting for paints or canvases or musical scores.

Earlier part-time jobs in store design and window display at places like Bonwit Teller taught me many of the fundamentals.

But my decade with Ralph Lauren, whom I consider a true artist and visionary as well as one of the greatest marketing geniuses of all time, definitely made me a more capable and confident designer. In fact, under his tutelage, I gained the confidence to take a leadership position at a smaller boutique firm that was a Polo licensee and eventually to launch my own business, carving out a niche for myself in a demanding and highly competitive arena.

What started as just a few freelance jobs twenty years ago has grown—exclusively by referrals and word of mouth—into a rewarding enterprise, with just the right number of people to handle just the right number of projects.

I have been extremely fortunate to work with a group of clients who have the same high standards for their home interiors as they do for their remarkable art pieces. I've had the opportunity to create an environment for collections of modern and contemporary art in magnificent houses and landmark buildings, many of which are works of art in their own right. And I've been blessed to live in the most visually stimulating and inspiring city in the world where the best resources, artworks, and antiques are readily accessible.

I've created a niche for my firm through social contacts who have introduced me to a wider circle of art patrons. Their needs and tastes may vary, but they share a forward-looking approach to art for which my transitional style—bridging the gap between the classic and the contemporary—is well suited. Most of them have their own art curators and installers for their collections, and my team has been able to work closely with theirs to ensure that their art is displayed to its best advantage. Partnering with John Meeks, who is a skilled designer and comes from a distinguished family of custom-furniture makers, has enhanced our ability to create one-of-a-kind pieces to complement the museum-quality collections

After all these years, my team remains small—no more than six or seven people. That's because I've always considered mine a "boutique" business. And it's because my clients have always expected me to be a "hands-on" presence. The truth is that I want to do everything, and that's why I haven't wanted my business to grow to a point where my role would be limited or specialized. Frankly, I'm having too much fun to do it any other way. There is no substitute for the feeling of elation that arises when the client understands the vision and is pleased with the end result.

A finished interior is just like a finished work of art, a kind of self-expression that, to paraphrase Edward Hopper again, is often beyond words. Whether it's the placement of accessories on a coffee table, the details of an embroidery design, or the way two fabrics complement an antique rug, the art is everywhere, not just hanging on the wall or displayed on a pedestal.

The dancer and choreographer Twyla Tharp once said, "Art is the only way to run away without leaving home." I hope the readers of The New Formal will lose themselves in the creativity featured in these rooms and find new ways to let the transportive power of art enhance their lives as well as their living spaces.

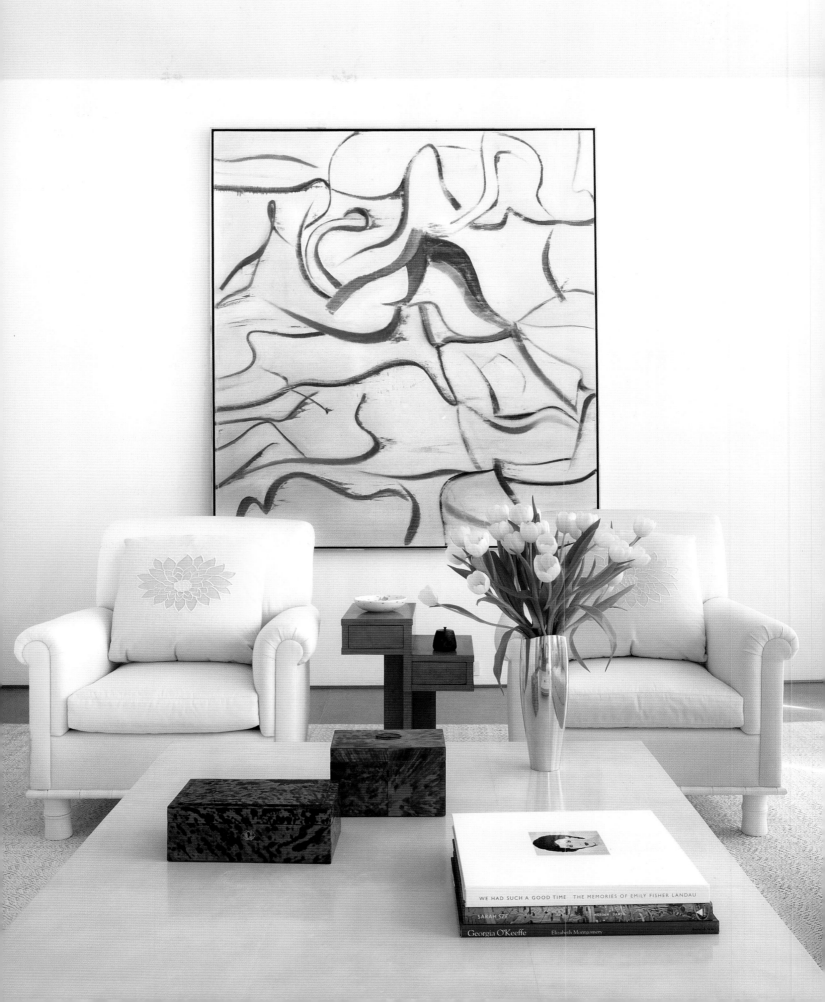

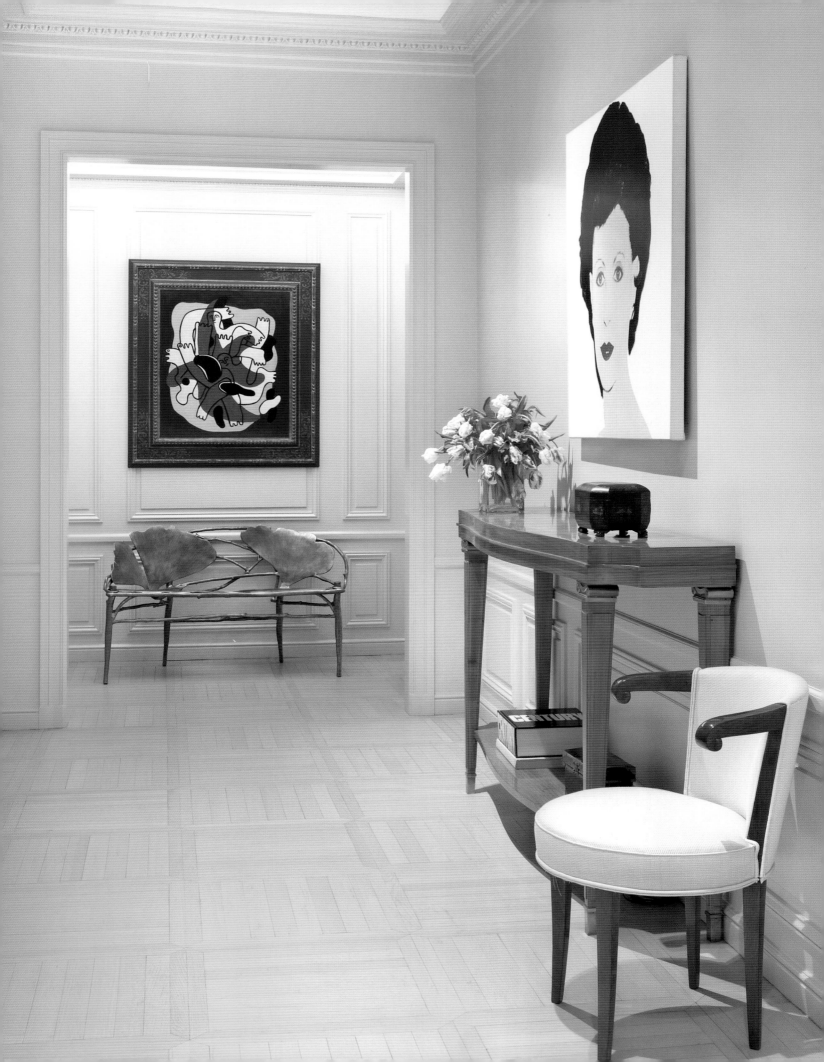

Park Avenue Aerie

The object of art is to give life shape.

—Pablo Picasso

When I started my design career in New York, I worked as part of a team in a nondescript commercial office building on Madison Avenue. Though the work environment was ordinary, my cramped cubicle was only a few blocks from the palatial apartment buildings that line Park Avenue in that very special enclave known as Lenox Hill. On my way to work, I would stroll through the neighborhood and marvel at these monumental prewar buildings with their majestic limestone facades, magnificent proportions, and superb architectural details. What was their history? What did the apartments look like inside? Little did I realize at the time that one of my earliest commissions would take me to a truly legendary apartment at one of these coveted addresses: 720 Park Avenue.

I still remember the feeling of awe and exhilaration when I first entered the building and took the elevator to the client's apartment. The original owner was Jesse Isidor Straus, the son of R. H. Macy's founder Isidor Straus and his wife, Ida, who both tragically lost their lives in the sinking of the *Titanic*. In the 1920s, Straus had contracted with the preeminent architect Rosario Candela and the sought-after team of John and Eliot Cross to design the building, reserving the most spacious and loftiest apartment for his family.

Though altered over time, the original duplex set a standard for luxury that is almost unimaginable today, with a 40-foot entrance gallery, a 36-foot library, seven bedrooms, a sewing room, and a kitchen so spacious that it could easily accommodate most modern living rooms. It remains one of Candela's crowning achievements—with panoramic views, ideal light conditions, harmonious proportions, and timeless, elegant details.

The challenge in redecorating was straightforward: to showcase the art collection while respecting the history, beauty, and integrity of the apartment and its grand ceremonial rooms in an environment that was warm and inviting for family life. After all, the apartment was the owner's principal residence. She wanted to be sure it highlighted her passion for art but was still welcoming and comfortable for her children, grandchildren, colleagues, and friends.

Of course, making room for art may sound like a standard assignment for an interior designer. But when the collection includes more than 1,200 pieces and features works by Pablo Picasso, Fernand Léger, Mark Rothko, Jean Dubuffet, Alberto Giacometti, Willem de Kooning, Georgia O'Keeffe, Jasper Johns, and Andy Warhol, then the project takes on a very special dimension. And when the collection is so vast and the quality so extraordinary that the owner has a museum of her own to share it with the public, then finding the right pieces for home display and creating appropriate settings becomes especially daunting.

But museums and homes are places apart. My client recognized that the paintings and sculptures she had collected—and, in fact, most works of art—were never intended to be displayed in institutions. The artists, she understood, wanted their patrons to "live" with their creations—to make the art part of their environment, to inspire and delight them, to harmonize with their surroundings and furnishings, to complement the way they lived, to give their life shape. And she knew this from personal experience, having recognized the brilliance of these artists early on and befriended many of them at the start of their careers.

Fortunately, my client has an eye for architectural integrity as sharp as her eye for art. Even though she had undertaken gut renovations on other properties and was aware of the advantages of a blank slate, she understood that the apartment was unique, a special place that deserved the utmost respect.

What we strove to create was an appropriate backdrop for her art collection—not bare-bones and minimalist, but simple and elegant. We wanted to keep the focus on the art without discarding the classic moldings and fine craftsmanship or making the residence an unlivable "white box" with stark walls and large, empty spaces.

Simply stated, we started out with the idea that the art would come first—the "star" of the show, as it were—with the color palettes and textures and fabrics and accent pieces as complements.

When major works by Picasso and Dubuffet face each other across a room, it's not likely that the furnishings will be the first

Opposite In the entryway, works by Andy Warhol and Fernand Léger bring color to the neutral palette.

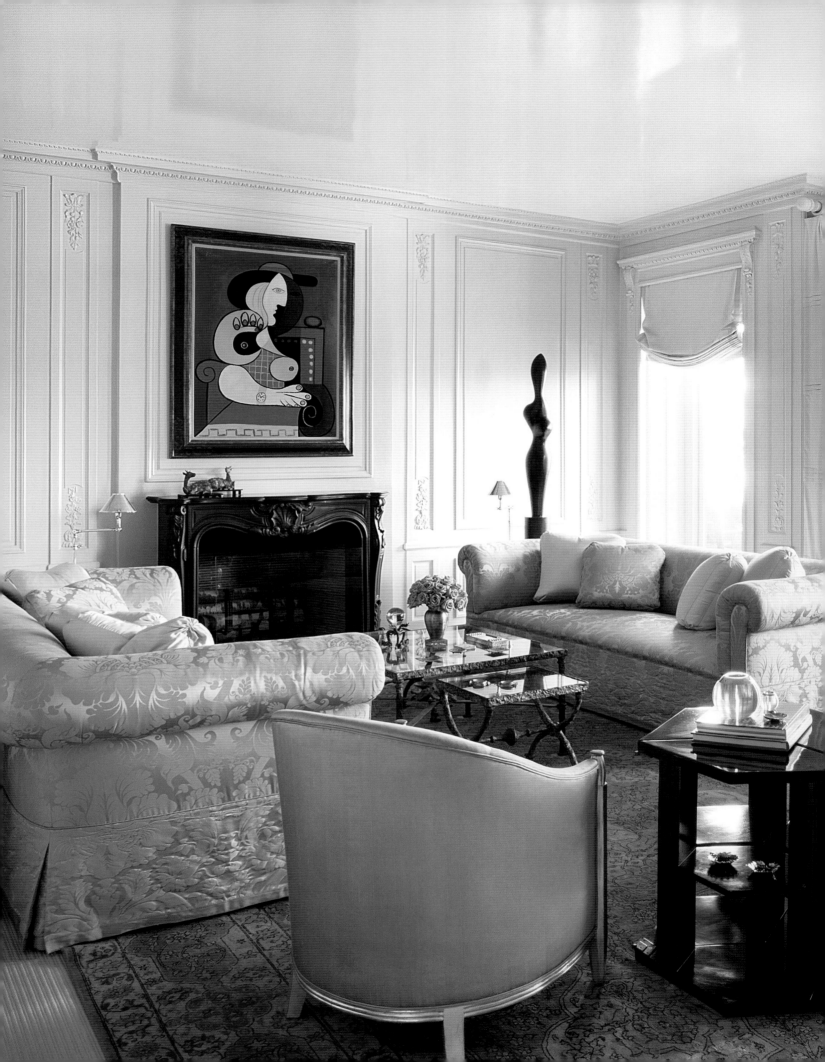

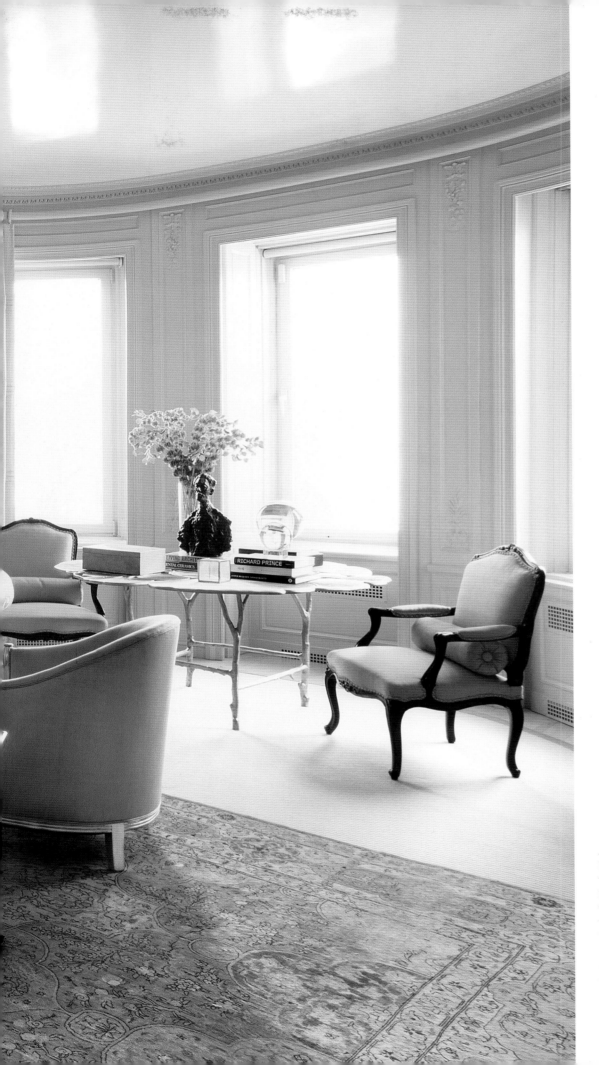

Left
In the living room, original moldings frame *Femme à la Montre* by Picasso. Neutral silk damask contrasts with the metals of the Giacometti nesting tables and the sculpture *Torse Vegetal* by Jean Arp. The octagon table by master cabinetmaker Eugène Printz salutes the apartment's Art Deco origins.

elements to catch the eye. But when a Giacometti coffee table is added to the mix and a portrait by Andy Warhol (one of six he created of the owner) hangs in the entryway, the need for subtlety and restraint becomes paramount.

First up—and essential in any design project involving art—was the lighting. Fortunately, Candela's plans created rooms with expansive views and windows that maximize daylight. But, over the years, the introduction of track lighting and recessed fixtures had left their mark, interrupting the flow of spaces and distracting from key elements in the rooms. We replaced these with small, unobtrusive fixtures that highlight the art and illuminate conversation areas. Of course, the dining room, with its walls hung with works by Léger, Rothko, and Ruscha, demanded an imposing light fixture. We chose an eighteenth-century Russian pagoda chandelier with multiple tiers of sparkling crystals. It's one of the best examples of my penchant for combining the classic with the modern, and I'm still pleased that the client wanted it as much as I did.

Next we selected a neutral color palette throughout the residence and added depth and a shimmering effect with hints of metallic silver and chrome. In a neutral environment, the color choices don't have to be white or gray. There is a full range of subtle possibilities that can enhance the impact of certain pieces and others that can offer effective contrast. For example, the floors and walls have the same basic tonality, which serves to make the spaces appear even larger. Even where oriental carpets were used, we focused on a more muted palette of soft grays and greens instead of the typical reds and blues that can be distracting.

We added punches of color and used black—a key element in any neutral color palette—judiciously but powerfully in the marble fireplace that anchors Picasso's *Femme à la Montre,* the ebonized Steinway piano, and the lacquered occasional tables designed by my firm.

We also emphasized clean lines and crisp tailoring in our upholstery choices, working in a range of silvers and platinums that complement the Art Deco bones of the apartment while paying homage to the art that surrounds it.

The same attention to detail carried through from the public rooms to the private spaces, where stately mantels set the stage and imposing tester beds draw the eye and call attention to the paintings that hang on the walls. Favorite pieces and more recently acquired furnishings were recovered to blend in with the neutral palette. The client also wanted a different, more artistic approach to displaying family photos, so we created special custom folding screens to provide additional room for display.

Finally, in a nod to classic design and to highlight a collection of rare Yixing ceramic teapots in the sitting room, we installed a wooden crown molding that complements the saddle leather of the sofa and chairs. The little teapots—short and stout— now sit proudly on recessed shelves lined with neutral pearwood. Overseeing them all is not another contemporary masterpiece but one of my client's most cherished objects: a pictogram of her grandson by Adam Fuss.

Opposite
A bust of Diego Giacometti by his brother Alberto rests on the Claude Lalanne ginkgo table. The silvery finish of the table blends with the hints of platinum and gray throughout the room.

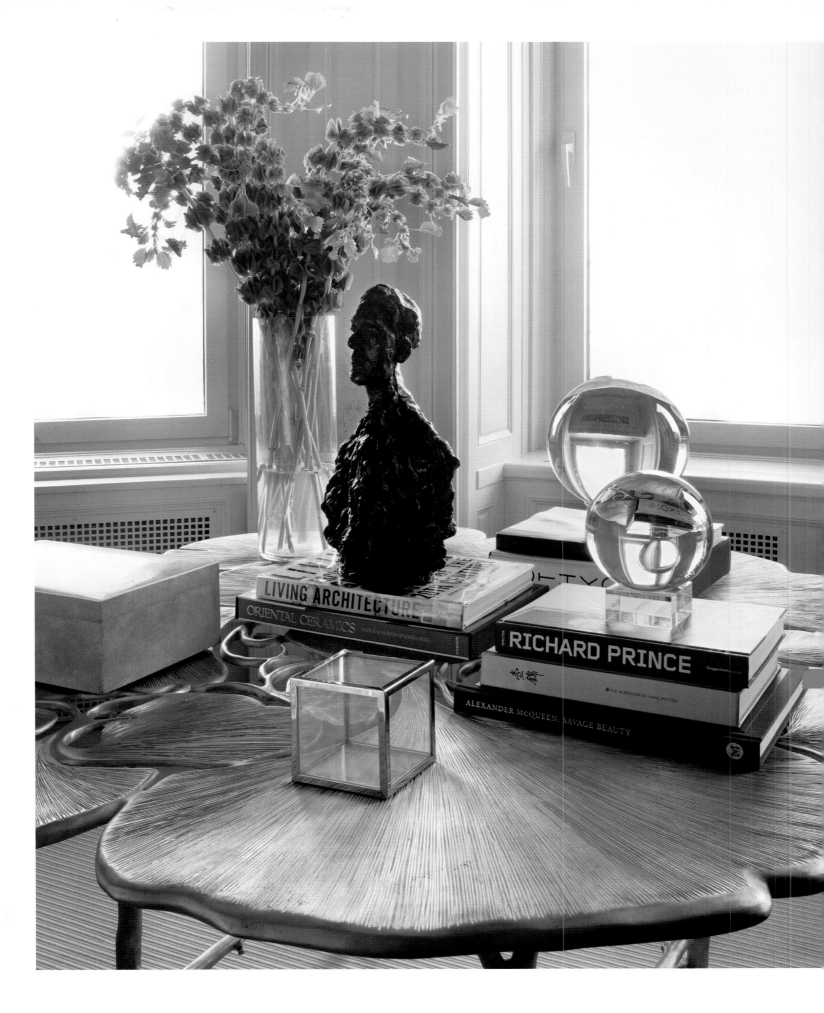

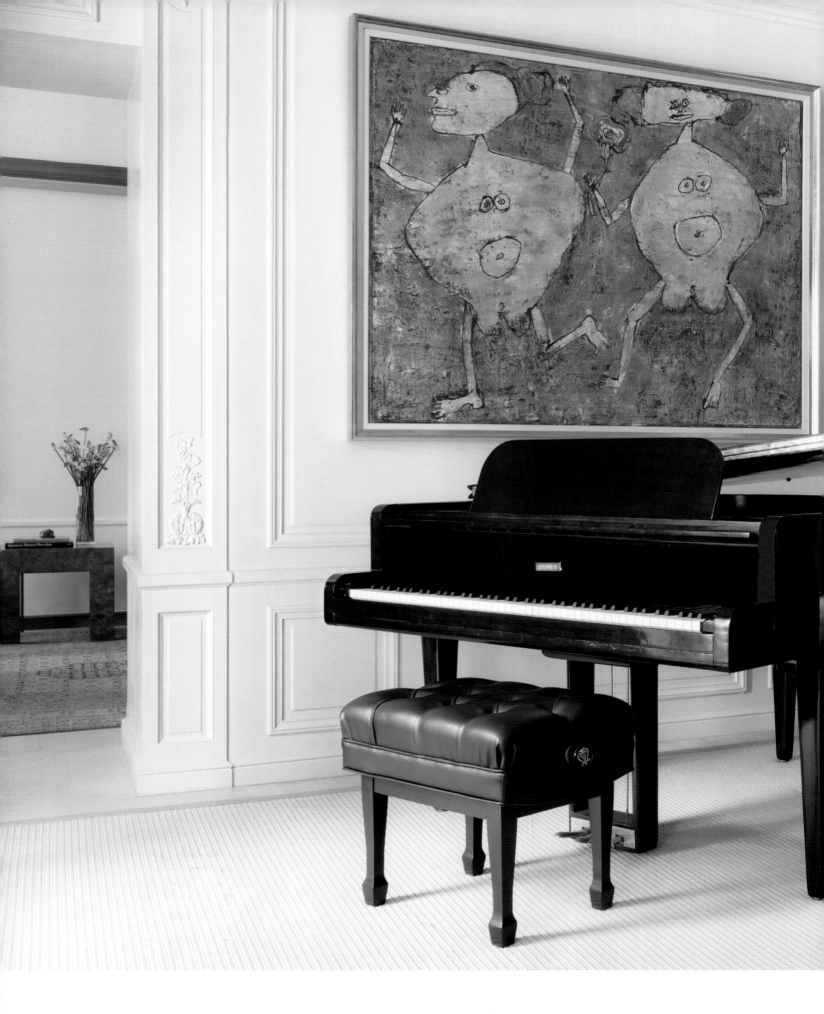

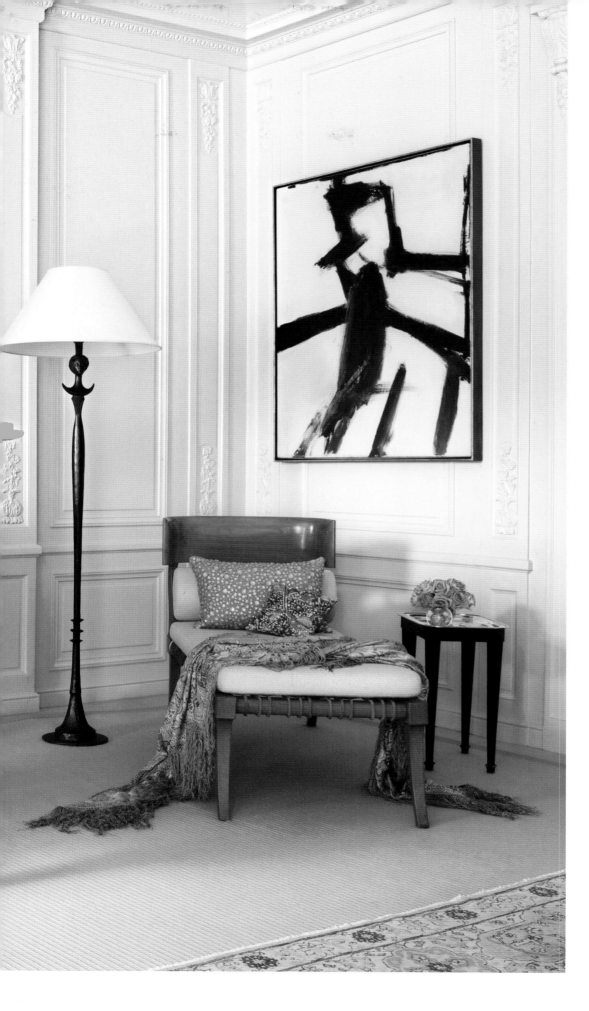

Left
A Giacometti floor lamp lights a quiet
corner where a Robsjohn-Gibbings
chaise sits comfortably. Franz Kline's
stark black brushstrokes echo the
ebony finish of the piano, which was
custom made to complement the
owner's collection of Art Deco pieces.
A large canvas by Jean Dubuffet
hangs above it.

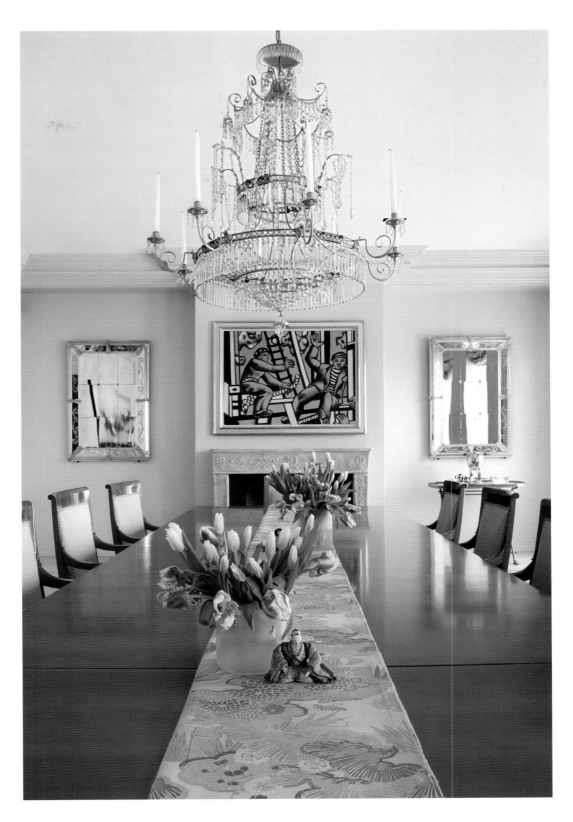

Opposite

The black Belgian marble mantel-piece creates a striking base for *Femme à la Montre*. Small-scale lamps on either side provide subtle lighting. Line Vautrin boxes on the Giacometti tables bring a touch of chic to the setting

Above

In the dining room, Venetian mirrors flank *Étude pour Les Constructeurs* by Léger. The owner's fondness for Asian art is seen in the antique obi that serves as a table runner and the pagoda chandelier with its three tiers of shimmering crystals.

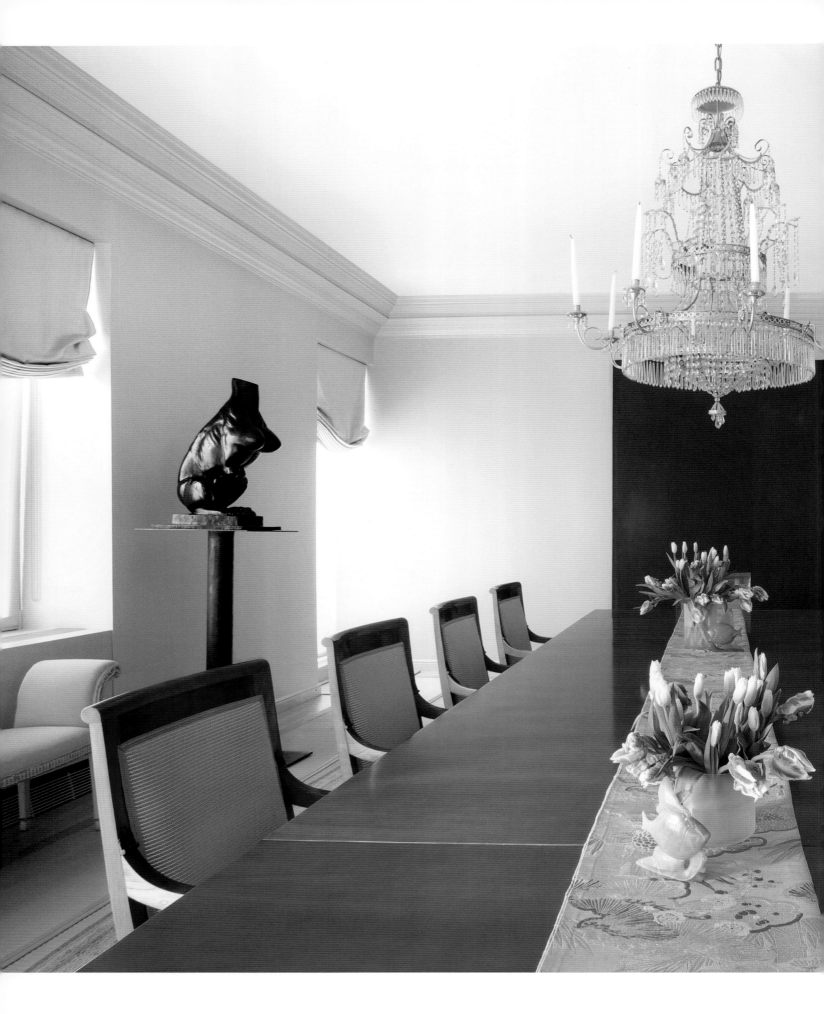

Left
A sculpture by Louise Bourgeois and works by Mark Rothko and Ed Ruscha are displayed around the dining room table.

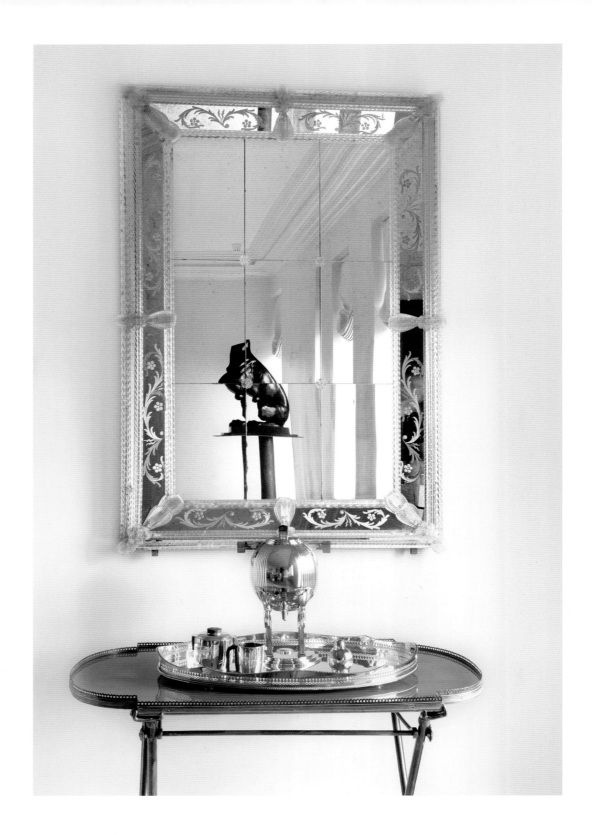

Above

A Louise Bourgeois sculpture is reflected in one of the dining room mirrors. The sterling silver Art Deco coffee service is a family favorite.

Opposite

Securing the Last Letter by Ed Ruscha is a bold counterpoint to the graceful chairs by Jacques-Émile Ruhlmann. The modernist side table is by Samuel Marx.

Overleaf

Polished pearwood paneling is a foil for the matte black surface of Yixing teapots. The warm brown of the wood is echoed in the leather upholstery and the cornice above. The trio of photographs is by Hiroshi Sugimoto.

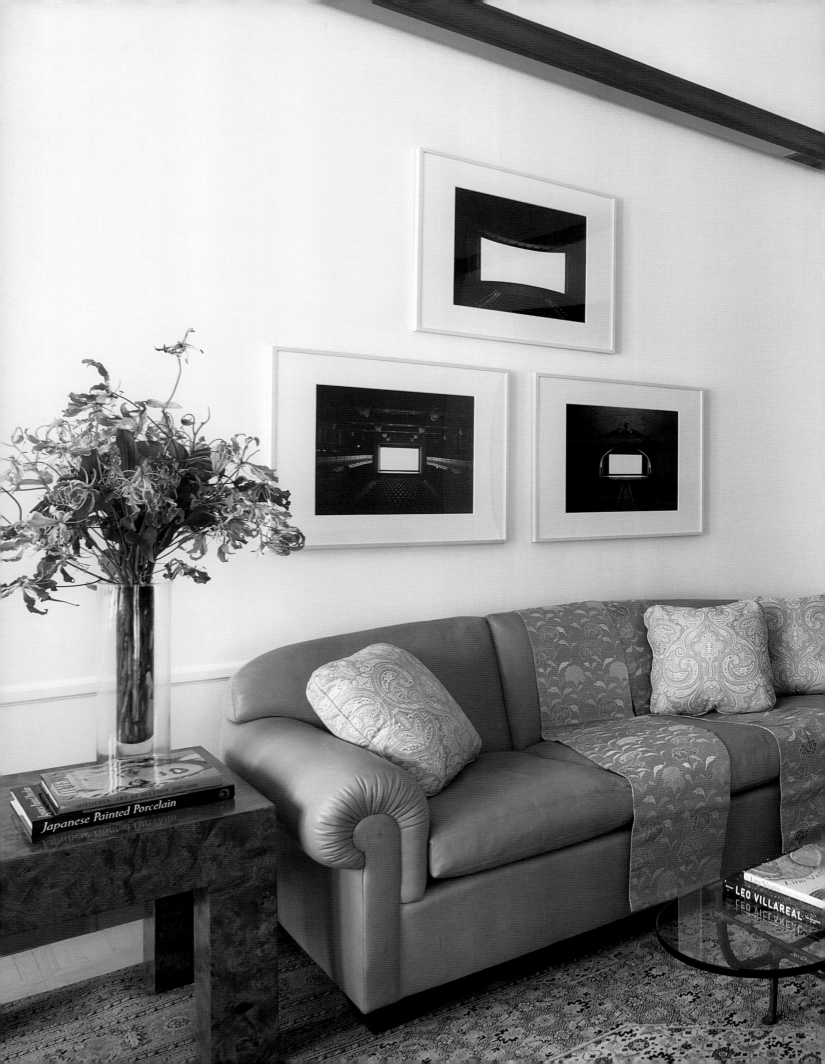

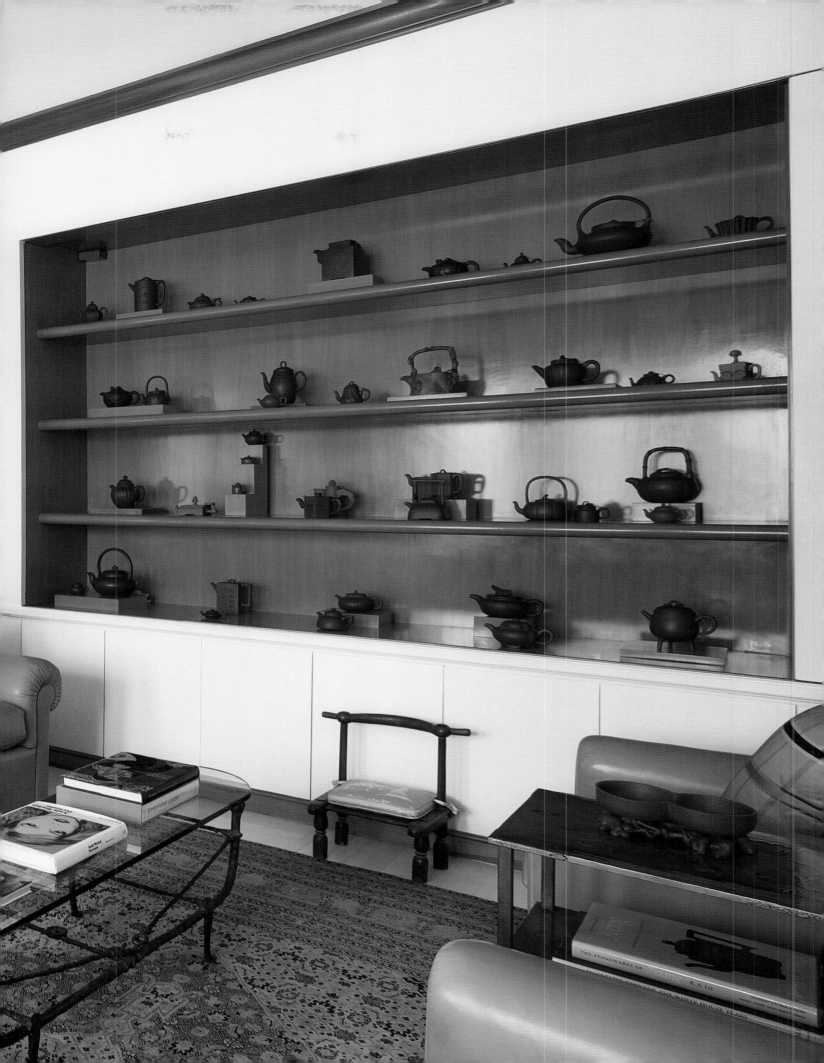

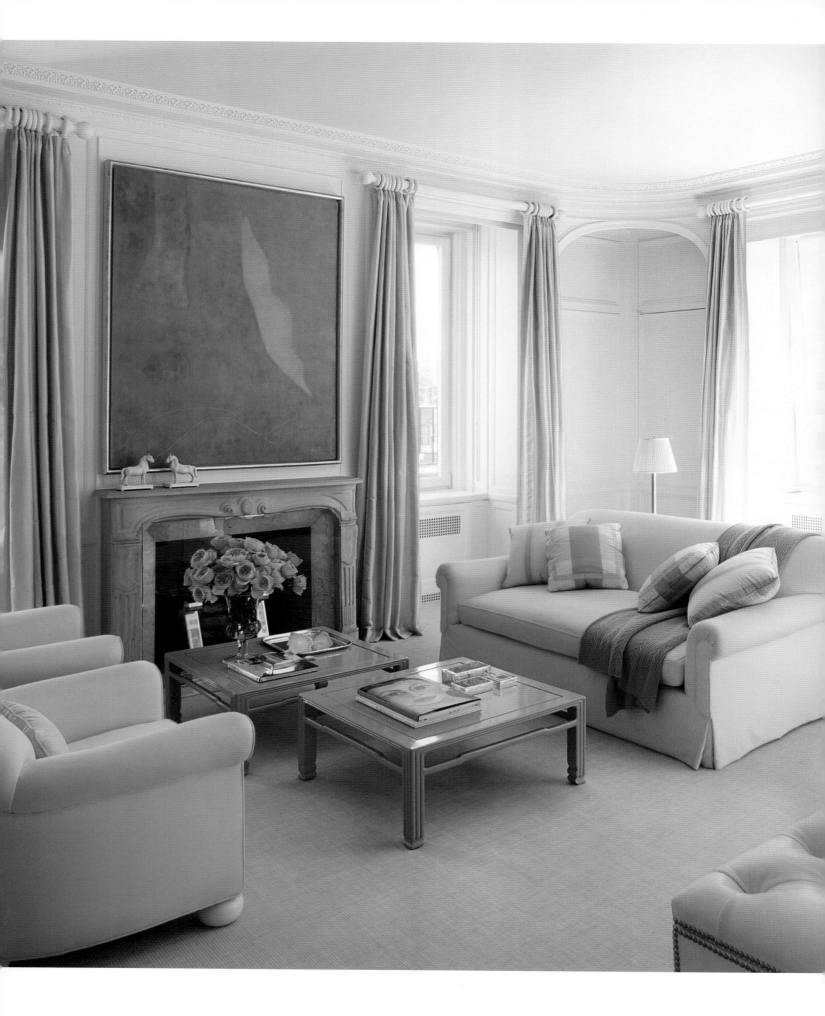

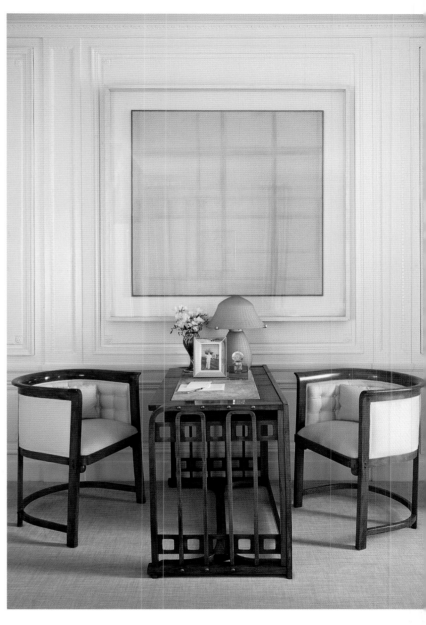

Left
In the master bedroom, *Morning* by William Baziotes adds to the calming effect of the soft, serene setting. Between the windows, *White Iris* by Georgia O'Keeffe enhances the mood with touches of yellow.

Above
The simple shapes of the Josef Hoffmann writing desk and chairs complement the lines of the Piet Mondrian charcoal composition, *Classic Drawing # 29 (New York V),* that hangs above.

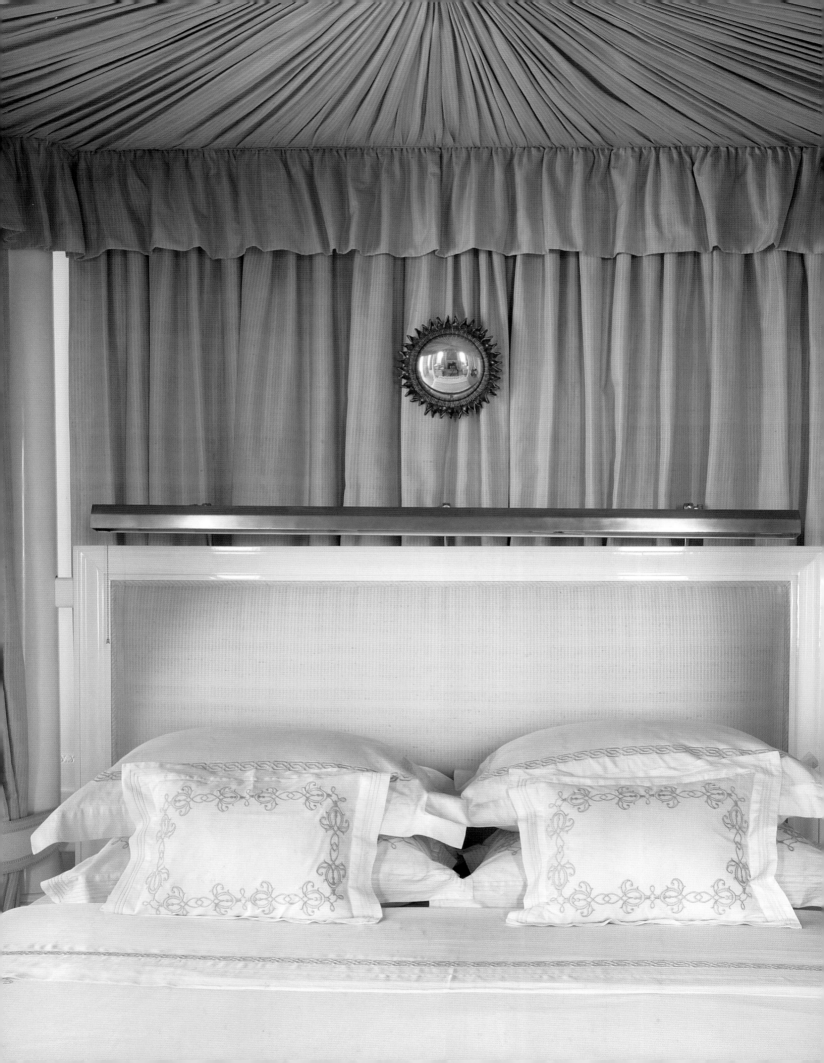

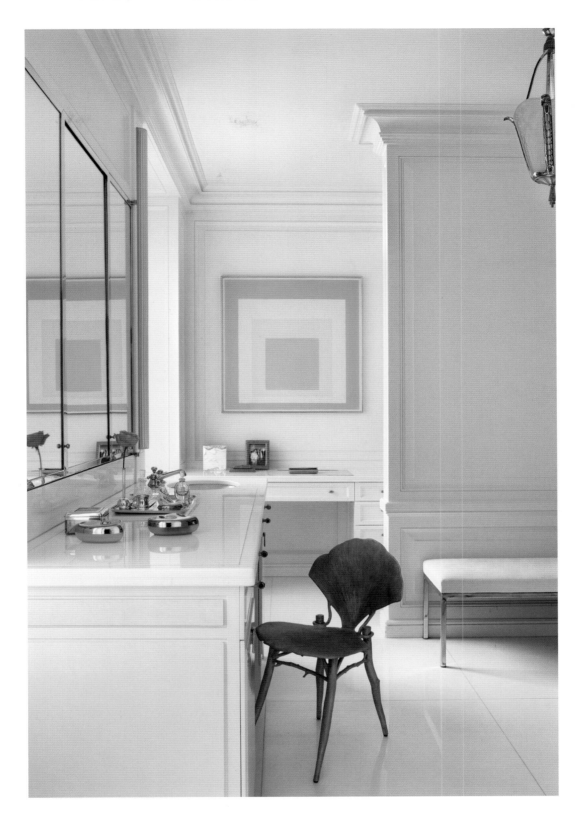

Opposite
A sunburst mirror by Line Vautrin
reflects the morning light against
the silk canopy of the custom
four-poster bed.

Above
Homage to the Square: Yellow
Resonance by Josef Albers brings
a pop of color to the master bath.
The sinuous ginkgo chair by Claude
Lalanne contrasts with the horizontal
lines of the custom vanity and its
white parchment inserts.

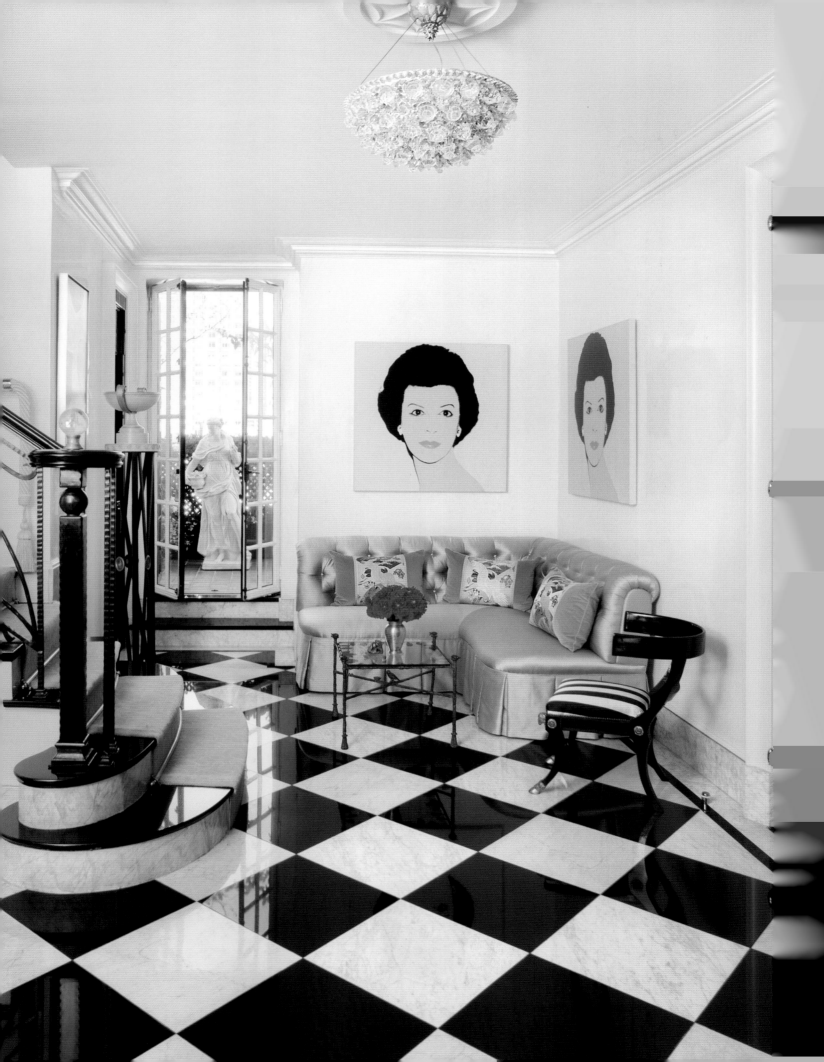

Beekman Place Duplex

Collectors are happy people.

—Goethe

Beekman Place has long been one of my favorite streets in Manhattan. Just two blocks long and tucked away close to the East River, it epitomizes New York City at the height of its Art Deco glamour. My client on this street of dreams is a Broadway producer who owns a magnificent duplex in a 1930s building by Sloan and Robertson. It's a classic prewar with all the architectural details associated with that period and sweeping views of the river and the iconic 59th Street Bridge. While entertaining is a frequent pastime—and an occupational requirement for any producer—the apartment is really more of a family retreat, showcasing an array of contemporary paintings, photographs, and sculptures in a setting filled with antiques, family pieces, and wonderful memories.

In many ways, this project may best represent my design aesthetic: an updated interpretation of classic elegance. At the same time, I believe it highlights my penchant for combining contemporary art with period furniture. "I love the bones of this place," my client told me early on. "But it's just too much old-world London and not enough New York, New York. It needs a little glamour and sophistication. Let's brighten it up."

So brighten it up we did, using an ivory-tinted dove-gray enamel over the somber paneling in the living room and library to highlight the prewar moldings. We used an automotive spray enamel that creates a subtle glow day or night and adds just the right amount of luster to the walls and ceiling. In the dining room and the foyer, where there was no paneling to preserve, a new wall treatment of Venetian plaster captures as much light as possible.

As soon as you walk through the imposing front door, you are reminded of the history of the residence. Its Art Deco origins are evident in the black-and-white marble floor in the entrance hall, where a plush settee softens the geometric pattern and invites guests to relax and feel at home. Silkscreens by Andy Warhol, a Francesco Clemente painting, and a charming poodle sculpture are clues that this is a modern apartment—and a happy place as well. The ebony-and-ivory color scheme continues up the graceful stairway where largely black-and-white photographs, including a classic of Marilyn Monroe by Bert Stern, showcase celebrities, friends, and family members.

In the public spaces, ebonized floors, Asian-inspired sideboards, and occasional chairs keep the look polished and sophisticated. Window treatments were selected to complement the soft white grayish walls and to filter the light and soften the lines of the space so the art and antiques have room to breathe.

My client's tastes in art may be specific, but she is interested in styles and fashions from many different periods. And, while she can appreciate the value of a minimalist backdrop for her art, she had no intention of consigning her books and family treasures to storage. She wanted the interiors to be elegant but still evocative of happy times with her family, projecting a sense of warmth and perhaps a little whimsy.

The challenge with this design was to create harmony among the variety of styles and to edit carefully to make sure the art didn't get lost in the details. Fortunately, as a producer, my client knows the importance of collaboration on creative projects.

The library may be the best example of an art-filled environment in a largely monochromatic space that is still warm and inviting. An imposing chinoiserie linen press now serves as a bar, reflecting the client's taste for Asian-inspired antiques as well as her fondness for entertaining. But this sophisticated lady is also very sentimental. The sofa and chair are vintage hand-me-downs from her parents' first apartment. Now they're upholstered in an eye-catching blue with rows of lavender pillows backed in yellow. Surprising color choices, yes, but the overall effect is welcoming and comforting around the midcentury Fornasetti cocktail table and well-stocked built-in bookcases.

Touchingly, in a space where Warhols and Twomblys compete for wall space, pride of place in the library is held by a large, colorful photographic work by my client's daughter. "Everyone loves it," she says. "It fits right in. It just makes me so, so happy."

Opposite A double portrait of Emily Fisher Landau by Andy Warhol hangs above an inviting banquette in the foyer. French doors lead out to the wraparound terrace with sweeping views of the East River.

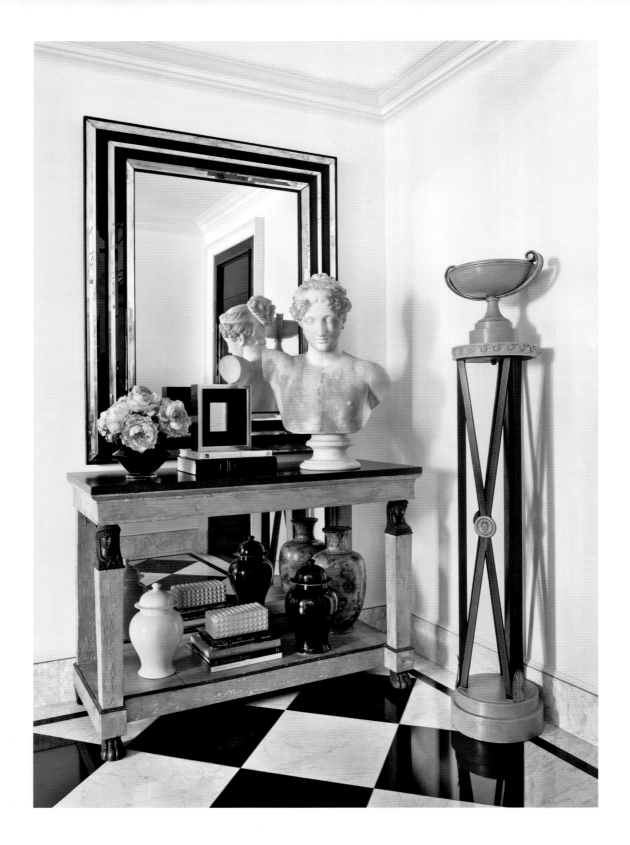

Above

The graceful marble bust and torchère bring a classical touch to the foyer. The Art Deco-era apartment combines minimalist settings for the large collection of contemporary art with Asian-inspired touches throughout.

Opposite

House of Cards by Francesco Clemente welcomes guests in the entryway. Soft gray carpeting on the stairs draws the eye to the intricate railing and the photographs displayed above.

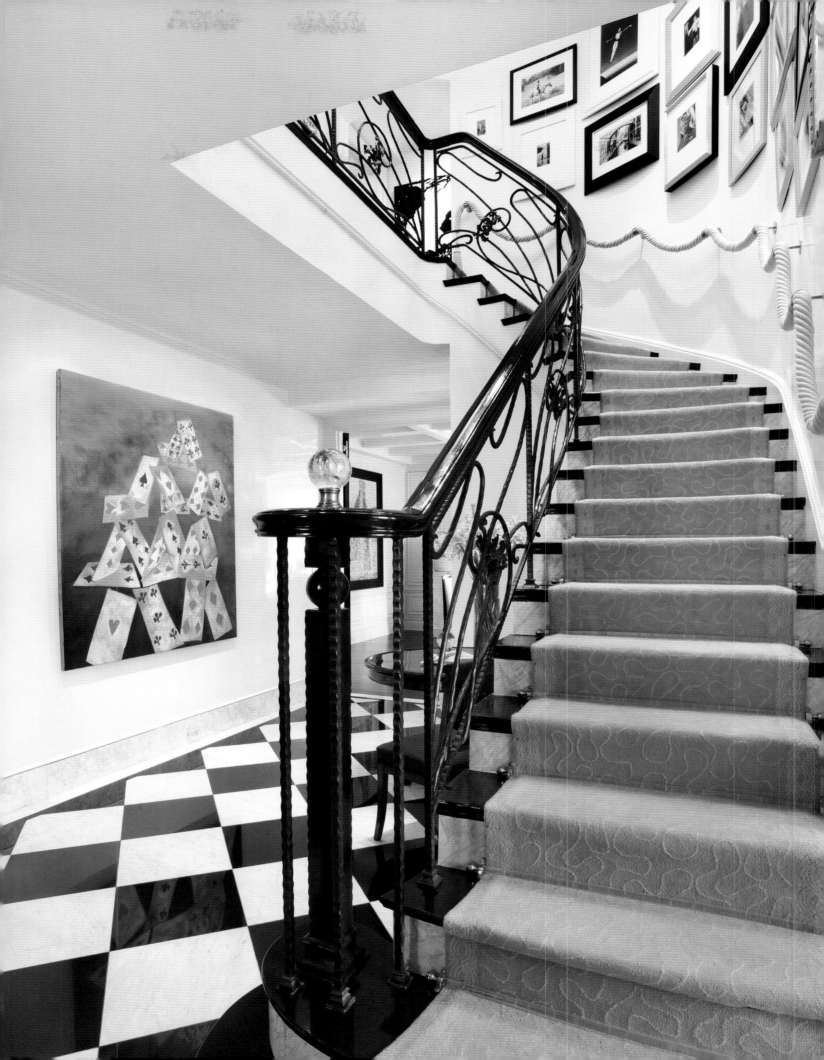

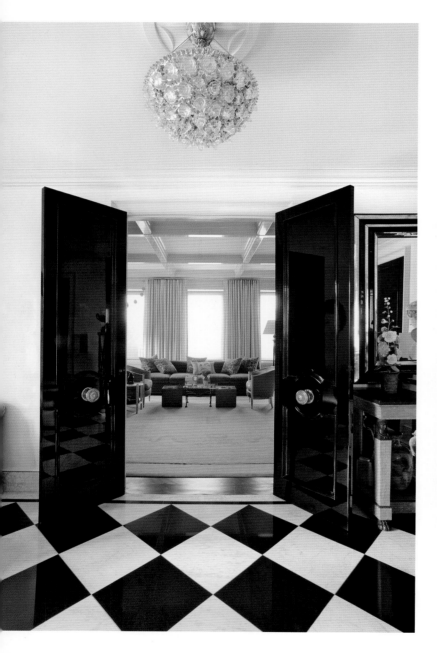

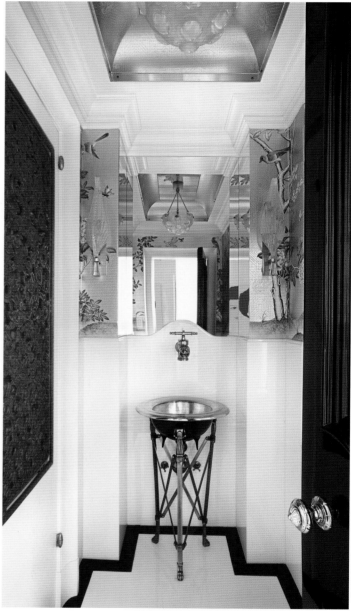

Above left
Large doors in highly polished black open onto the living room. The owner likes to remind visitors that they are in the building where Auntie Mame was created—and where her spirit still lives.

Above right
The black-and-white marble floor of the foyer is reinterpreted as a white field and black border in the powder room. Panels of vintage hand-painted wallpaper flank the mirror above the neoclassical basin.

Opposite
The high-gloss paint on the coffered ceiling in the living room reflects light on *Man Crazy Nurse #3* by Richard Prince and a trio of works by Josef Albers above the banquette. Iridescent lavender upholstery complements the reds and oranges in the art.

Overleaf
A mobile by Alexander Calder balances beneath ceiling beams lacquered with car spray enamel for maximum light. The neutral palette for the curtains and low-slung furnishings allow the Diego Giacometti floor lamp and cocktail table to command attention.

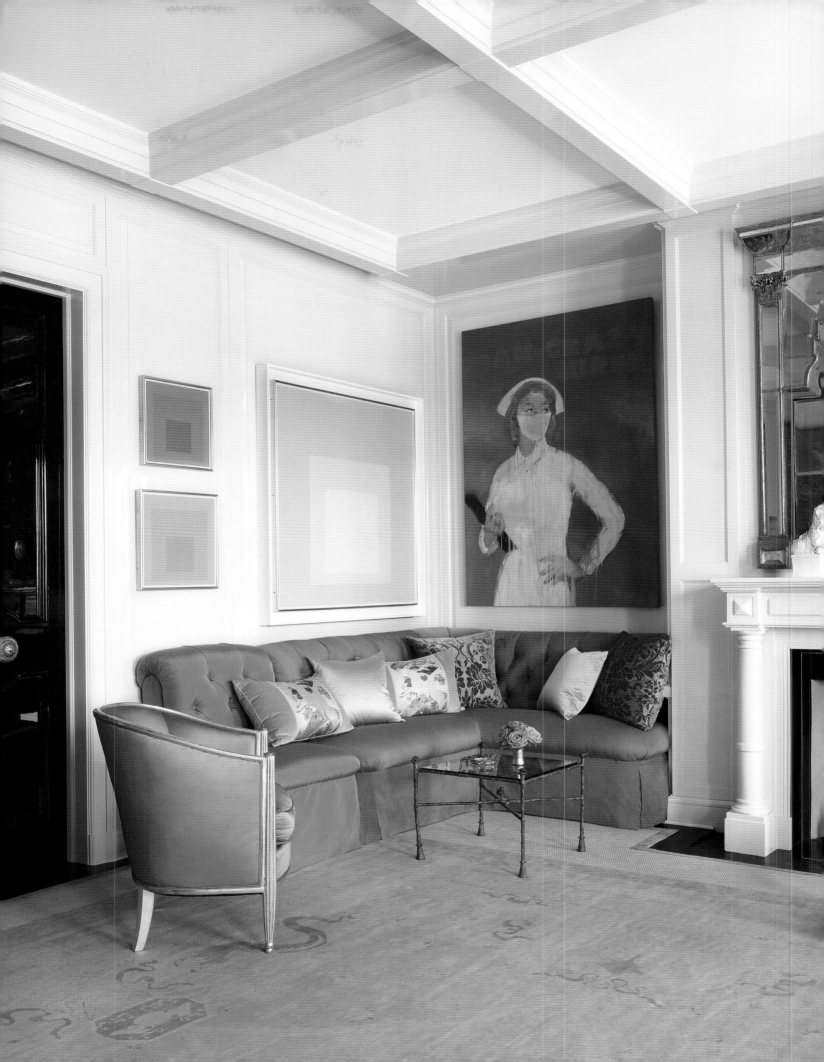

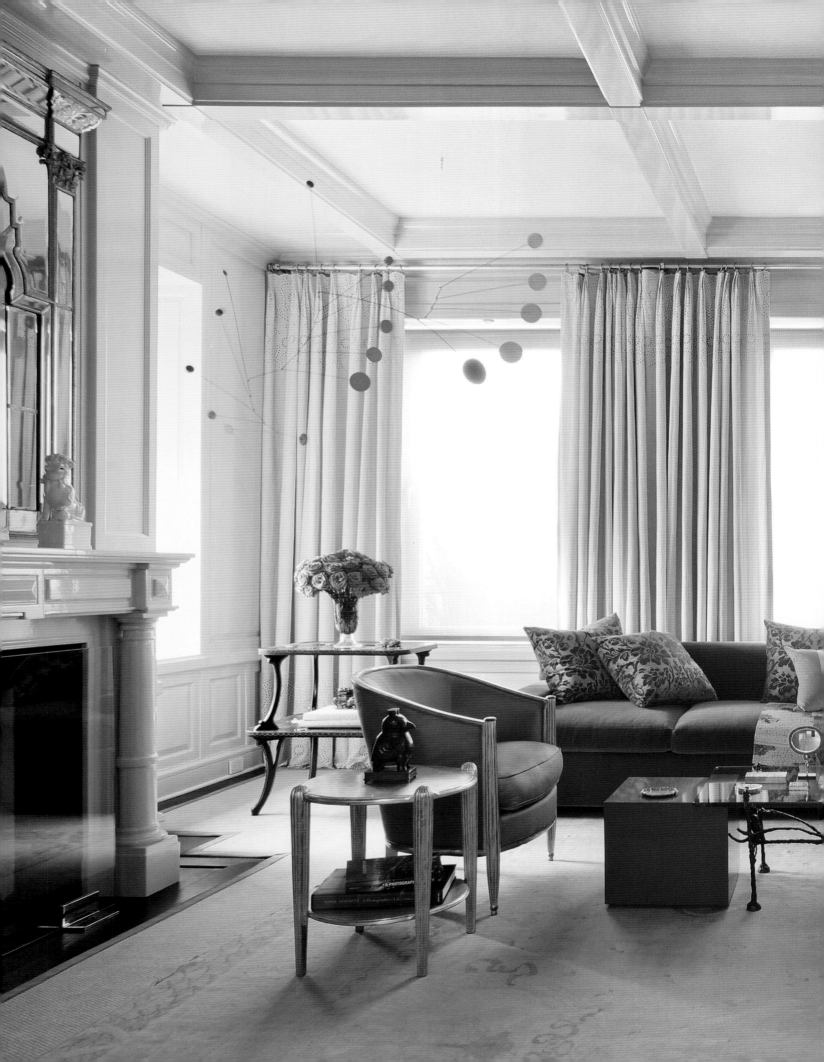

Clockwise from left

An English chinoiserie clock sits on the mantel; A silk obi adds an Asian accent to a throw pillow from the living room; Gilded accessories by Line Vautrin contrast with the bronze Giacometti table.

Opposite

A "blackboard" painting by Cy Twombly hangs above a console by James Mont, chosen for its low silhouette, Asian styling, and high glamour.

Overleaf

In the library, streamlined midcentury furnishings combine with the intricate details of the linen press/bar for a look that is as inviting as it is eclectic.

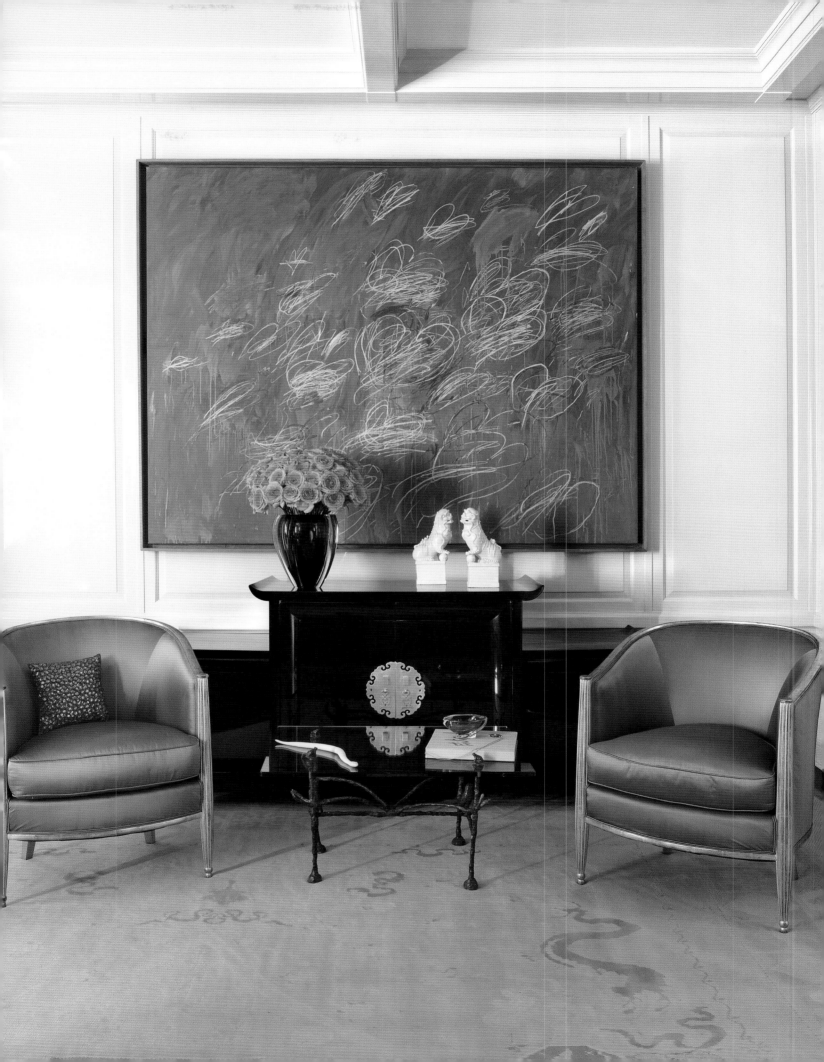

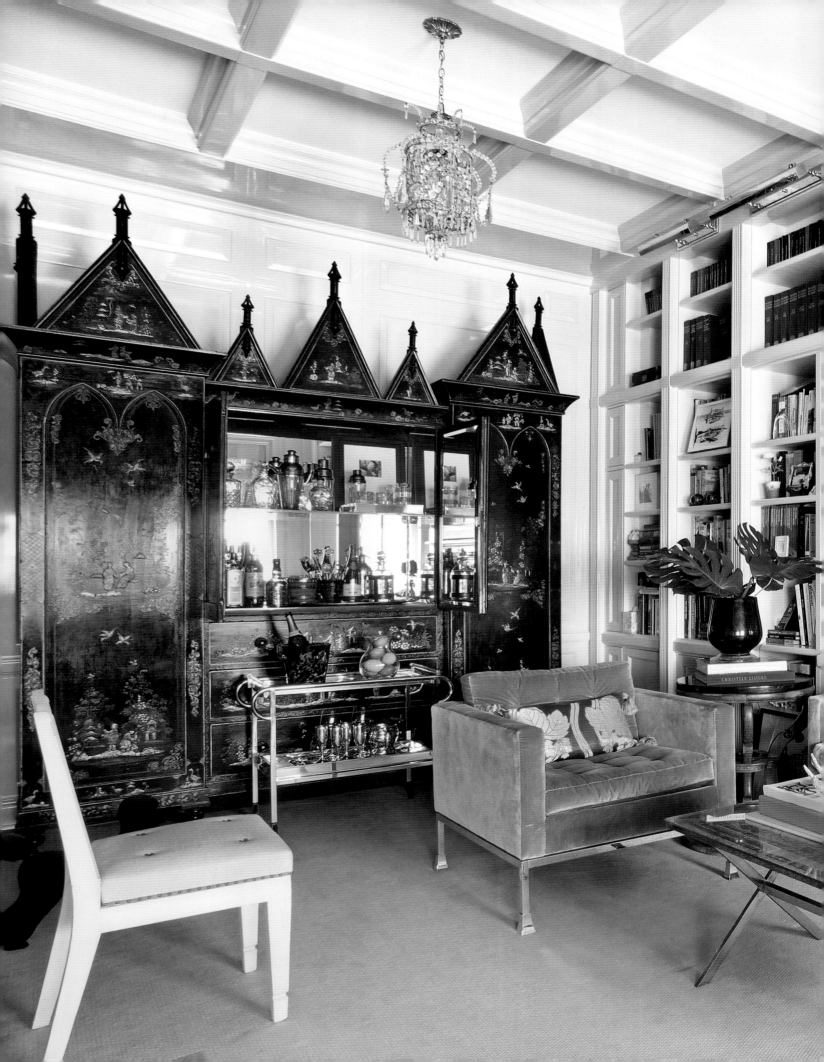

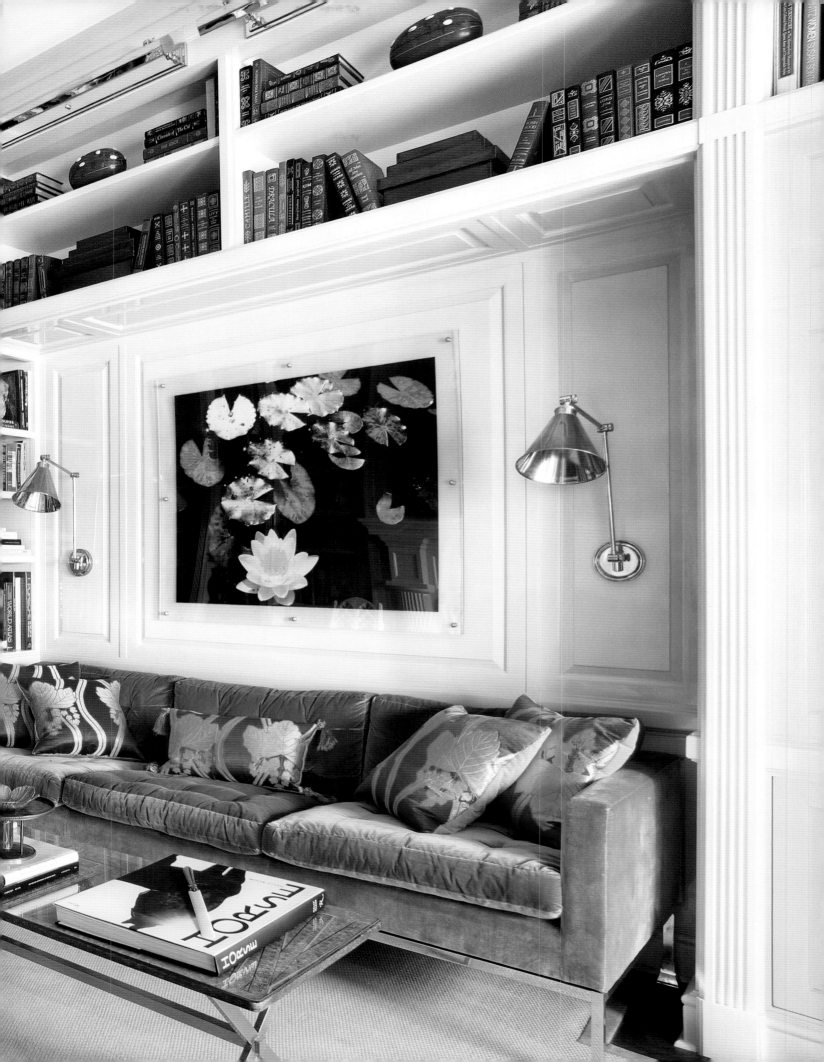

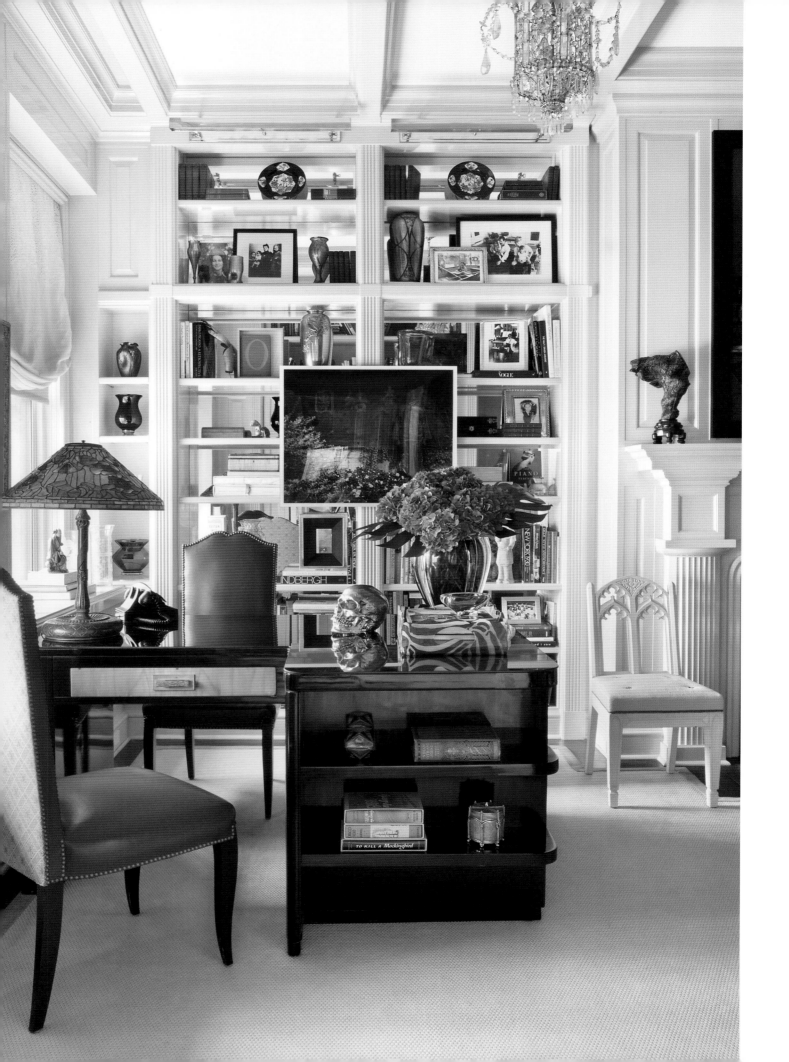

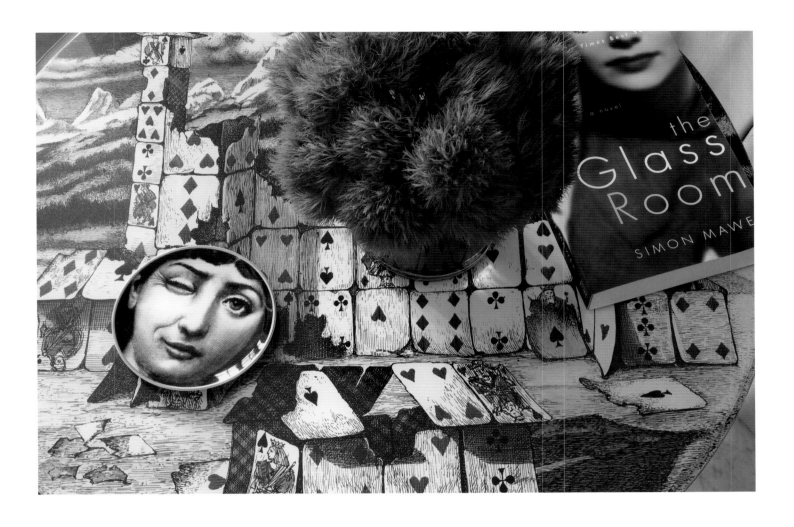

Opposite

A Tiffany lamp stands on a partner's desk purchased in London. Cherished objects are interspersed with the books on the shelves. The skull on the desk is by Damien Hirst.

Above

A Fornasetti plate featuring a winking Lina Cavalieri rests on a round table created by the Italian painter, sculptor, and decorator.

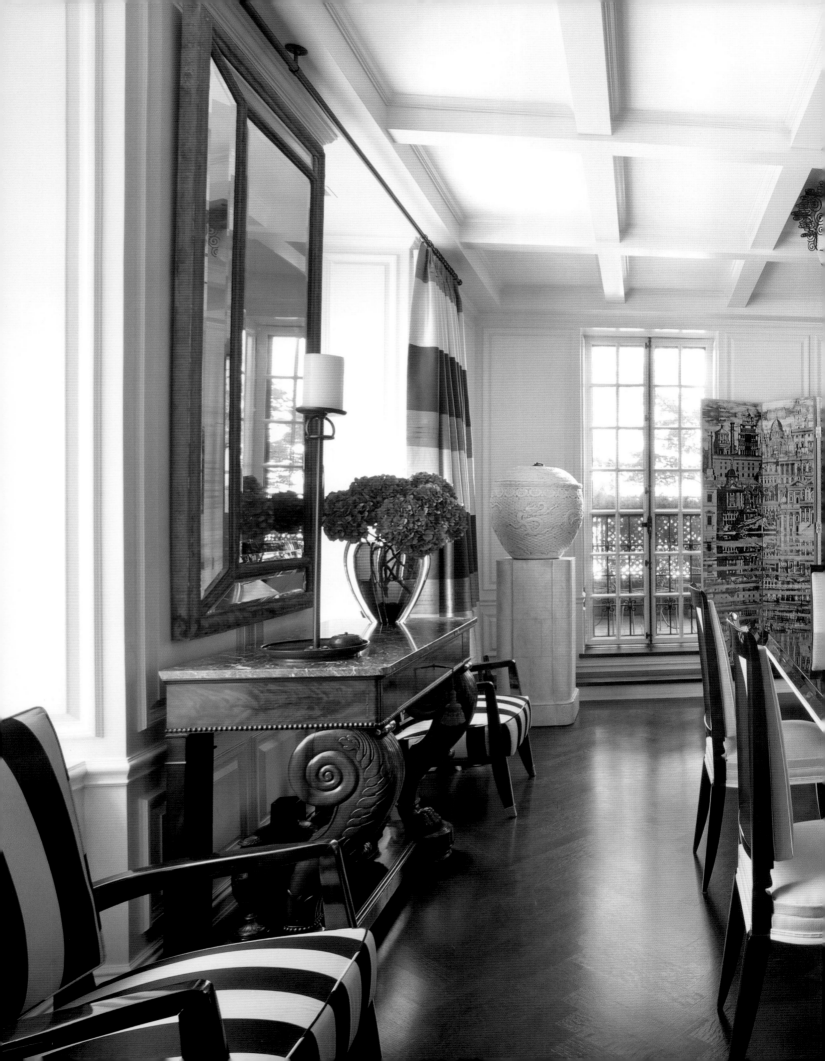

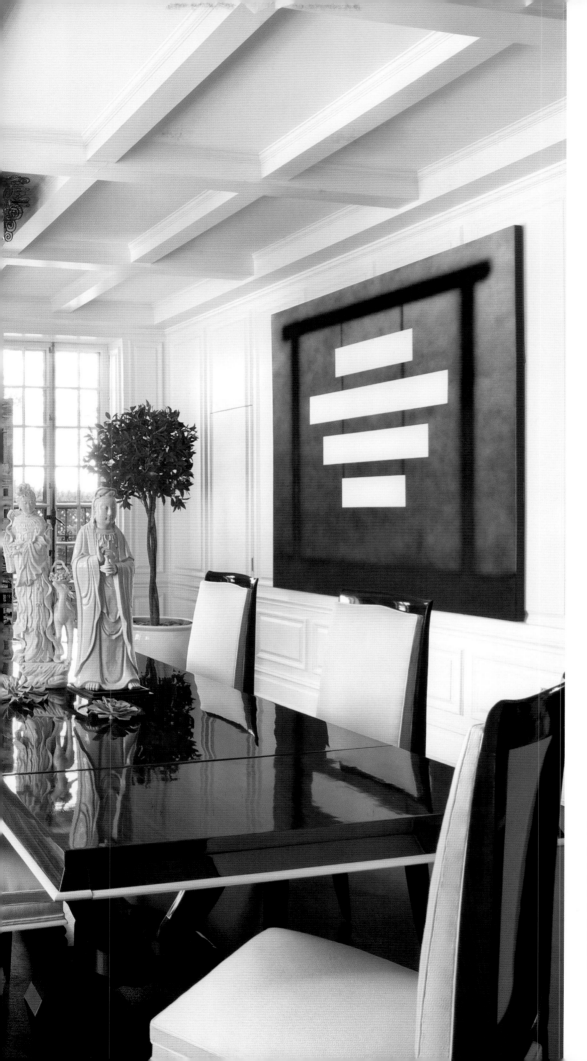

Left
The dining room reveals the owner's
eclectic tastes and fondness for Asian
art. Blanc de Chine figurines are
displayed on the table. The contempo-
rary canvas by Ed Ruscha contrasts
with the Art Deco styling of the tables,
chairs, and bronze light fixture. The
screen between the French doors
is another piece from the owner's
Fornasetti collection.

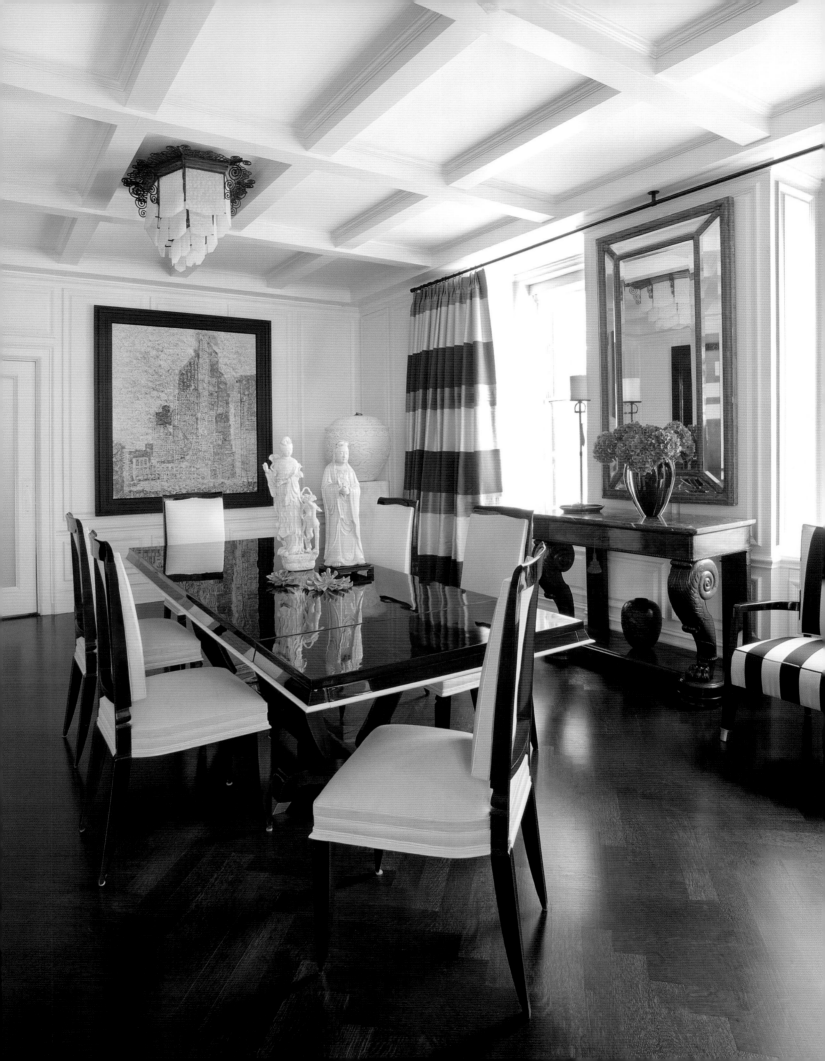

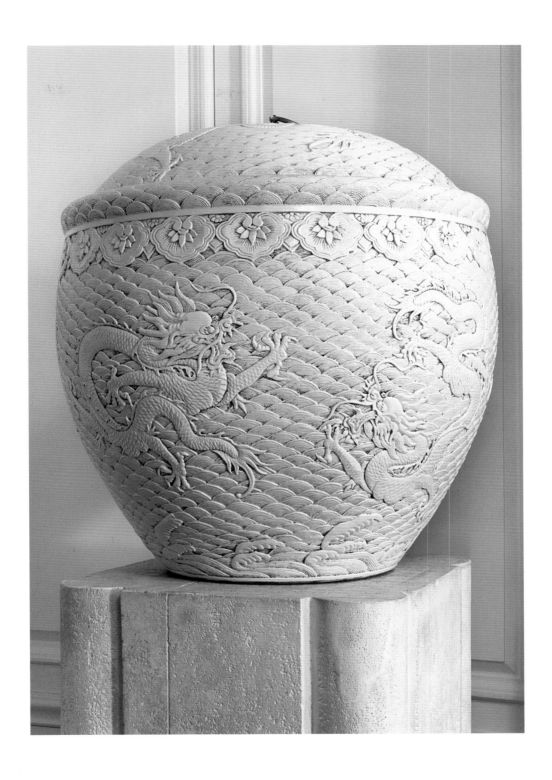

Left

The monochromatic *The Shadow* by
Richard Artschwager brings texture
and dimensionality to the rear wall of
the dining room. A second ceiling-
mounted Deco-styled fixture in bronze
and opalescent glass provides light.

Above

One of a pair of covered ceramic urns
installed in opposite corners of the
room.

Above and opposite
In the kitchen, the terra-cotta flooring is stained a chocolate brown for additional contrast with the white millwork. The wall clock, in laser-cut metal, is an interpretation of a traditional cuckoo clock by Pascal Tarabay.

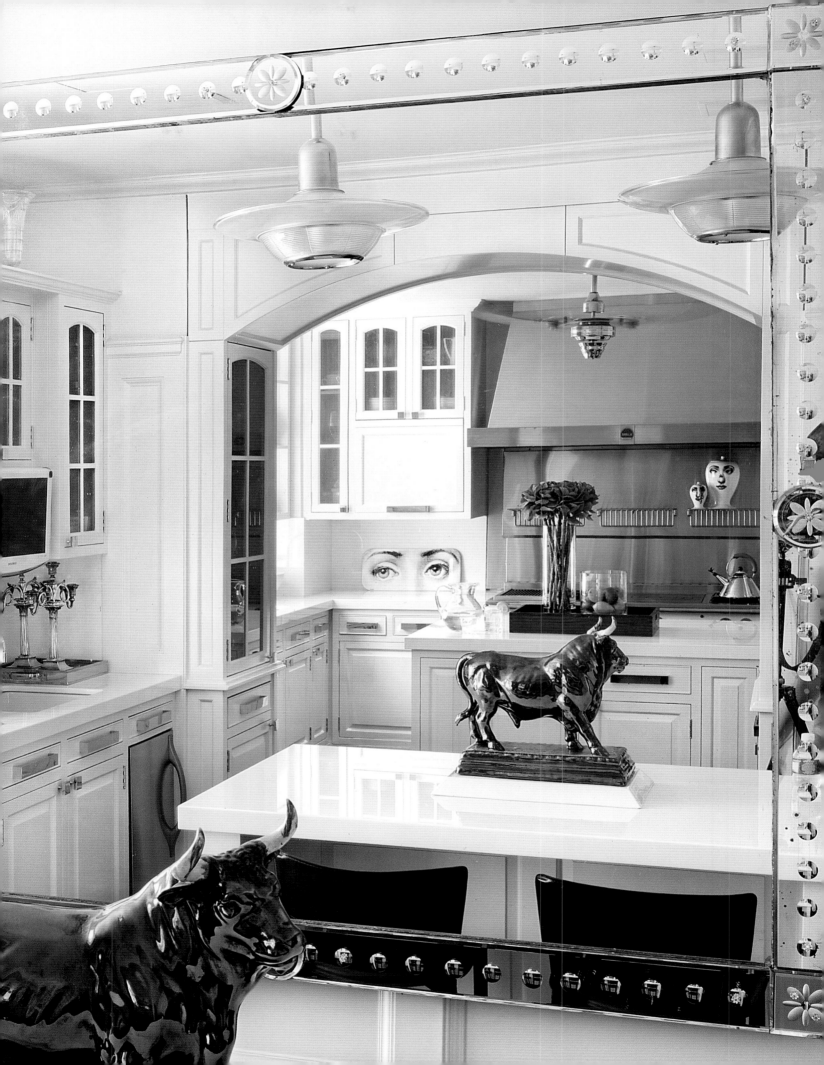

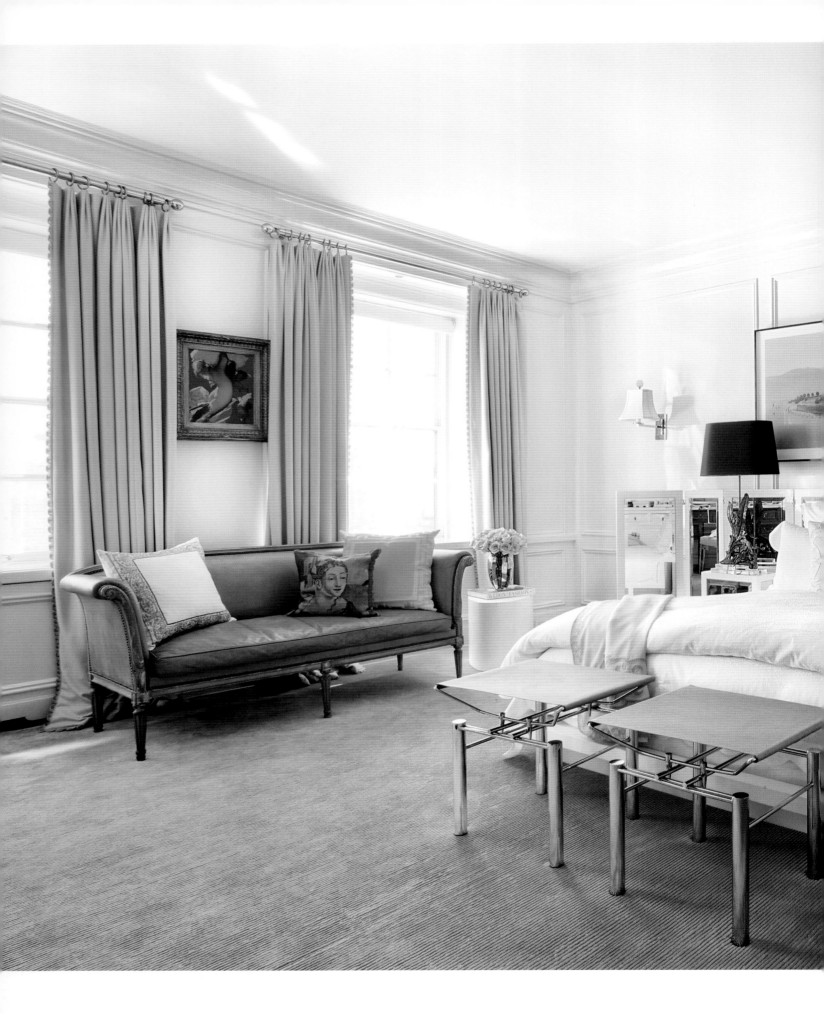

Left

The master bedroom features a lacquered platform bed that keeps the scale low. Custom mirrored screens extend from the headboard and beyond the side tables to reflect the light. A view of Dunhuang, China, by Lynn Davis hangs above the bed. The lamp bases on the night tables were custom made from andirons.

Overleaf

A black-and-white scheme prevails on the stairway wall where the collection of photographs features celebrities, friends, and family. A custom crystal chandelier and strategically placed ceiling lights highlight the images.

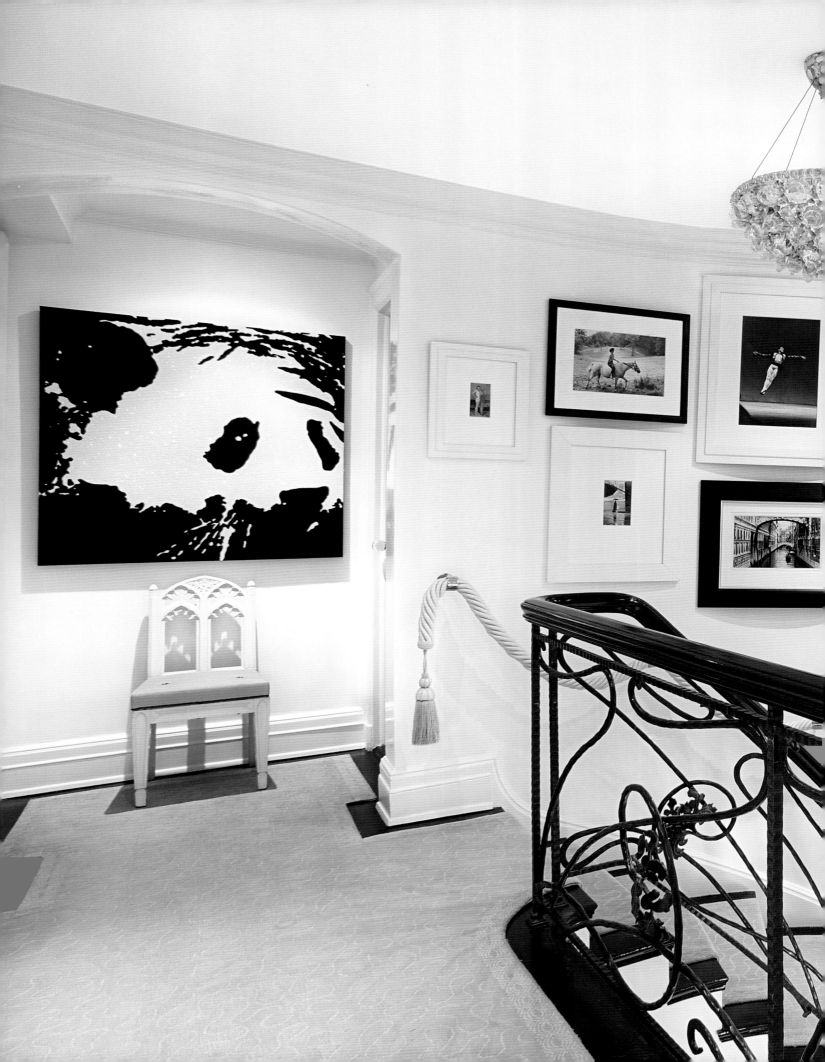

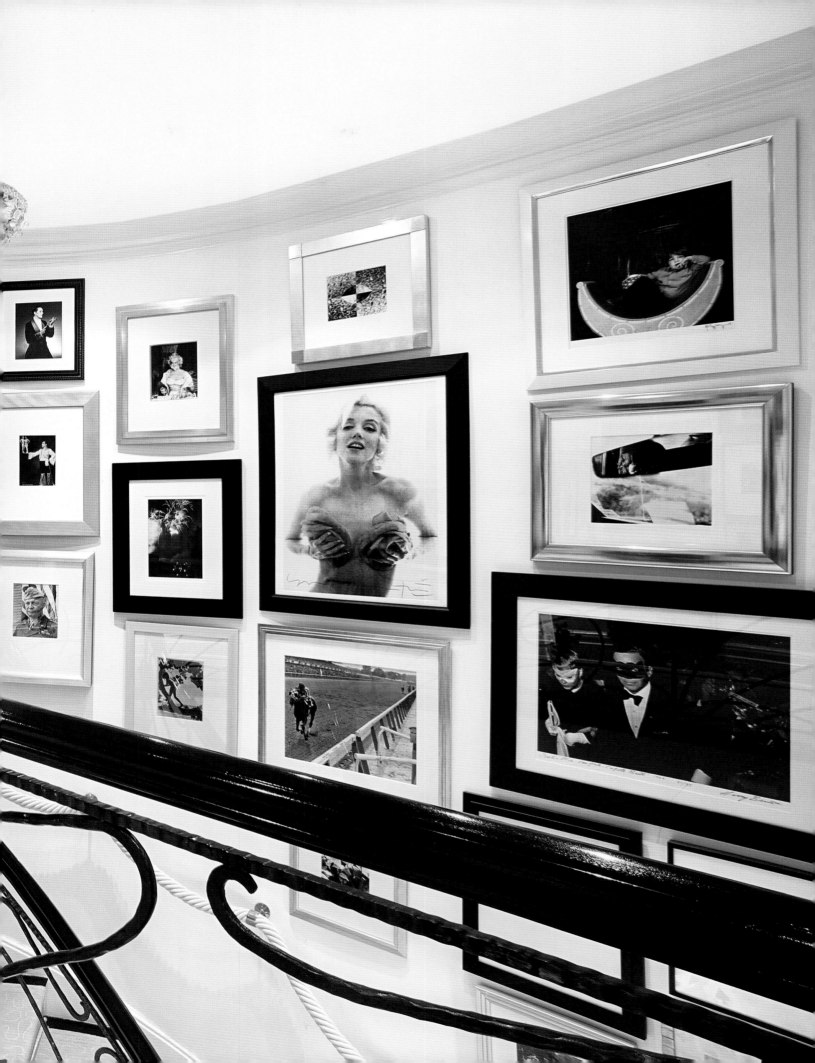

Greenwich Georgian

Art is much less important than life, but what a poor life without it.

—Robert Motherwell

A fieldstone Georgian-style house is the latest property acquired by a family that I've worked for ever since I began my design career. Over the years, two generations have owned homes in New York, New Mexico, and Florida, and I've been thrilled to help them with everything from gut renovations to simpler decorative updates.

As some of the foremost collectors of contemporary and postwar modern art, they have always placed a premium on residences that reflect their tastes and showcase their collections in the best possible light. But they have no interest in a glass box of stark white walls with scarcely a place to sit. The house in Greenwich is warm and inviting, with classic bones that go back to 1929 and manicured grounds that extend almost as far as the eye can see.

On the outside, the house would work perfectly in a Merchant-Ivory period drama, with its stone walls, circular driveway, Palladian windows, classic cottage, and trio of brick chimneys. On the inside, however, the look was dated and uninspiring, with too much chintz, thick carpeting, and heavy drapery, as well as a kitchen and bathrooms that hadn't been updated in years. The mother and daughter, who now spend weekends and summers here, bought the house as a family retreat, but they wouldn't compromise when it came to refreshing the interiors and creating appropriate settings for their art.

Renovations began in earnest shortly after the house was purchased in 2010. Decades-old carpeting and wallpaper were stripped away to reveal the original hardwoods and plaster. Paneled rooms were hand-polished to restore the luster and celebrate the classic origins of the architecture. Heavy floral drapery and valances were eliminated altogether or replaced with lighter, less obtrusive window treatments. A mix of family favorites, custom pieces, and low-to-the-ground chaises, distinguished by their smooth textures and streamlined silhouettes, was installed in the sitting rooms.

Although most of the walls are in shades of white or cream, the wood-paneled library was lacquered aubergine in a nod to the octagon room at Beauport, the seaside retreat of the legendary decorator Henry Sleeper. Throughout the house, the rooms are largely monochromatic, but the darker backgrounds and period details make the carefully selected paintings, photographs, and sculptures stand out almost as much as they would against a paler palette.

Only a few rooms have high ceilings so the placement of oversized canvases had to be considered carefully. A pencil sketch of Marilyn Monroe by Andy Warhol may fit comfortably over the living room mantel, but it takes almost an entire wall nearby to showcase one of Ross Bleckner's massive works. The billiard room with its barrel-vaulted ceiling became the ideal setting for one of Mark Tansey's distinctive paintings. The collection includes works from Georgia O'Keeffe, Agnes Martin, and Anne Peabody to Ed Ruscha, Joe Andoe, and Jasper Johns.

The dining room, with its flat sunburst lighting fixture and long dimensions, works well for smaller pieces, including a stunning array of black-and-white photographs by masters like Robert Mapplethorpe, Herb Ritts, and Alfred Stieglitz. Interspersed among the greats are beloved images of family and friends, making for lively conversations and reminiscences during dinner parties and gatherings.

"I used to collect jewelry," says the mother, relaxing with her daughter on the loggia overlooking the grounds, "but the art has enriched our lives so much more. We have so much here—our family, our friends, our collections. We're truly blessed—and so, so grateful."

Opposite The moldings and bannister in the entrance hall may suggest a traditional interior, but there are bold statements with cutting-edge art around every corner. The vignette of *The Dark Eclipse* by Louise Nevelson and the window is reflected in the cube by Larry Bell below. The glass ball finial adds a "touch of magic" to the space.

Opposite and above
An untitled work from Robert Rauschenberg's Salvage series hangs at the top of the stairs. Generous double doors open into the living room where contemporary art is juxtaposed with nineteenth-century English and Asian furniture. A large abstract by Ross Bleckner and a wood sculpture by Nancy Dwyer are counterpoints to the camelback sofa and rosewood nesting tables.

Overleaf
Etched-glass panels by Anne Peabody bring light and drama to the setting. *Dry Waterfall* by Georgia O'Keeffe hangs between the windows while a Gothic Revival center table anchors the room.

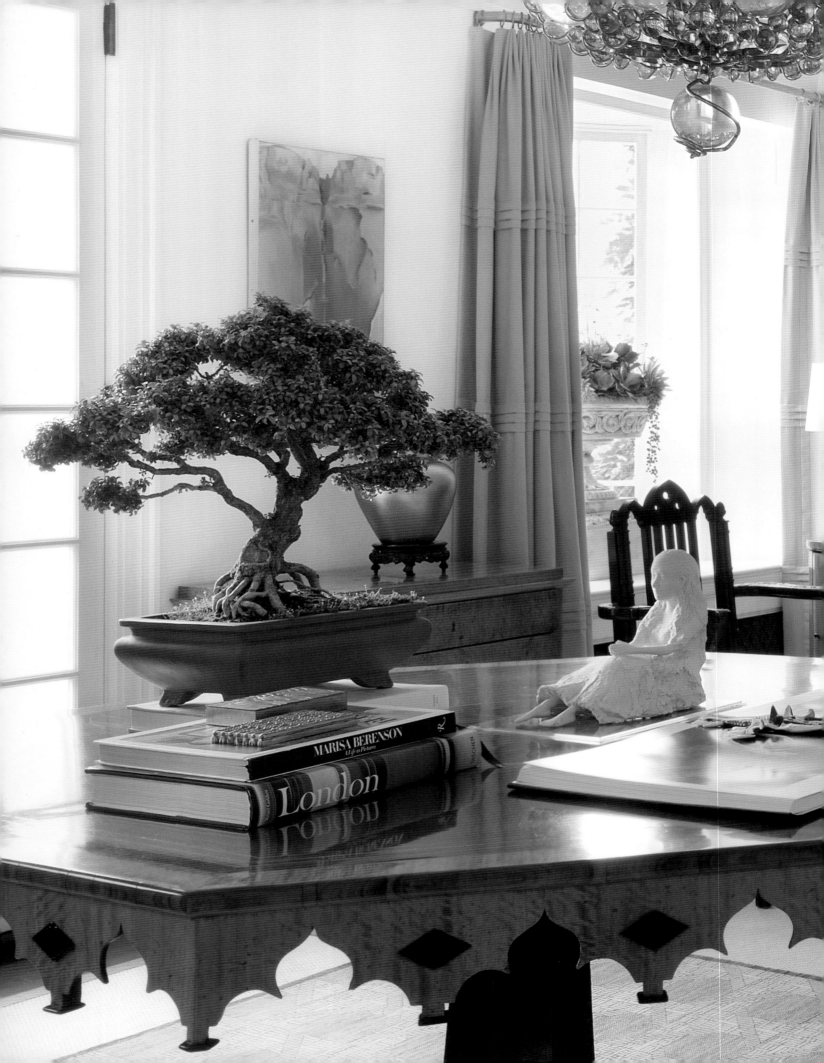

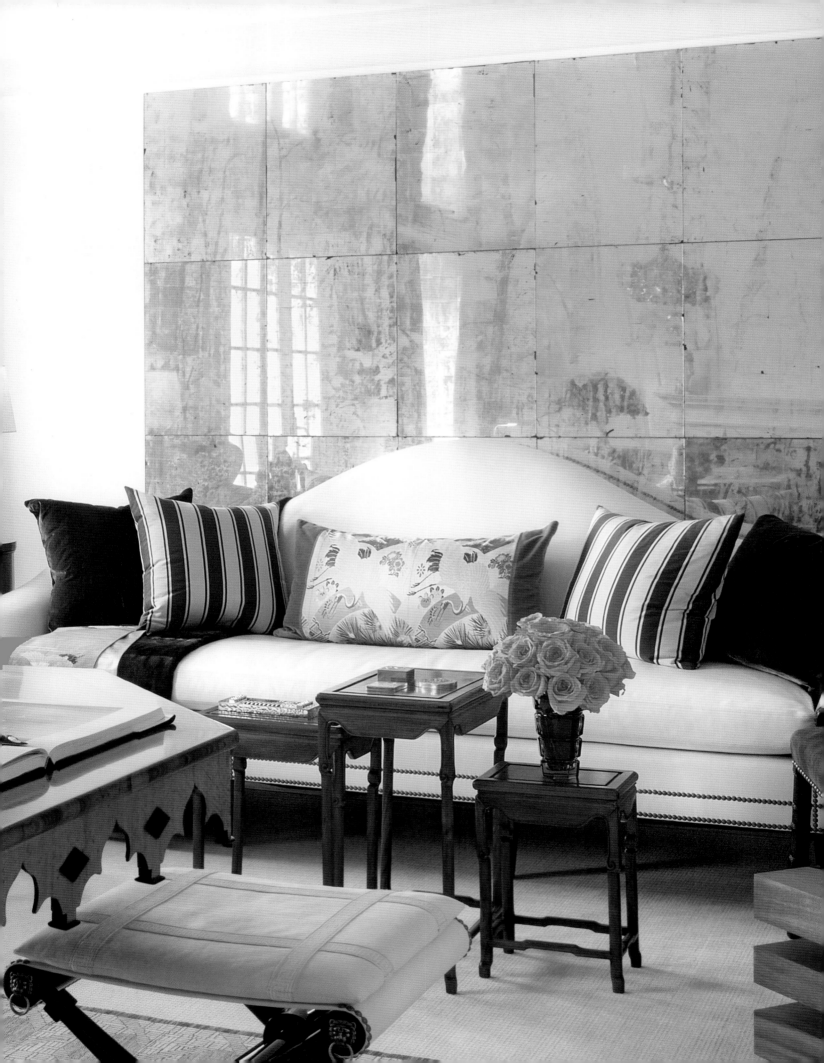

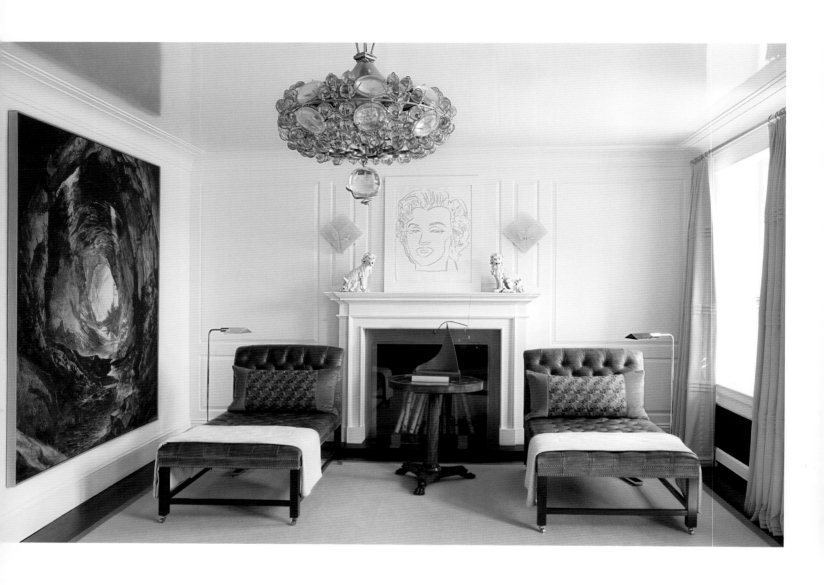

Above and opposite
Tufted leather chaises offer relaxed
seating, keeping the scale low and
allowing a Mark Tansey painting to stand
apart in its blue splendor. Porcelain
Foo dogs flank Andy Warhol's sketch
of Marilyn Monroe above the fireplace
while a Calder mobile stands on a
Biedermeier table.

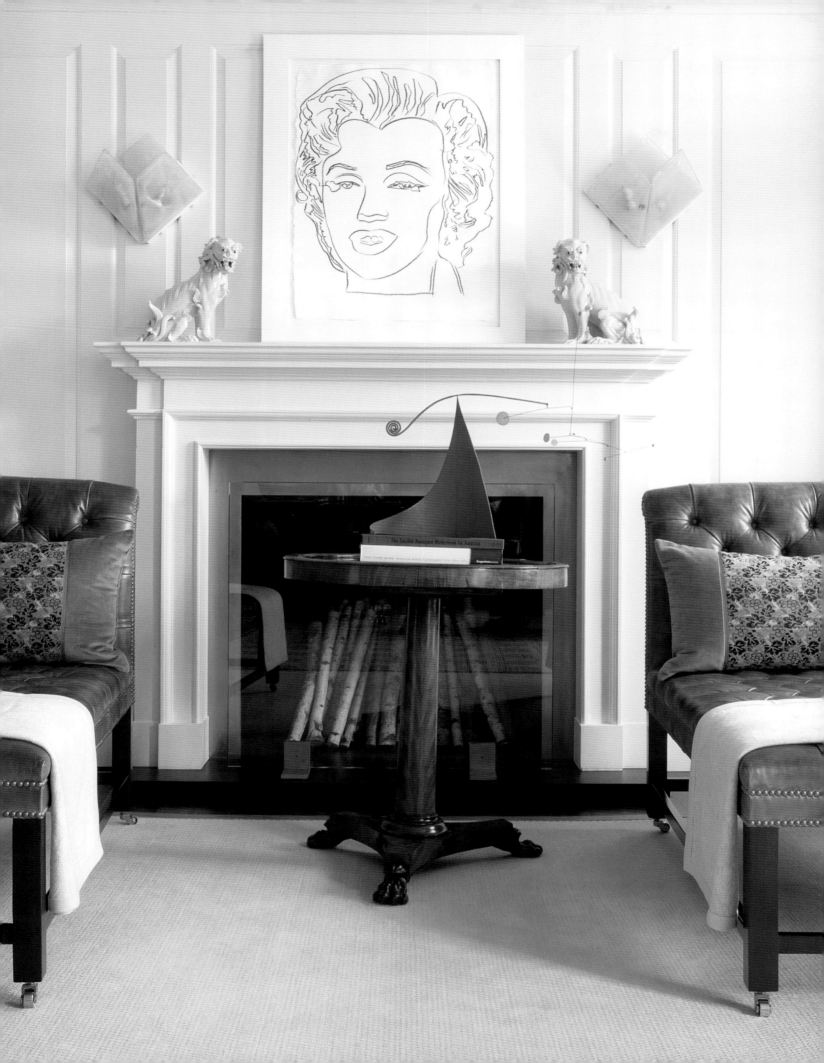

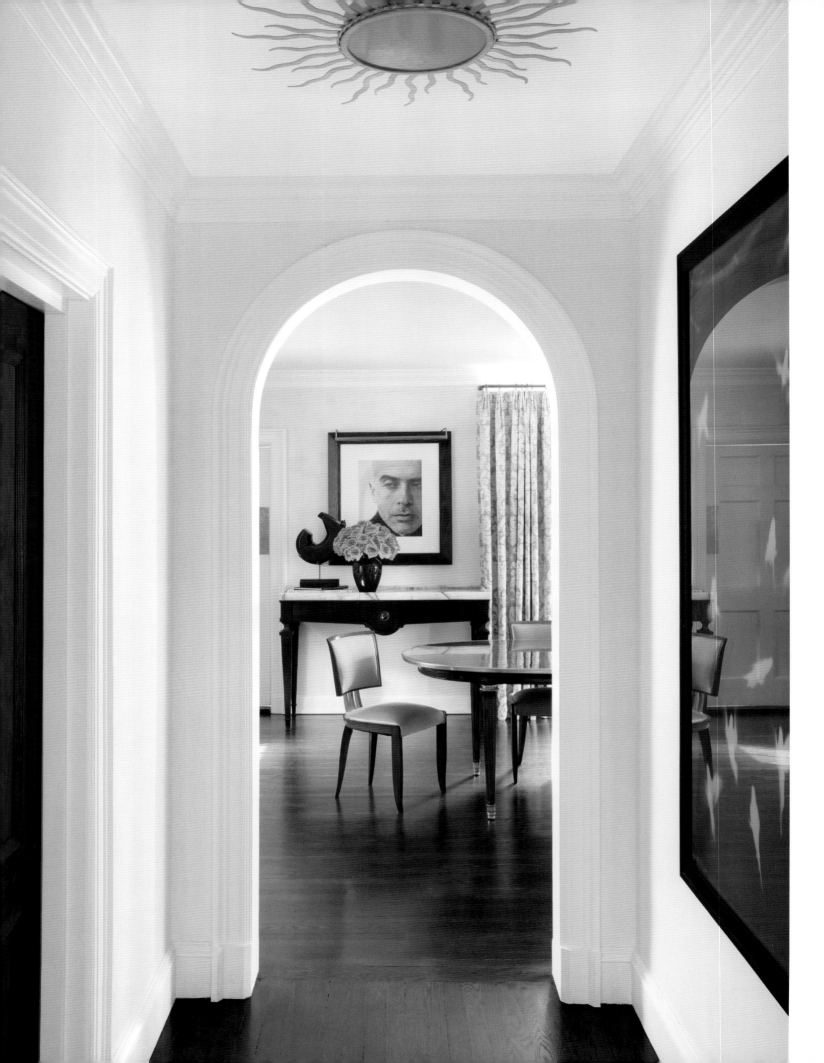

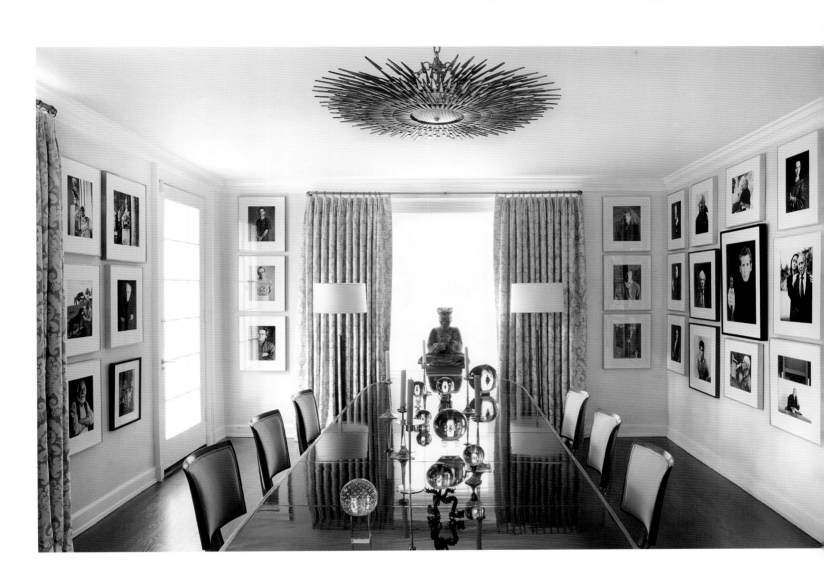

Opposite and above
A photograph of artist Francesco Clemente by Herb Ritts is centered on the opening to the dining room. A Buddha is placed near the head of the table, which is always set with crystal balls and silver candlesticks. The photography display includes works by artists that the family has collected over the years.

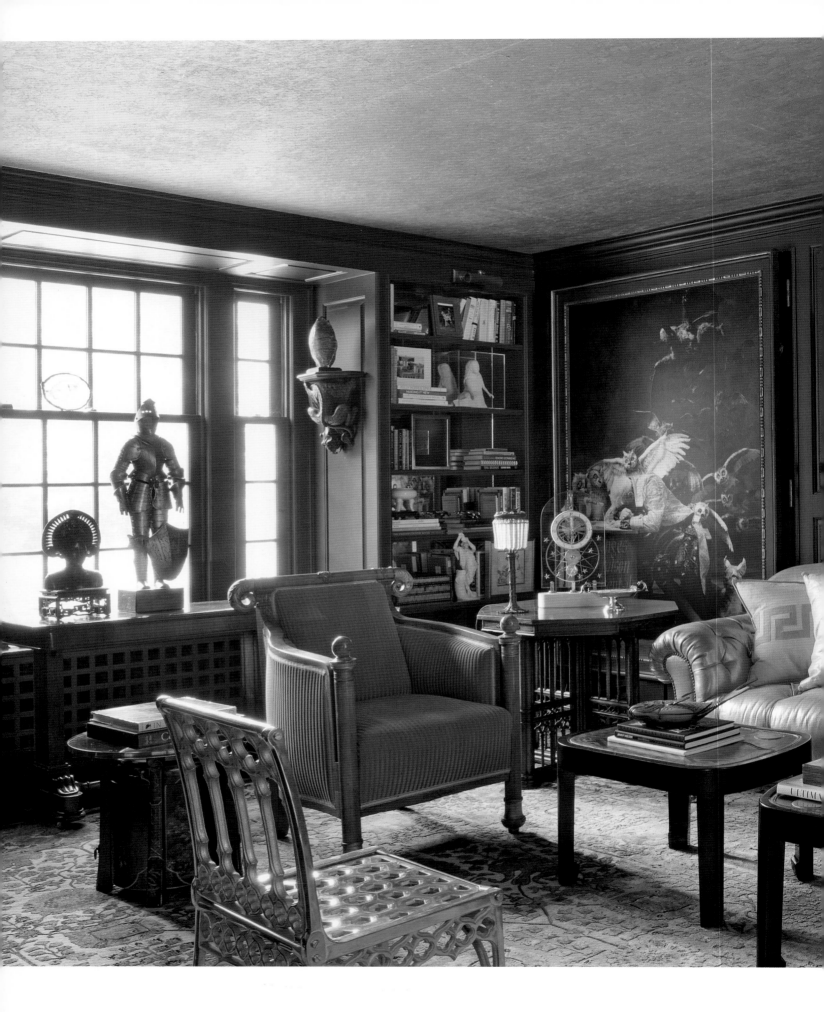

ATMOSPHERE

Left
In the library, a traditional custom-made chesterfield sofa in leather contrasts with the eclectic seating choices, including a Biedermeier armchair and Gothic side chair crafted in aluminum. The painting is by Neil Jenney and the large photograph is by Yinka Shonibare.

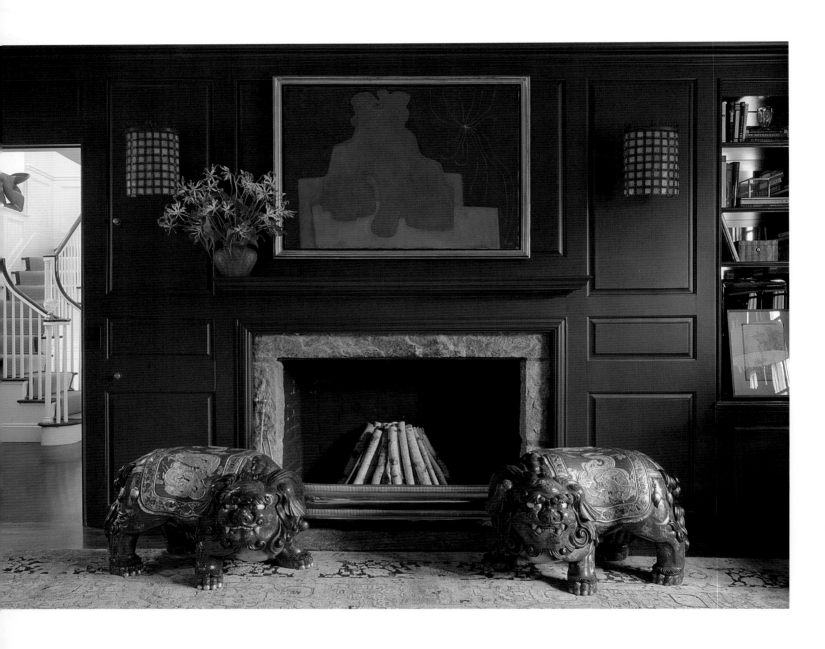

Above

Lacquered aubergine paneling and Tiffany glass sconces complement the purple and blue in *Chinese Dog* by William Baziotes above the fireplace.

Opposite

A leather wing chair, antelope antlers, and Blanc de Chine figurines strike classic notes amid a collection of more contemporary works by Ralston Crawford, Thomas Nozkowski, and Jean Dubuffet.

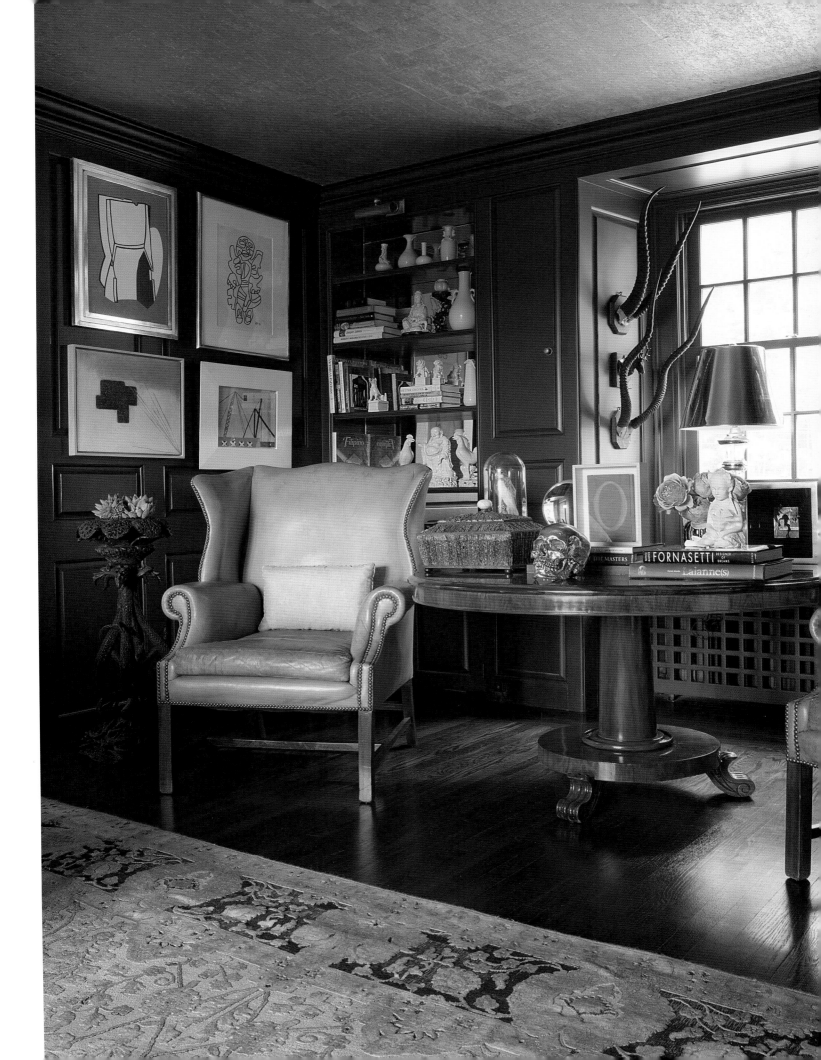

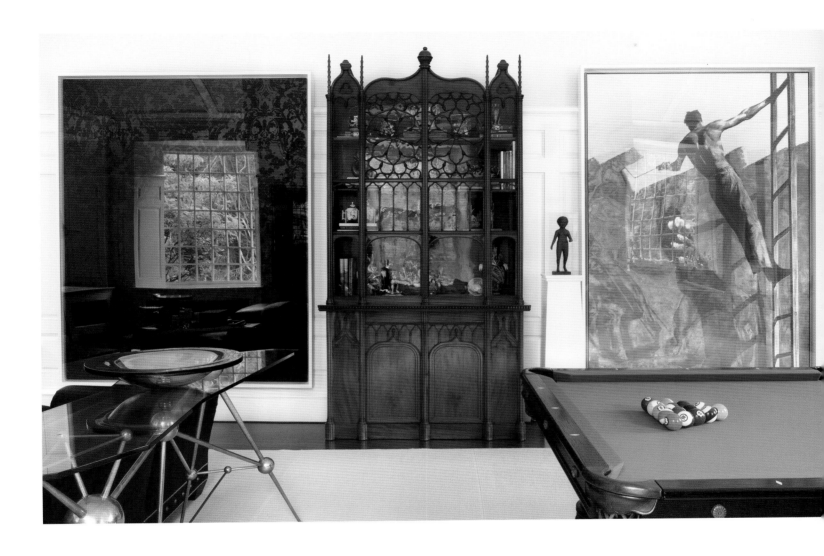

Opposite
The brass clock, in the form of a
conveyer system, is a family piece.
The drawing is by Cy Twombly.

Above
Large-scale works by Rudolf Stingel
(left) and Mark Tansey were chosen
to flank an imposing Gothic mahogany
bureau bookcase. The bronze figure
is by Kiki Smith.

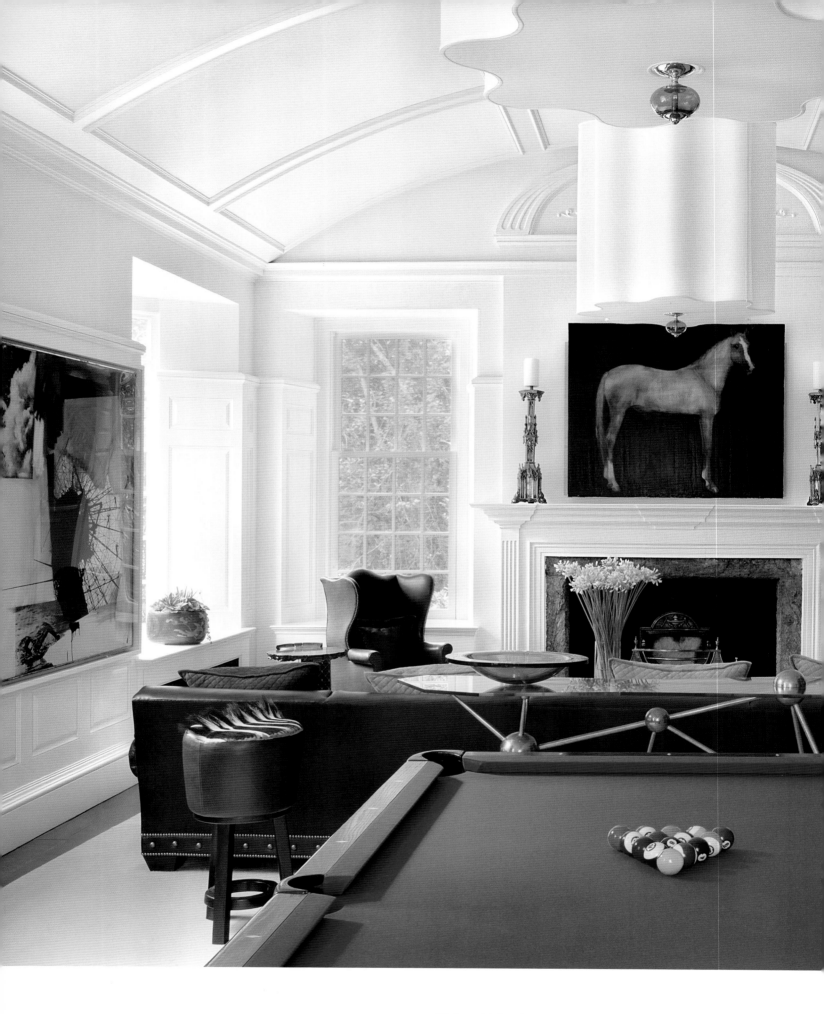

Left
The large sofa in the barrel-vaulted billiard room was custom made to balance the mass of the pool table. In a nod to more traditional Connecticut interiors, a leather wing chair and a Chippendale armchair flank the fire-place. A monochromatic horse by Joe Andoe is displayed above.

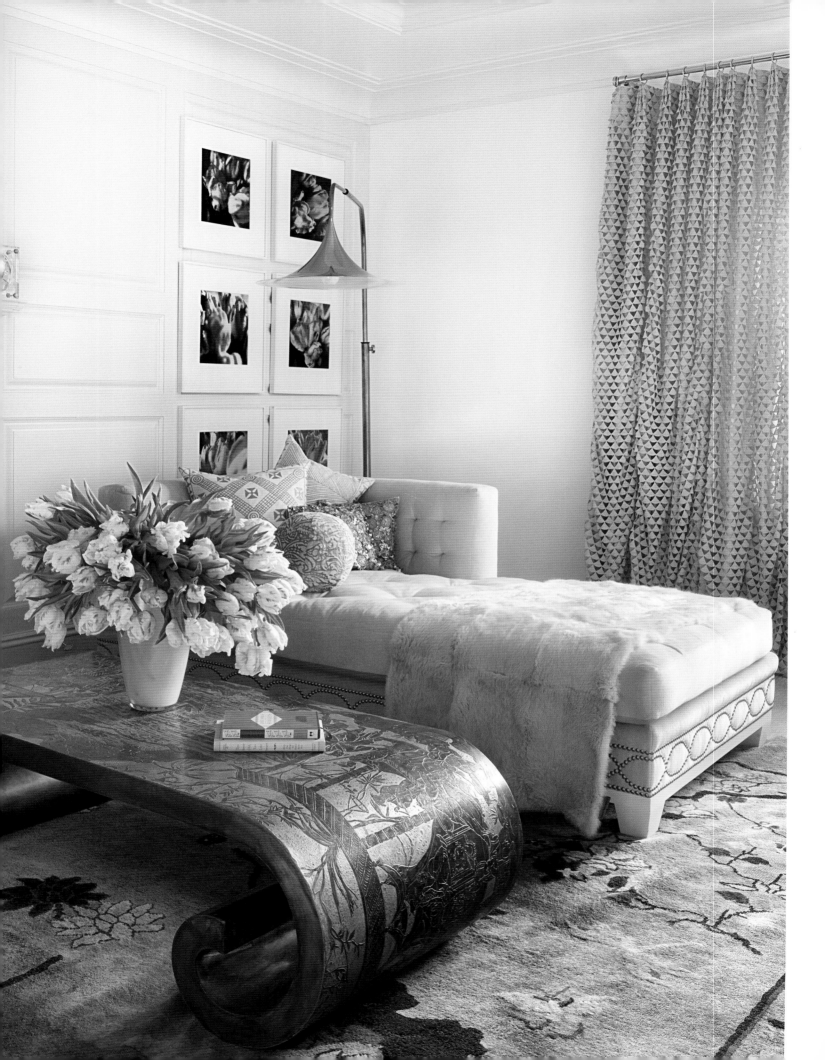

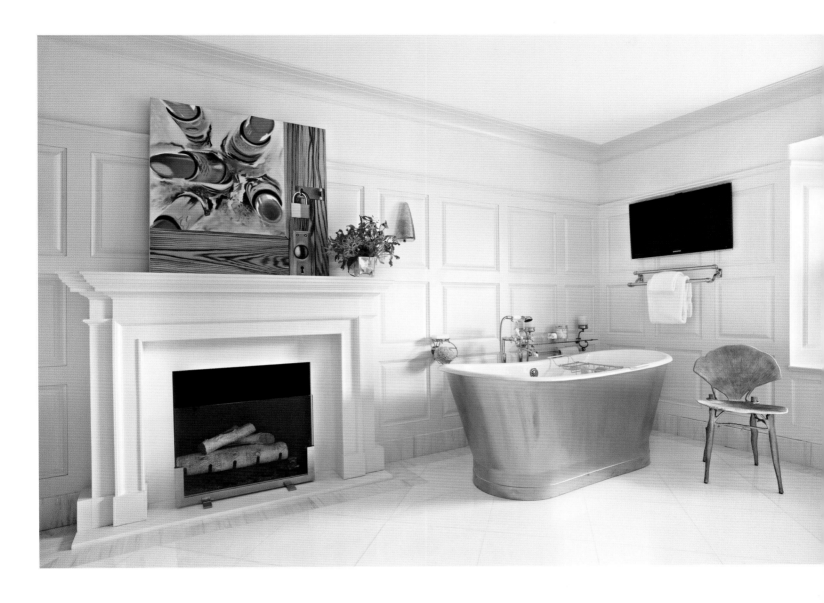

Opposite
In the master suite, a chinoiserie table by Philip and Kelvin LaVerne matches the scale of the welcoming chaise.

Above
Bright reds in the James Rosenquist painting add a splash of color to the large master bath, a retreat with its own fireplace and television. A Claude Lalanne chair is nearby.

Overleaf
John Meeks designed the bed and side tables in the master bedroom. A quartet of Line Vautrin mirrors above the curving headboard captures light from the round ceiling window.

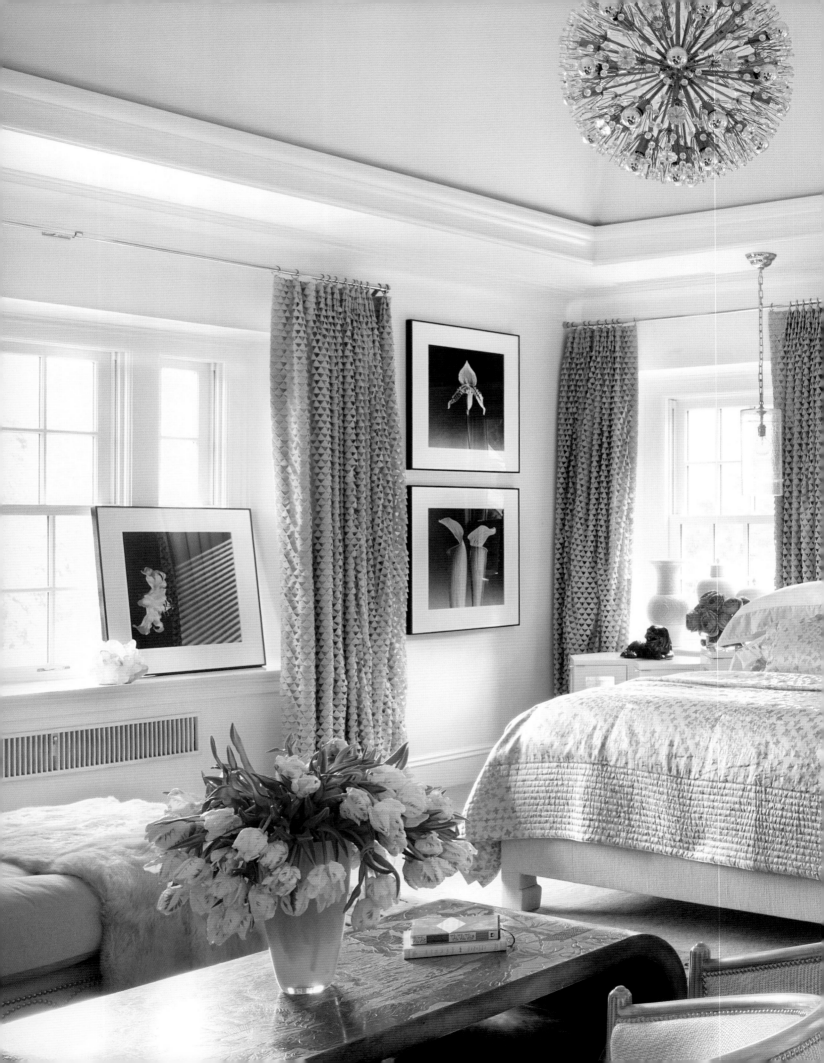

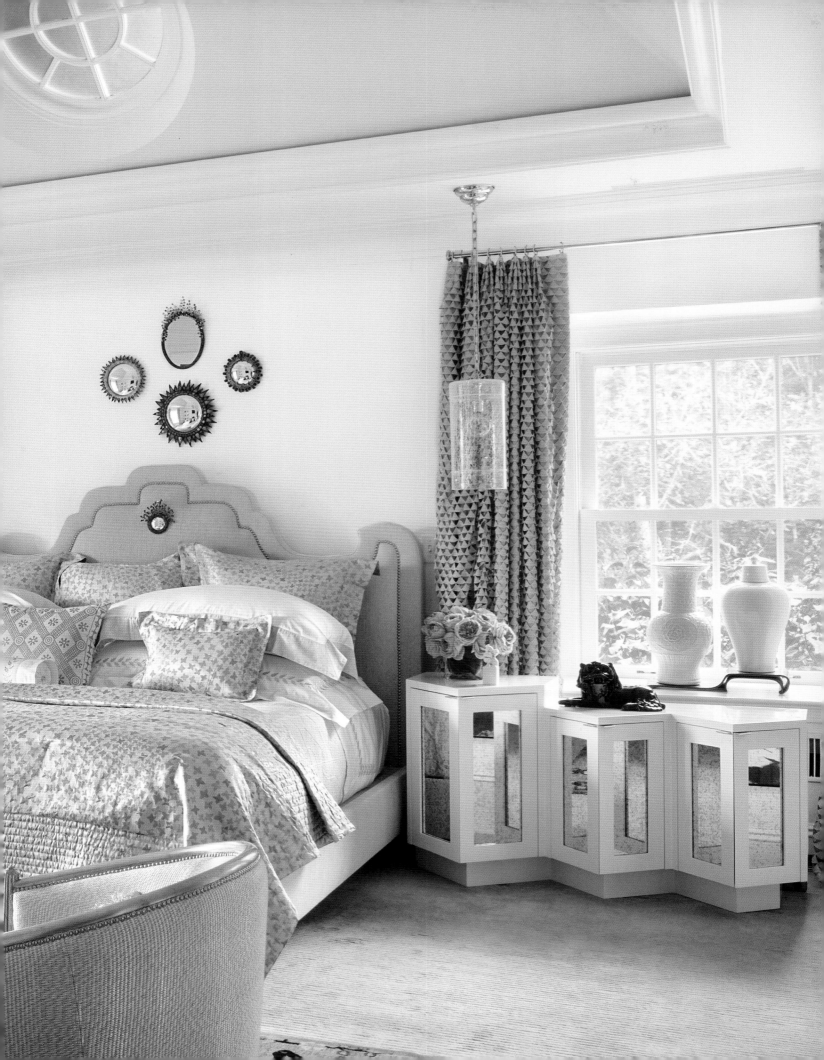

Palm Beach Regency

The artist's vocation is to bring light into the human heart.

—George Sand

Over the past twenty years, I've been fortunate to work on a variety of residences in Palm Beach, from magnificent Beaux-Arts palaces to classic Georgians to stunning contemporaries. But the style that has always been a favorite of mine and a coveted choice among locals is "Gottfried Regency," named for the developer John Gottfried. He built hundreds of homes in this seaside resort and gave the town much of its enduring style and glamour. A "Gottfried" is still one of the most sought-after residences in Palm Beach, prized for high ceilings, classic lines, light-filled interiors, and effortless symmetry.

One of my earliest clients and her family moved to Palm Beach from an ultra-modern house that I had decorated in Ohio. When they had the opportunity to "get a Gottfried," they were lucky enough to purchase one of the developer's last masterpieces on what is arguably one of the prettiest streets in Palm Beach.

From the start, my clients were enchanted by the house, with its 14-foot ceilings and its combined indoor and outdoor spaces with large windows and French doors that drenched the interiors with sunlight. The spacious rooms were ideal for the display of their paintings and sculpture. In fact, they were so perfect that my clients decided to make this house their full-time residence. Their only requirement was that the decor remain streamlined and elegant without fussiness or cliché tropical touches.

"The house is everything we dreamed of," my client told me. "But the main focus has to be the art. It's what we love most of all. We just don't want a lot of other elements that compete for attention."

A Stack sculpture by Donald Judd and works by Cindy Sherman, Louise Bourgeois, Richard Artschwager, Terry Winters, and Rudolf Stingel: the list of artists reads like a who's-who of the postwar and contemporary art scene.

To meet the family's goals, we adapted our "transitional" style, mixing traditional elements with the clean lines of contemporary, even minimalist furnishings for a look that can best be described as classic with an edge. The concept was to give each room one or two grand pieces and then keep the rest restrained and cool.

In the living room, a central seating area anchors the space while furniture groupings along the perimeter allow for more intimate gatherings. The tone-on-tone upholstered pieces throughout the room recede into the background and let the art command the most attention. Here a gilded English console and a pair of Baccarat crystal chandeliers are the only pieces that really stand out on their own, and they feel right at home in the classic Regency setting.

In the dining room, our focus was on creating additional space for changing art, keeping the palette cool and quiet with Gustavian chairs and a minimalist silver-leaf table lit by a vintage rock-crystal chandelier. John Meeks designed the table and the custom embroidery that graces the backs of the chairs, making each one a unique artistic creation. In fact, John was responsible for many of the custom furnishings throughout the house.

The challenges we faced on the project were twofold: one on the outside and one on the inside. When our client told us she would prefer a fountain, we replaced the pool with a combination pool and fountain that is artistic, inviting, and provides additional seating around the edge for guests. We couldn't imagine a Palm Beach estate of this magnificence without a pool, and now our client feels she got exactly what she wanted and more.

On the inside, when we suggested painting the walls of the living room a pale shade of pink, we met some initial resistance. We didn't want to rely on the "Gottfried Gray" that Benjamin Moore created for so many of these classic Regencies. But the pink we had in mind was not of the "shocking" variety; rather, it was meant to evoke the inside lip of a conch shell—that very pale, almost off-white tint with just a suggestion of rosiness. It may have been a bold choice, but it's one that definitely works.

"When I entertain, it's like looking at everyone through rose-colored glasses," my client says. "All my friends and guests look so healthy and maybe even younger in this wonderful light."

I don't know if John Gottfried would have followed our advice. But I'm pretty sure he would have been just as pleased with the results.

Opposite The sculpture in pink terry cloth is by Louise Bourgeois.

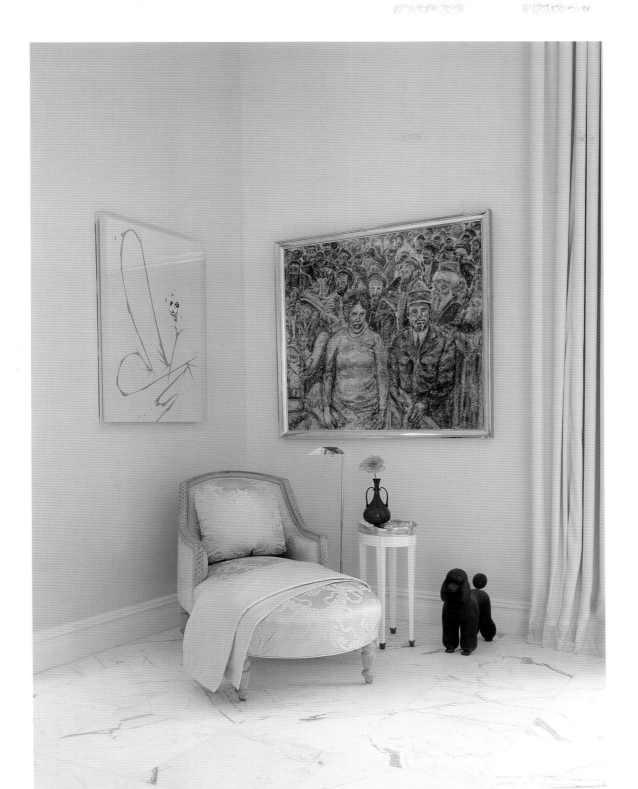

In the entryway, relief panels designed by John Meeks echo the tropical foliage outside. The carved wood is enriched with gesso.

Above
A corner of the living room holds a poodle sculpture by Katharina Fritsch beside a silk-covered chaise. A commissioned work by Takashi Murakami and *Elective Affinities III* by Richard Artschwager share space on the pale pink walls.

Overleaf
A limited palette of pale pink, white, gray, and silver in the living room complements the sculpture of a stag by Kohei Nawa and the reflective painting by Rudolf Stingel and draws the eye to one of Gary Hume's glossy "door" paintings hanging in the hall beyond.

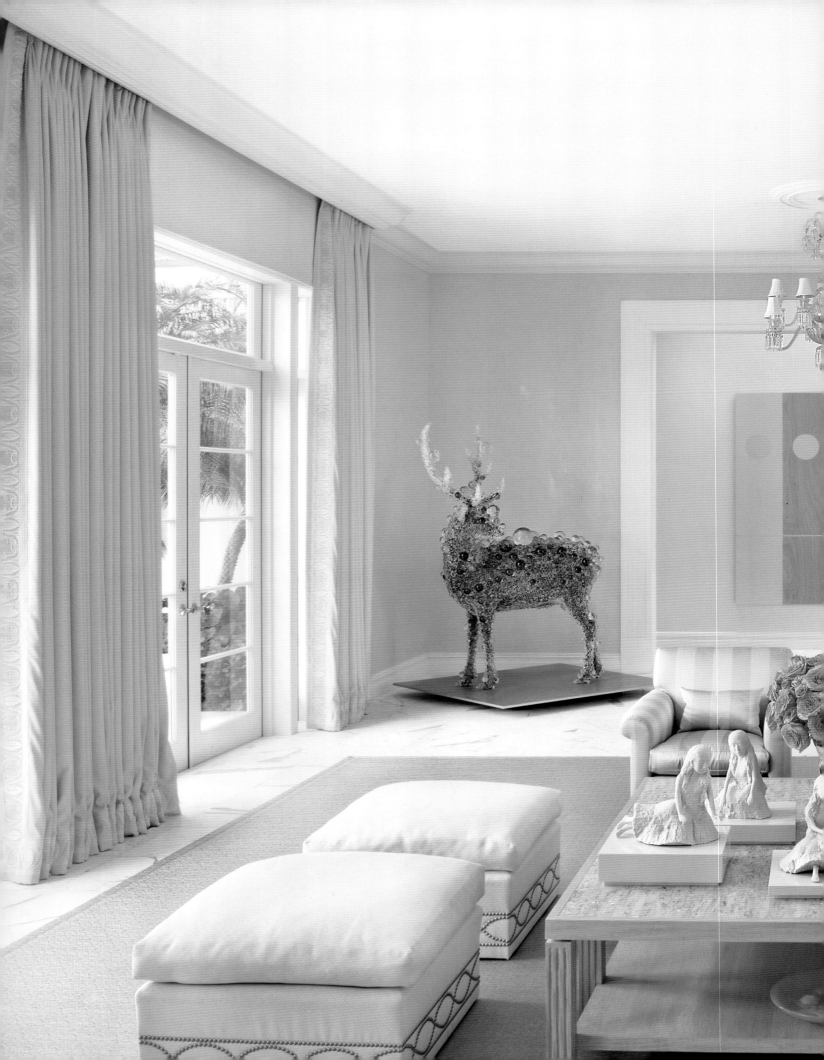

Above
The furniture arrangement in the living room is a study in symmetry, with views from the front entry to the rear pool. Tone-on-tone stripes in silver on the armchairs echo the Stack sculpture by Donald Judd and the bands of ethereal color in the Agnes Martin canvas.

Opposite
Three ceramic figures by Kiki Smith sit on the coffee table. Subtle flashes of pink are embedded in the surface of the top.

Left
A George I giltwood console stands out against the neutral color scheme and cool marble floor of the living room.

Above
Custom-made shell-encrusted frames on the mirrors in the foyer are a Floridian motif. A dog sculpture by Jeff Koons sits beneath a giltwood demilune table.

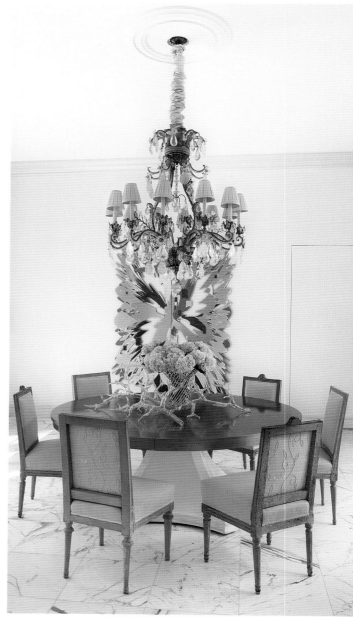

Above

The soft, iridescent sheen of one of Craig Kauffman's wall sculptures blends easily with the pastel pinks throughout the house. A rock-crystal chandelier lights up the minimalist dining room, which is used as a gallery for changing art displays. John Meeks designed the platinum leaf table and chair-back embroideries.

Opposite

A wall hanging by Jorge Pardo looms large on the wall, filling the space with an explosion of pink, coral, salmon, and green.

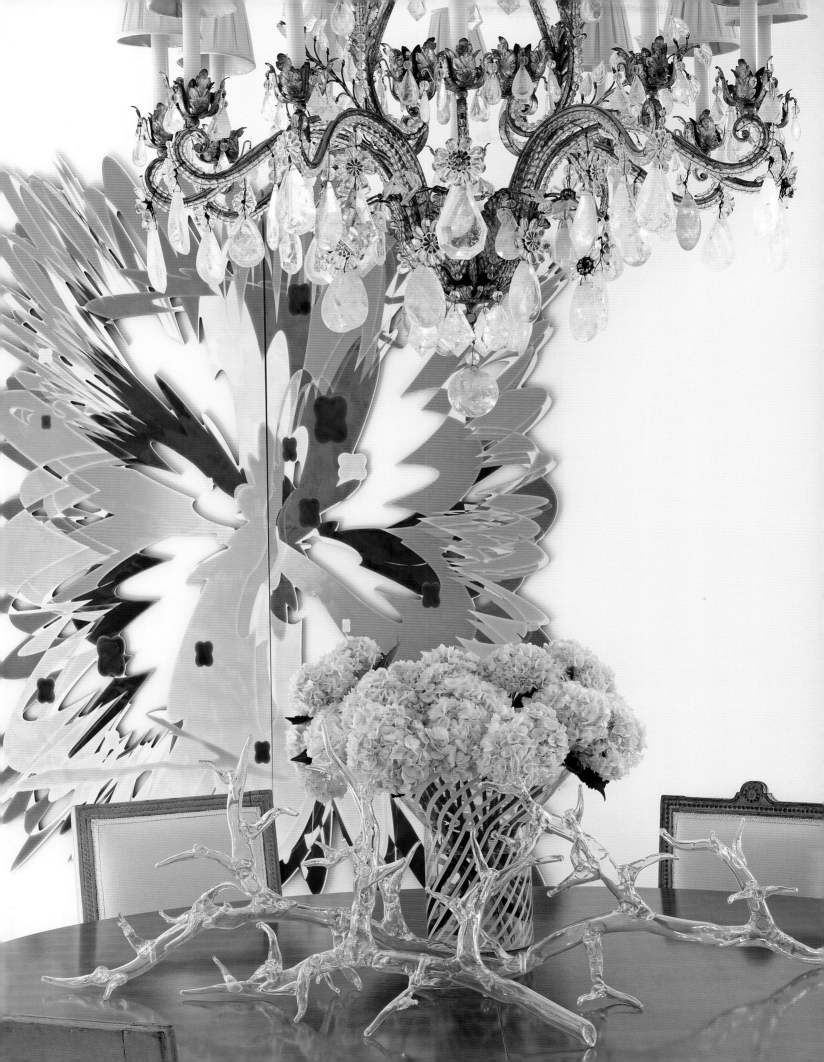

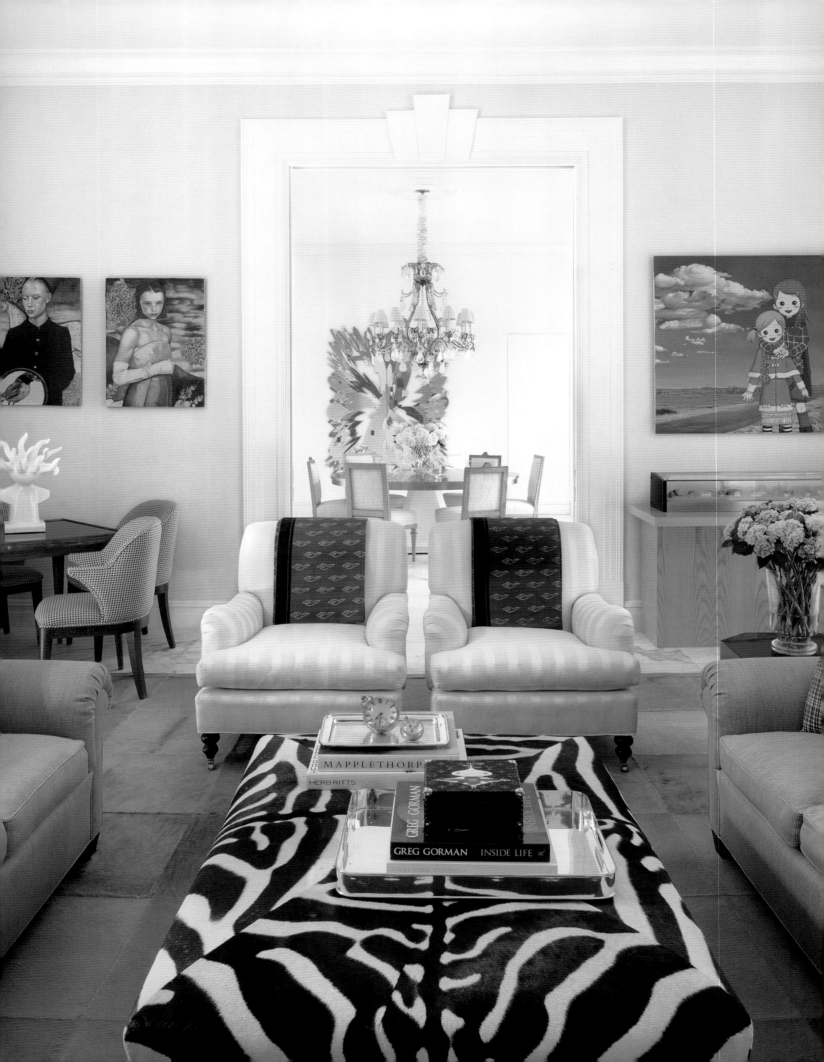

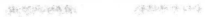

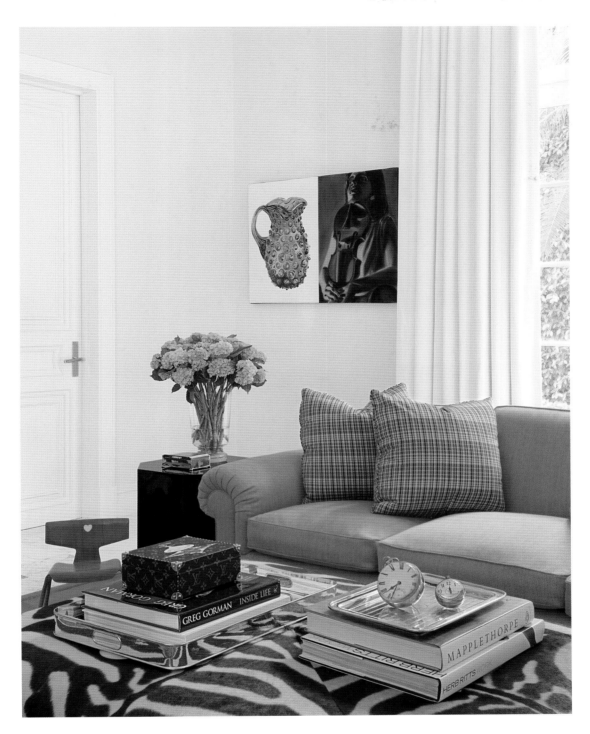

Opposite and above
In the study, a zebra-skin ottoman
and array of art break the neutral
palette. To the right of the opening
is *Look At How Much We Raised!* by
Masakatsu Iwamoto, known as MR.,
which reflects the owner's passion for
contemporary Japanese art. On the
opposite wall is a work by David Salle.

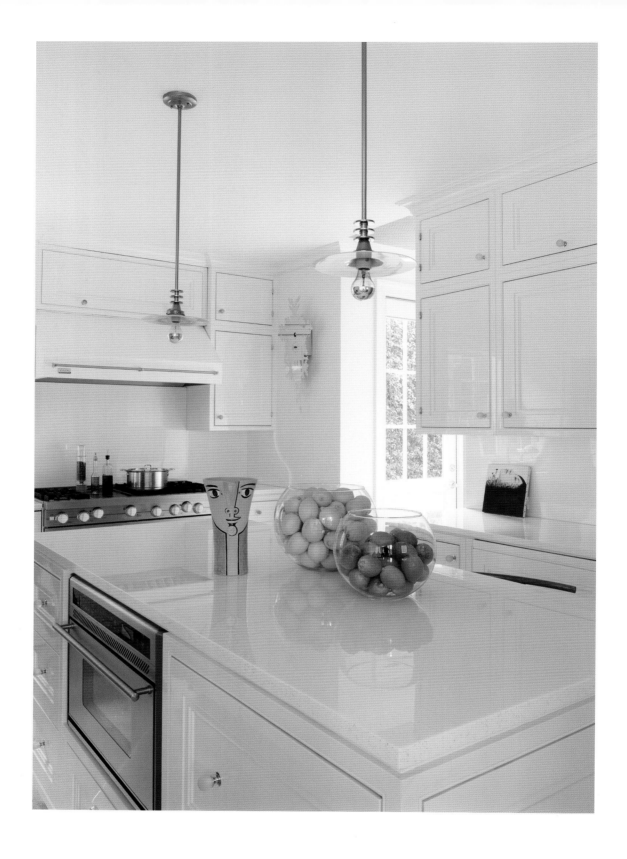

Above and opposite
The kitchen and breakfast nook emphasize clean lines and shades of white and the faintest of blues. The custom-made table is surrounded by modern interpretations of the classic klismos chair. Crushed mother of pearl was added to the terrazzo floor for a low-luster shimmer. On the windowsill is a photograph by Sally Mann.

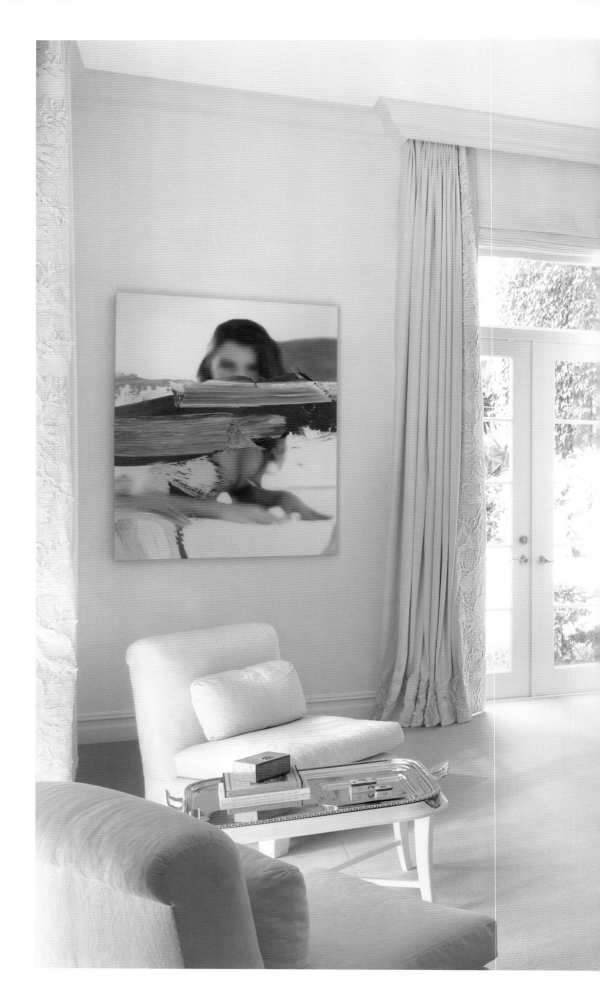

Right
Silk taffeta and pearl on the four-poster canopy bed and custom embroideries in wool sateen bring elegance to the master suite. Upholstered slipper chairs and works by Richard Patterson and Peter Halley complete the scene.

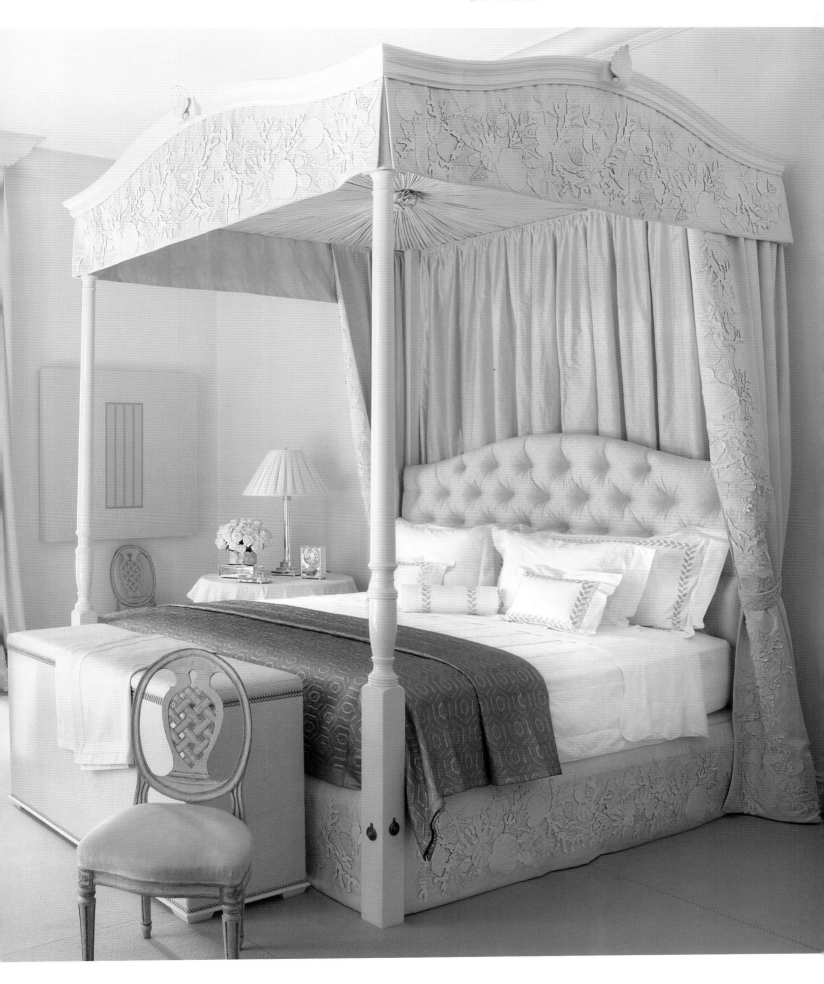

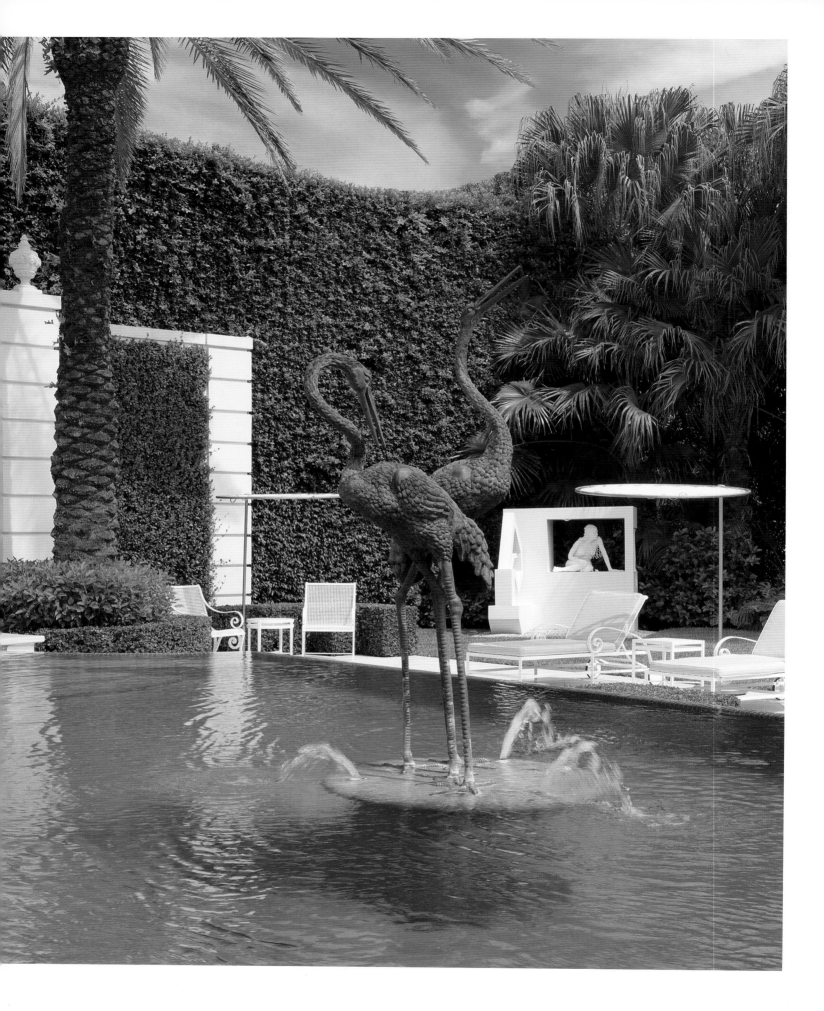

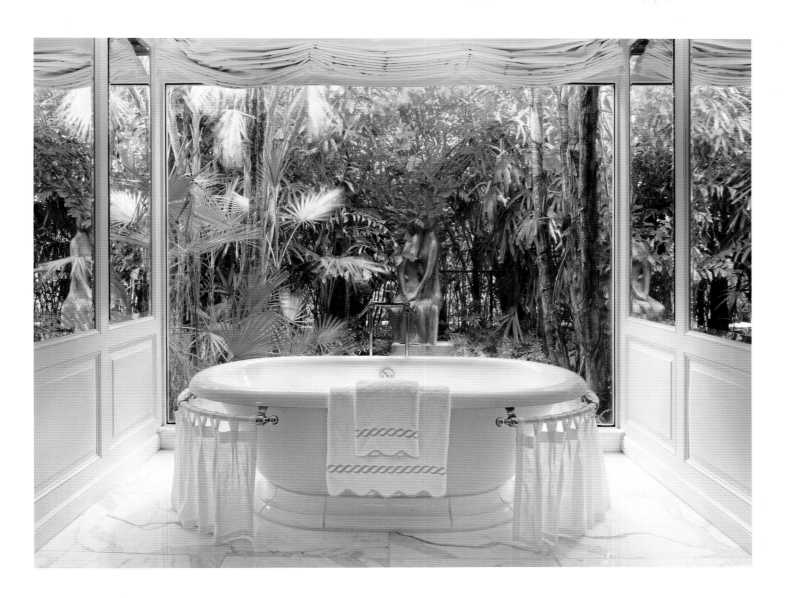

Opposite
Bronze herons add Palm Beach
panache to the fountain, pool,
and terrace.

Above
A floor-to-ceiling window brings the
outdoors inside in the master bath.

97 Palm Beach Regency

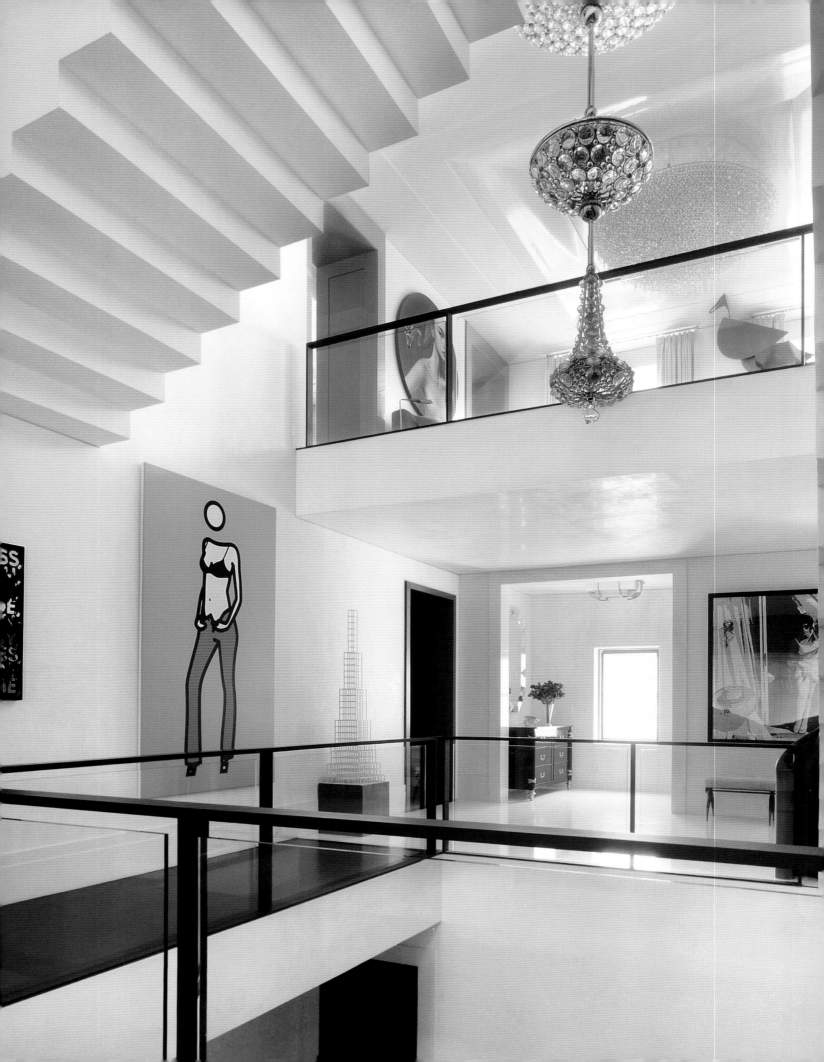

Carnegie Hill Townhouse

Art is for everybody.

—Keith Haring

Carnegie Hill is another of my favorite New York City neighborhoods. It's a place close to Central Park that's famous for its cavernous family apartments and townhouses. While most residences are large by Manhattan standards—with long halls, multiple bedrooms, and staff quarters still intact—few can match the scale of the residence I was invited to decorate on East 94th Street.

This was a complex project: a gut renovation spearheaded by the architectural firm Leroy Street Studio that, with all the New York City regulations and permitting, took almost six years to complete. The program involved combining three adjoining townhouses for a young family with three active boys and a dog, a formula that would be challenging for any interior designer.

The couple had worked out a happy compromise on the question of whether they should raise their family in the city or the suburbs. The challenge was to create a space that supported a largely suburban open-space lifestyle, the husband's choice, in an urban, culturally rich setting that the wife preferred. Both loved Manhattan so when they discovered the adjoining properties in Carnegie Hill, they were ready to draw up the plans.

The husband, a real estate developer, was eager to transform the houses—with a "messy" assortment of small rooms and offices—into the home of his dreams and a handsome addition to the streetscape. The wife, a fashion accessories designer and former model, was captivated by the 1980s art scene, when Keith Haring and Jean-Michel Basquiat were leaving their imprints around the city. She developed a passion for art during this heady period, and she has gone on to assemble a collection that includes Robert Rauschenberg, Cindy Sherman, Sol LeWitt, Banksy, and, not surprisingly, a series by Haring.

The mandate they gave me was clear: take the three houses, work with their construction team, and make them a home, a place where they could live comfortably and their children could grow up with an appreciation of culture and creativity. "No austerity. No Old World masters. No stuffiness or rigid formality," they

requested. "Of course, we want it to be glamorous and beautiful. But we also want it to be fun and upbeat for everyone—a place where there's room for blue jeans and bare feet."

With so many adjacent spaces, lighting was the key. I used hand-polished Venetian plaster to line the walls and create a sparkling effect—this time around a dramatic five-story atrium that almost fills the center of the combined buildings. A series of catwalks, perhaps reminiscent of the owner's model days, were created to connect the first and second levels. Needless to say, this was a major undertaking that managed to create openness and harmony among previously disparate spaces. Vintage light fixtures and custom crystal chandeliers illuminate the rooms and raise the level of drama with their scale.

In the living room, study, and library, the clean lines of the furniture recede in the background, allowing the art to take center stage. This was a deliberate strategy, and John Meeks played a key role in making sure the art had a setting of comfortable, bespoke furnishings. He designed the "floating" mirror and also created the mantel in the living room, working closely with stonemasons to ensure the correct proportions. The goal was to create "couture" furnishings as unique as the art that surrounds them. Other pieces that he sourced—like the chandelier in the family room that's actually parchment or the painting that makes use of artists' brushes—fascinate and often evoke a smile. Of course, the scale of the house allows for spaces most urbanites can only dream of—rooms for the boys to work out, study, or just be kids as well as a 75-foot-long outdoor space that features a wall tagged by Cey Adams, a noted graffiti artist. "Domesticated street art," my clients call it.

My clients don't believe in rooms that are off-limits to their children. In the simplest sense and perhaps recalling their own upbringings, the parents said they wanted a house of "yes" and not a house of "no." It may have taken six years, but the house of "yes" in Carnegie Hill is a home that seems to work for everybody—as does the spectacular art collection inside.

Opposite A five-story atrium rises through the center of the house. Stairs and catwalks provide vertical and horizontal circulation.

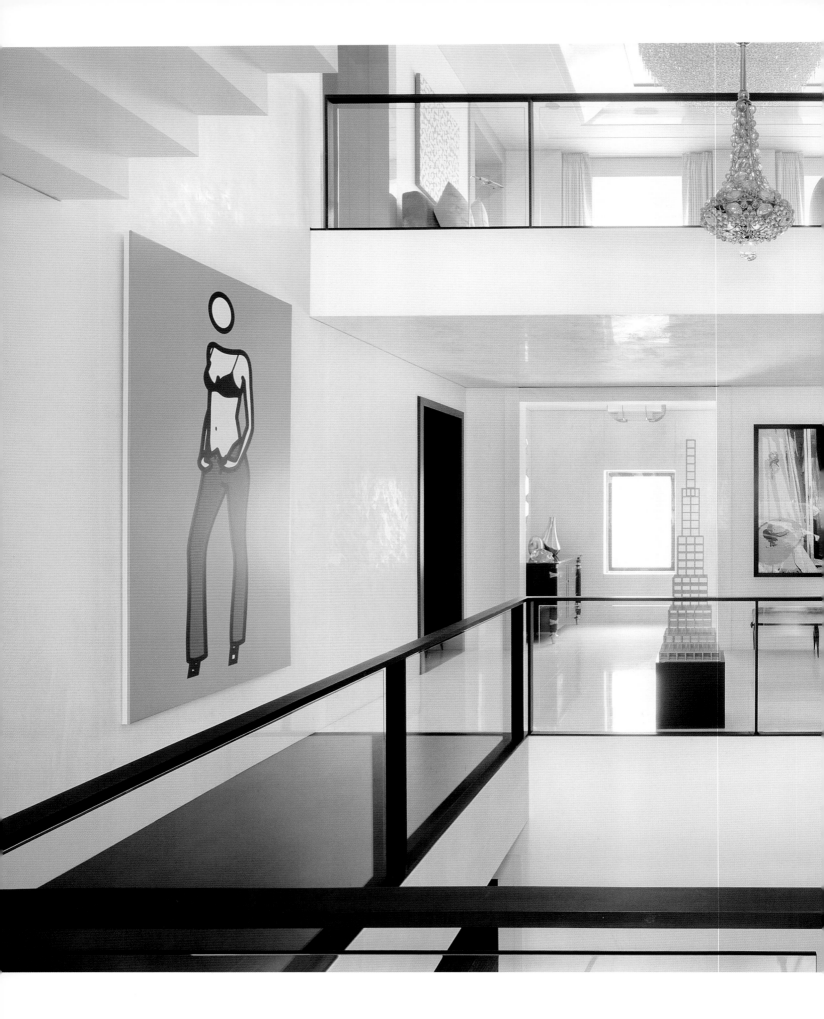

Left
Glass and high-gloss Venetian plaster
bring light to the minimalist stair
landing. A sculpture by Sol LeWitt,
with its ascending geometric lines,
blends easily in the vertical space.
The large, colorful canvas is *Woman
Taking Off Jeans 7* by Julian Opie.

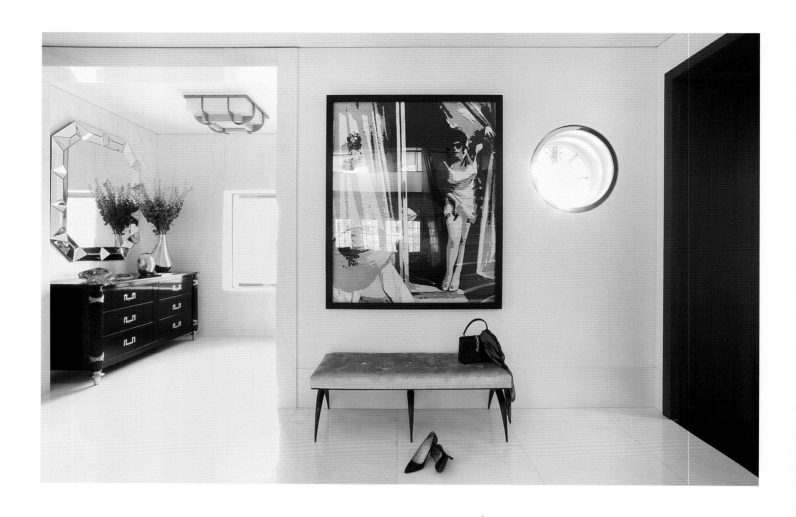

Above
Photographer Cindy Sherman is a favorite of the family, and her works appear in several rooms.

Opposite
The family room is a comfortable retreat for reading, games, and television. The orange of the Hermes Shopping Bag sculpture by Jonathan Seliger is repeated in the pillows that line the chairs and couch. On the wall is a work by hip-hop artist Juan Gispert.

Overleaf
A tone-on-tone color scheme keeps the mood subdued in the living room, with its custom armchairs and brocade sofa. Floor-to-ceiling windows and massive crystal chandeliers maximize light. The lamps and tables are by Willy Daro.

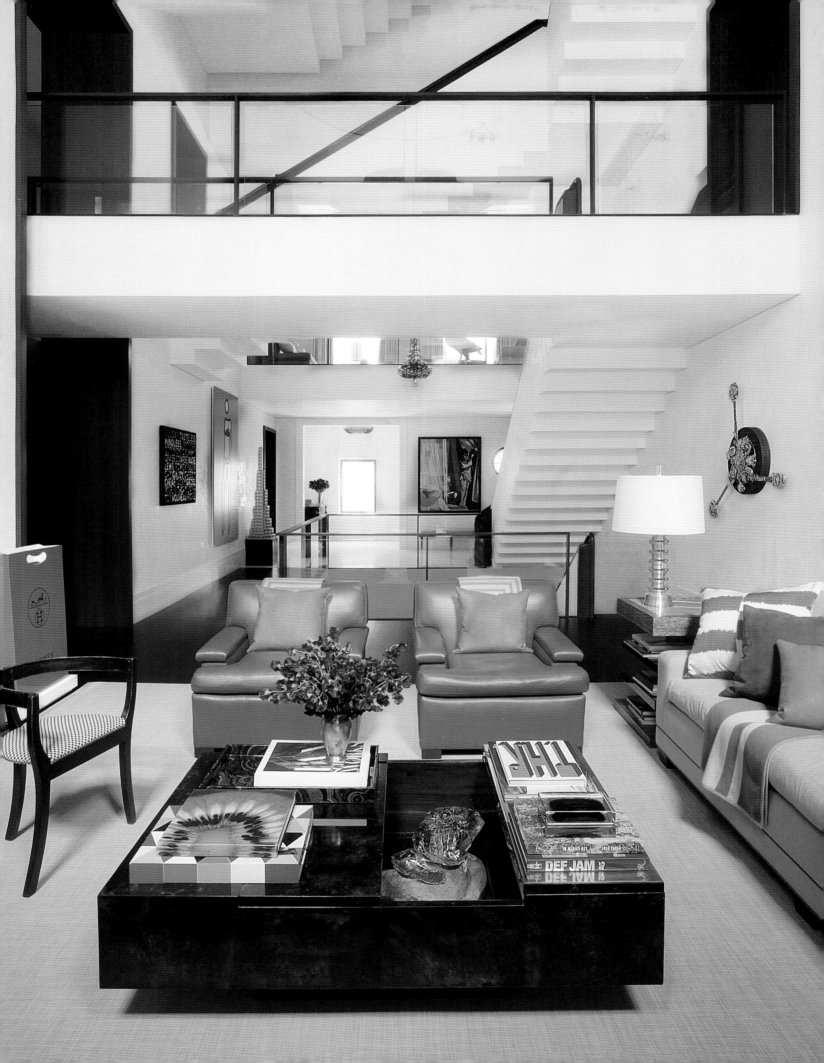

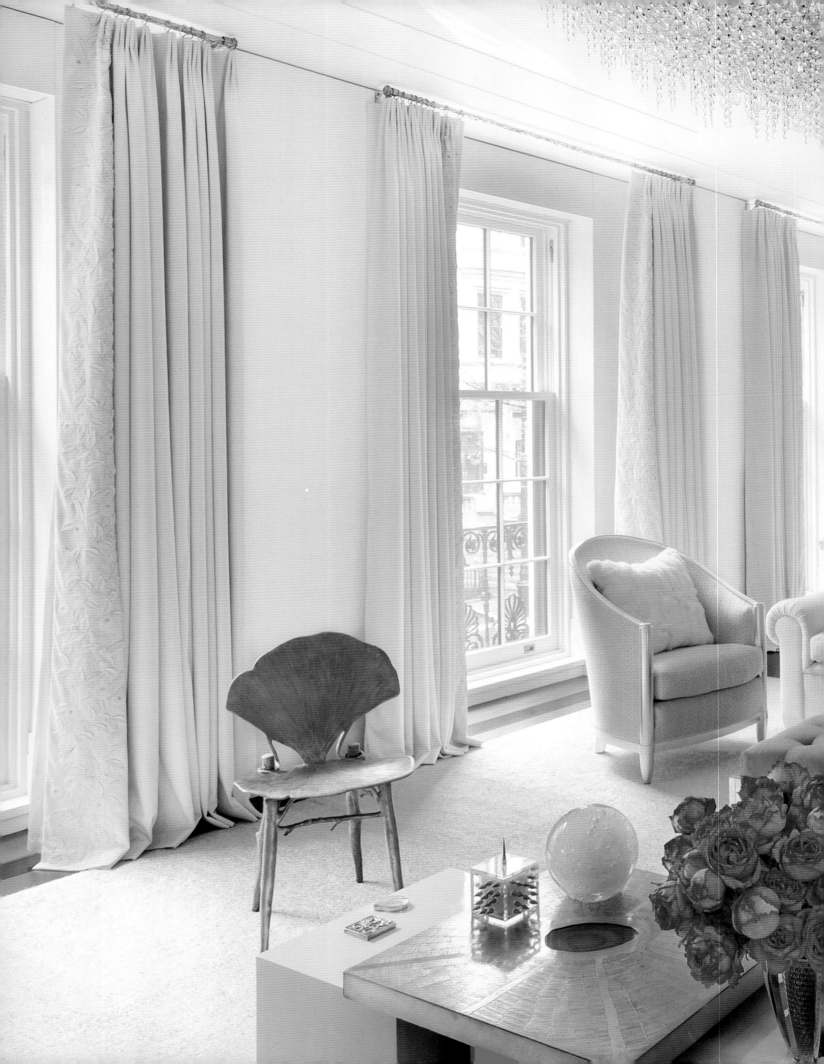

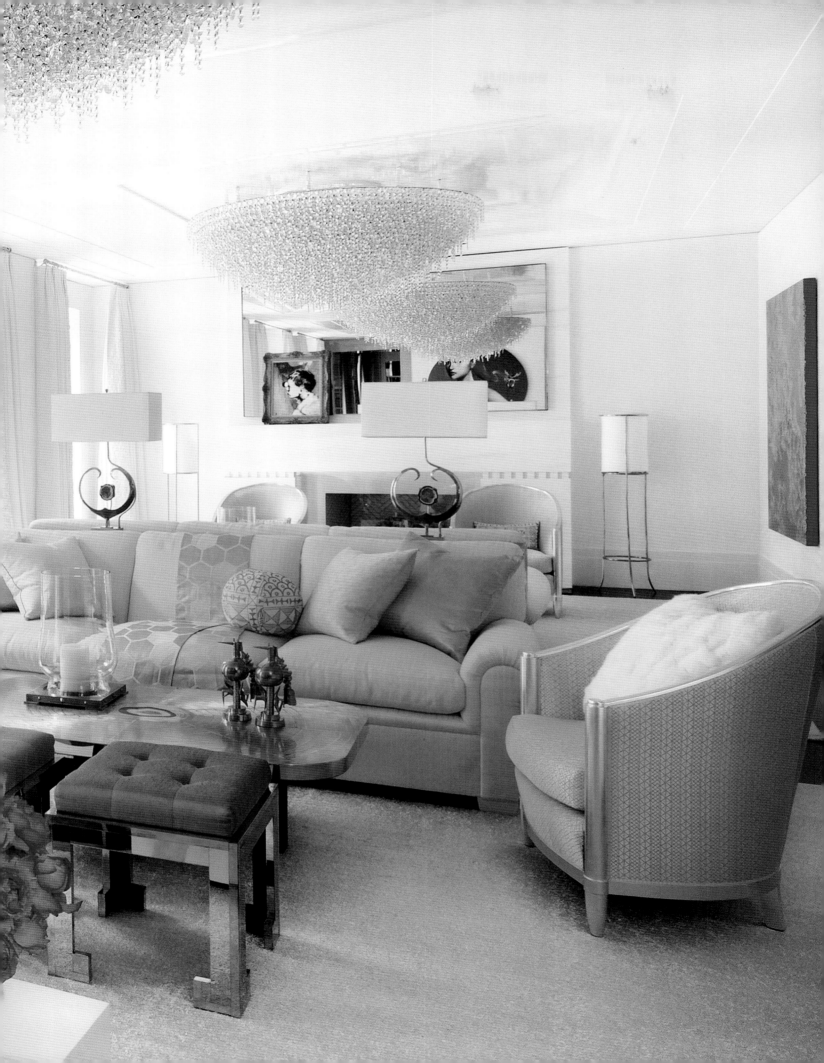

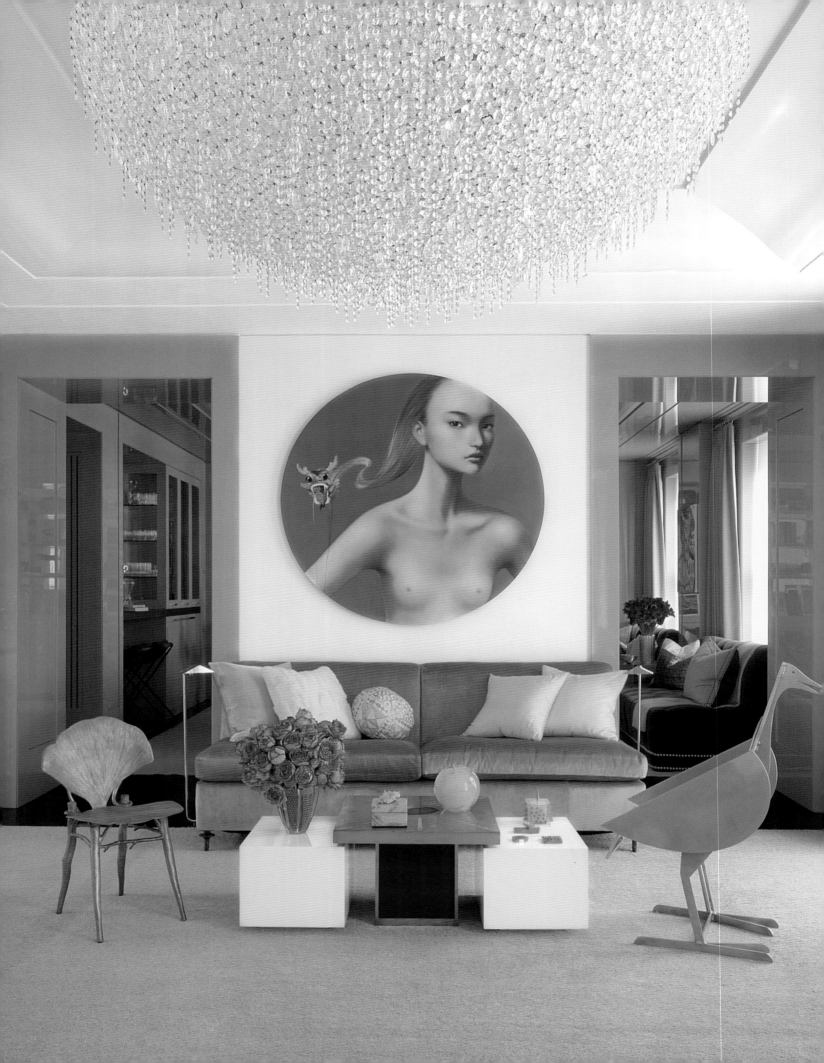

Opposite

Ling Jian's nude hangs above a
streamlined banquette. Gold
upholstery and dove gray carpeting
are a neutral foundation for the
idiosyncratic shapes of the chairs
and coffee table.

Above

A custom console designed by John
Meeks is executed in bronze with
enamel inlay of butterflies and birds.
The fixture is a lamp by Willy Daro.

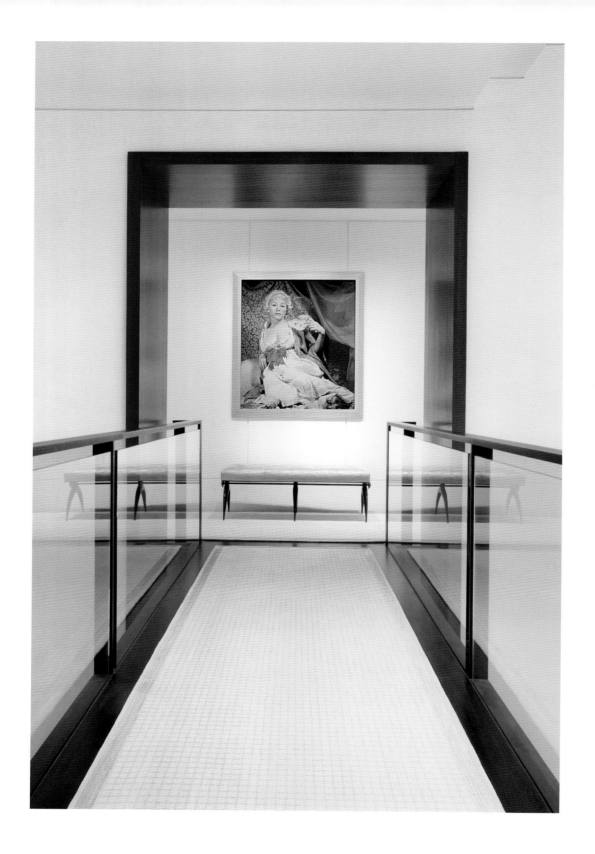

Above
A catwalk leads to a Cindy Sherman photograph from the History Portrait series. The entryway is accented with sleek walnut molding.

Opposite and overleaf
In the dining room, Deco-era chairs upholstered in horsehair complement the custom pedestal tables. The brass sculptures are by Robert Lee Morris. The fishscale motif on the fireplace surround provides a gleaming base for Cindy Sherman's *Untitled Film Still #24.*

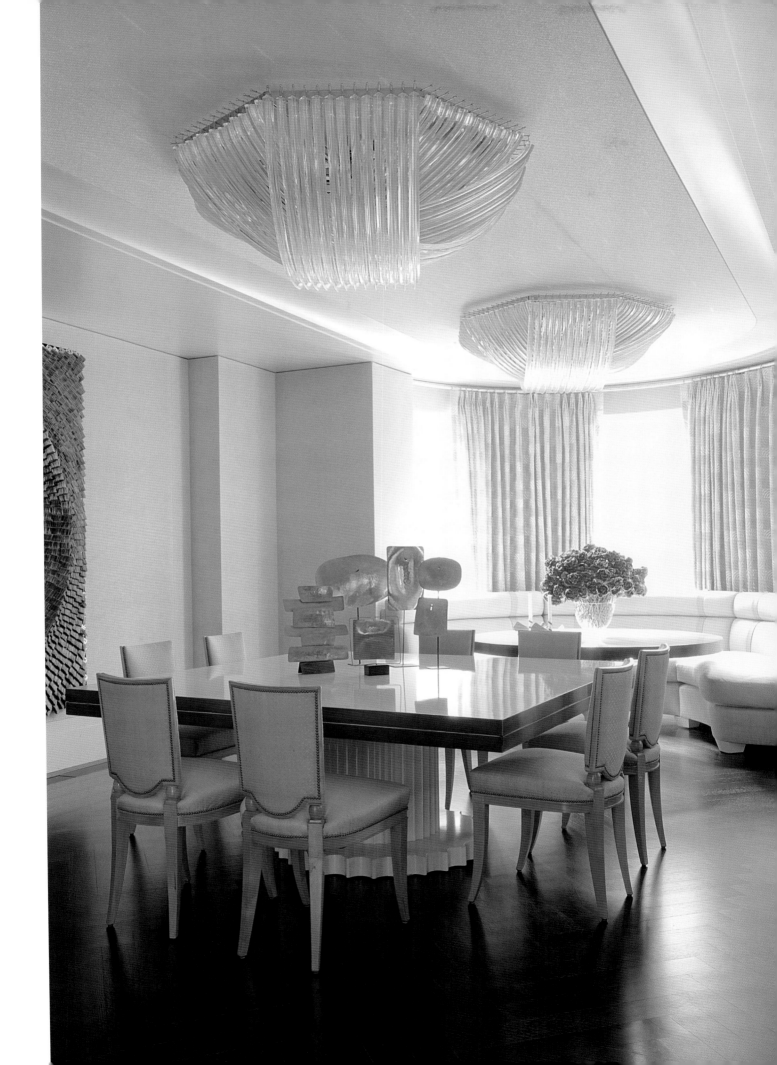

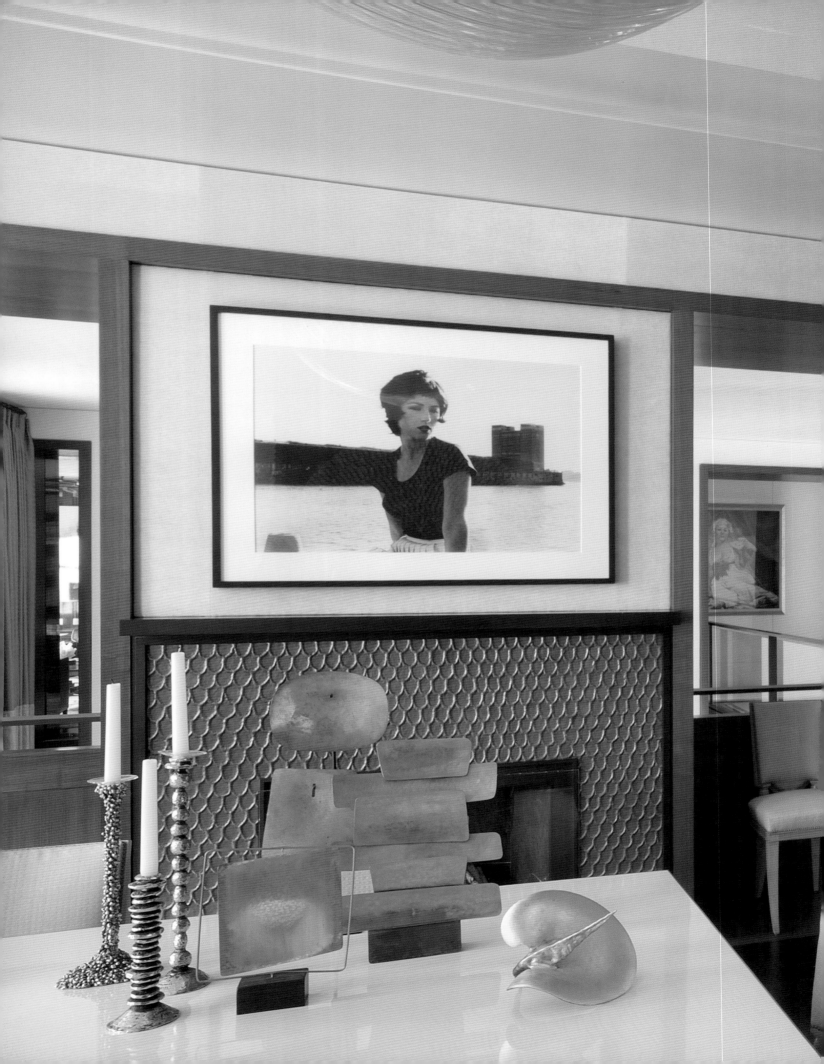

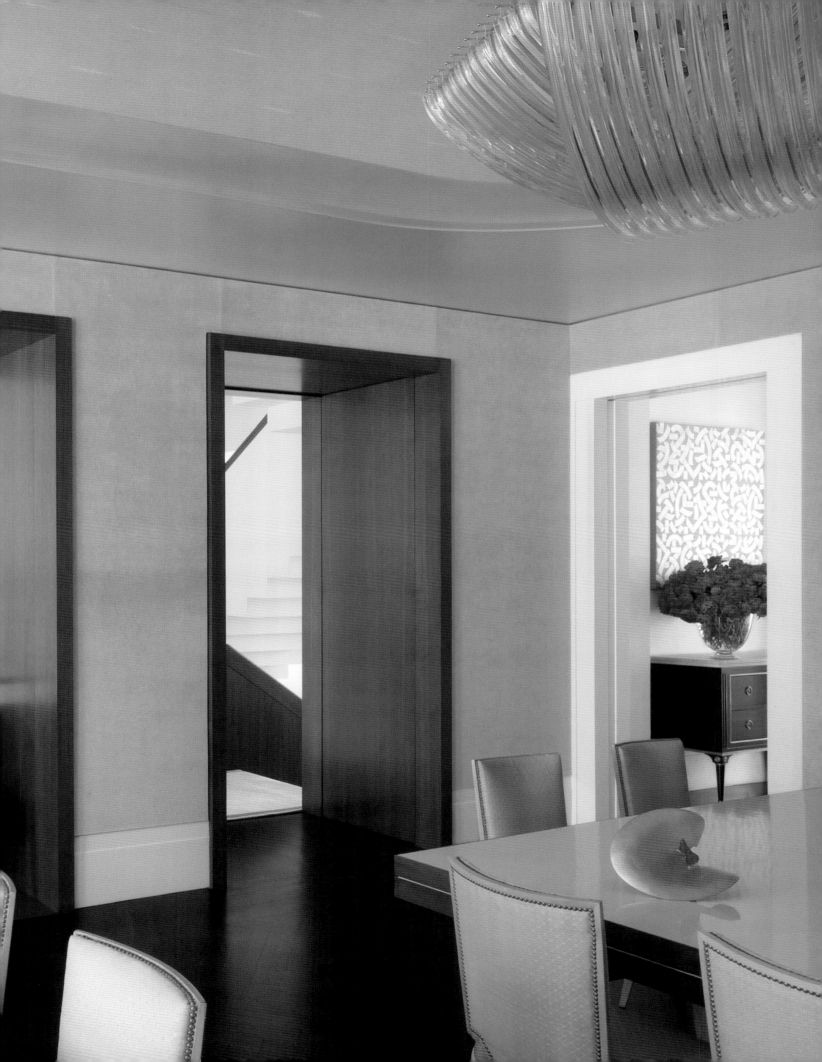

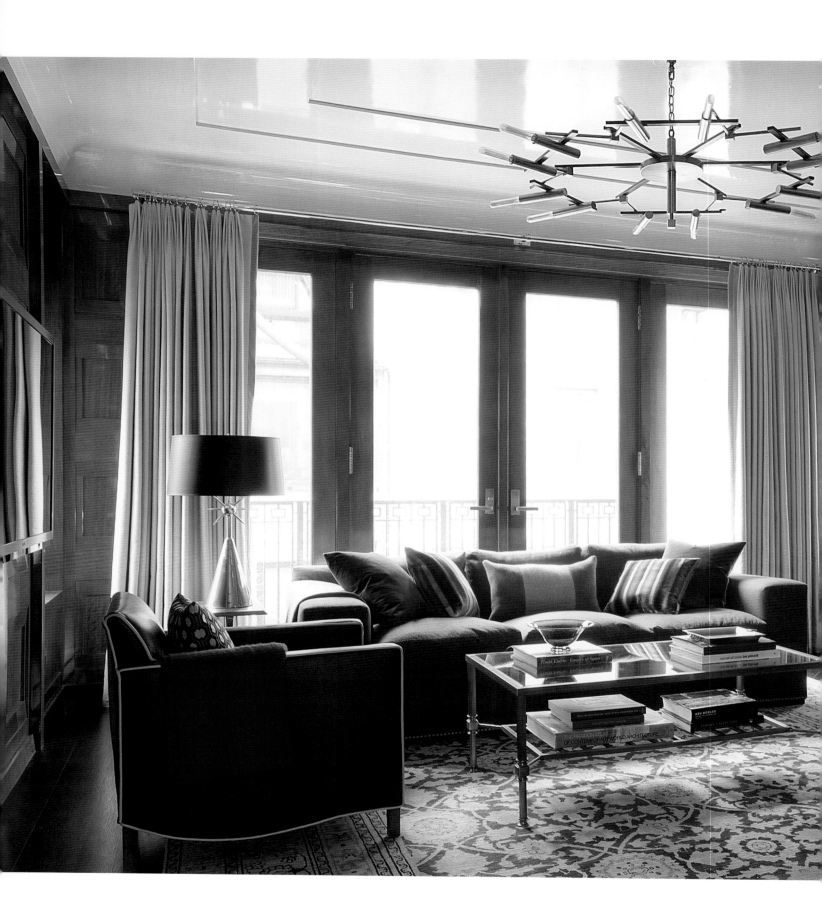

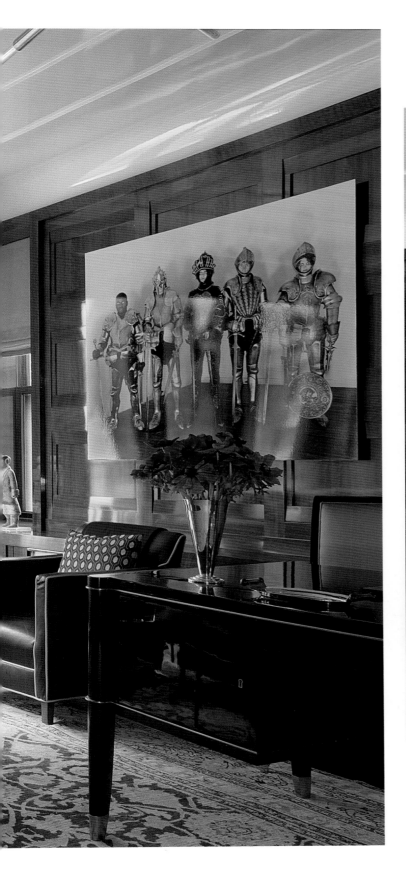

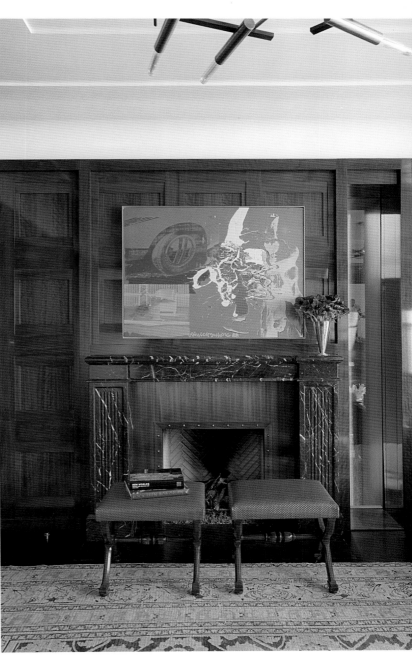

Left
In the study, the blue palette in the carpet and furnishings keeps the mood relaxed and comfortable. Over the console, *Knights,* a C-print by Olaf Breuning, adds a note of macho swagger.

Above
Runaway from Robert Rauschenberg's Galvanic Suite series captures the eye with its colorful display on galvanized steel—a stark contrast with the room's more traditional paneling.

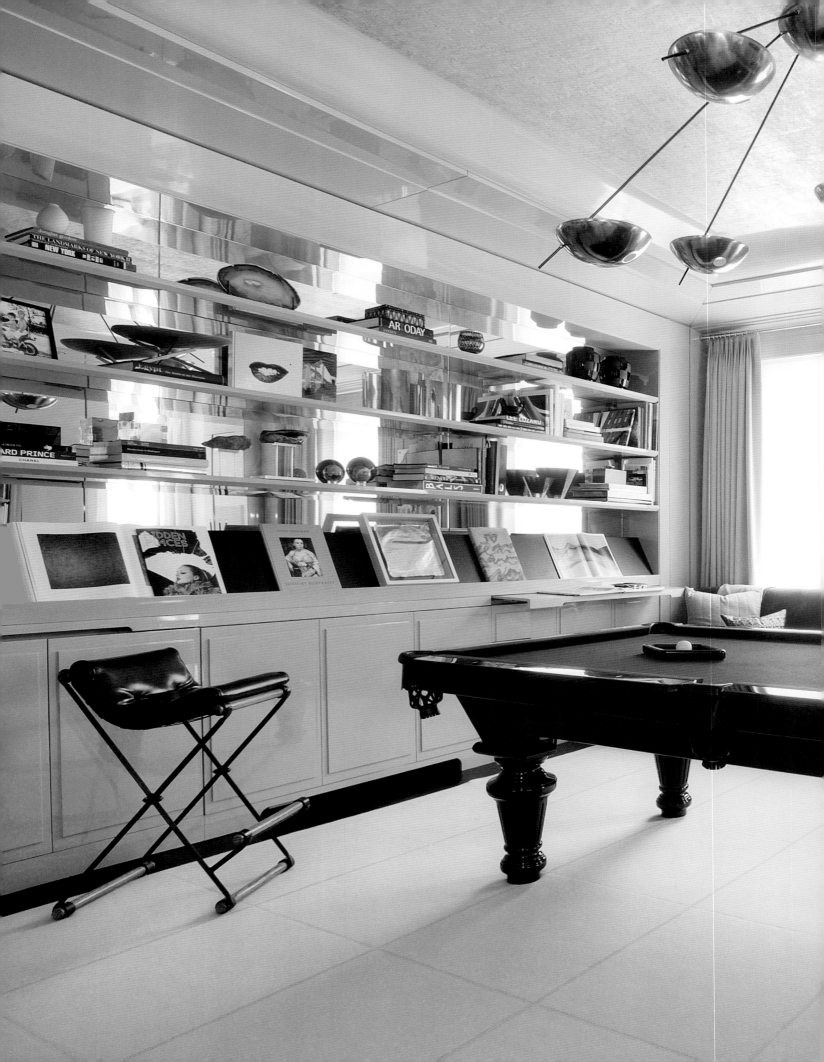

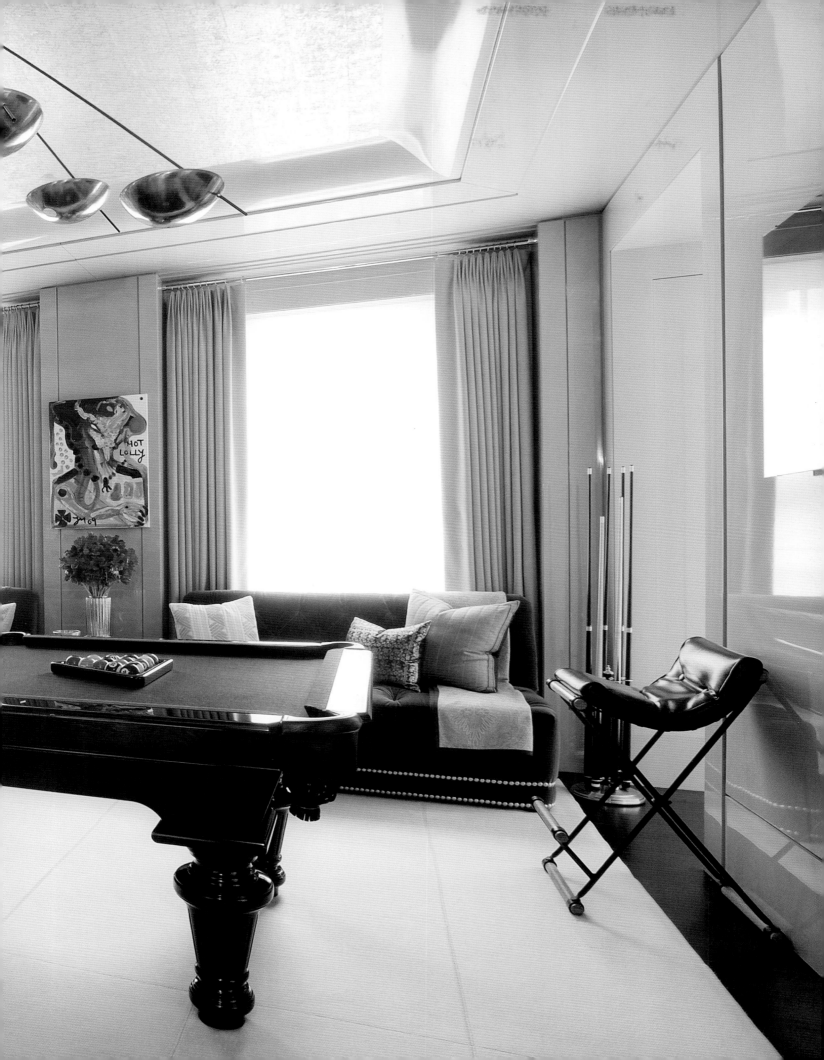

Preceding pages
A Stilnovo chandelier doubles as
a sculpture in the billiard room and
breaks with the style of traditional
poolroom lighting fixtures.

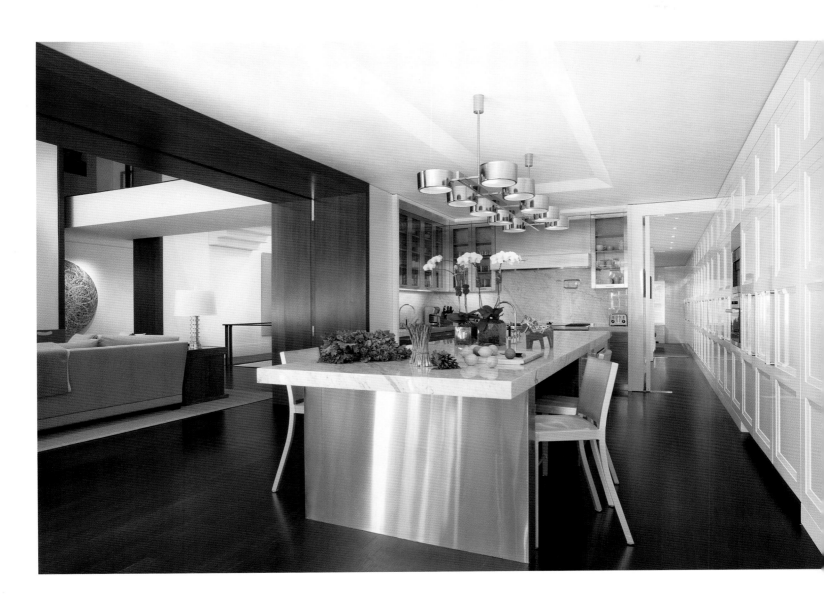

Opposite and above
A painting from Ryan McGinness's
Black Hole series can be seen through
the opening between the family
room and the kitchen. John Meeks
designed the long table surrounded
by Philippe Starck bar chairs.

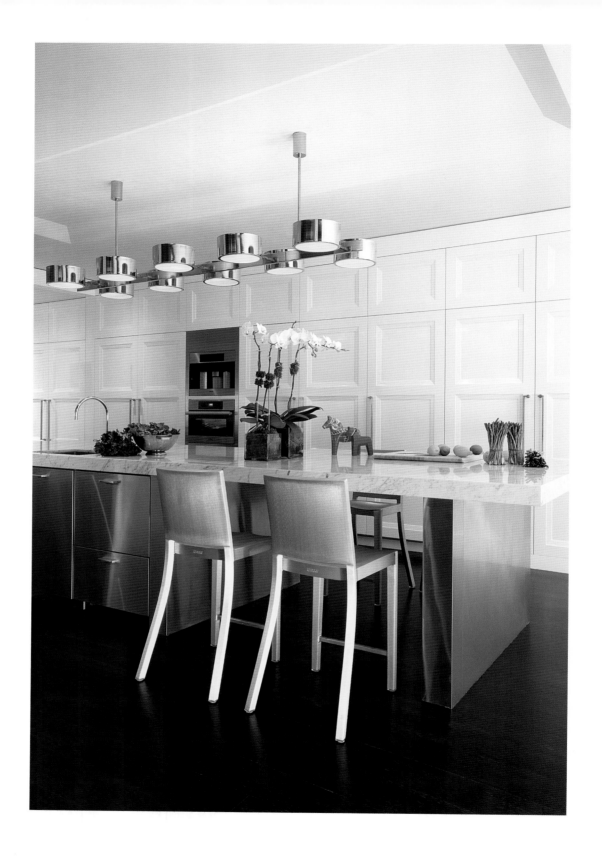

Above
A midcentury chandelier by Stilnovo complements the sleek lines of the kitchen.

Opposite
Eero Saarinen's white tulip chairs surround a table designed by John Meeks for the breakfast bay window.

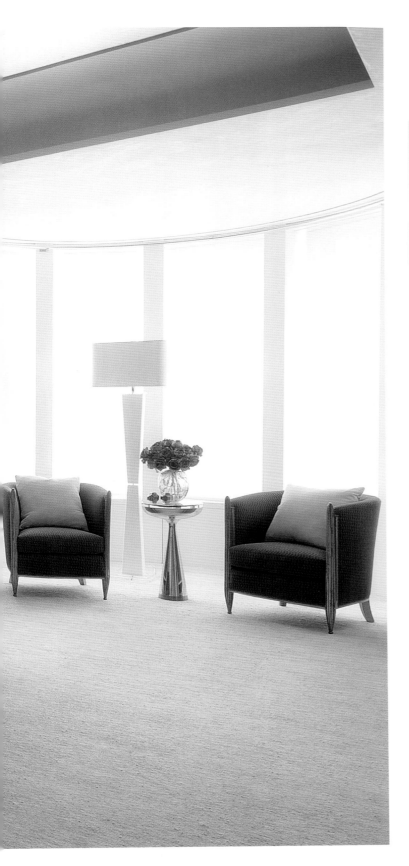

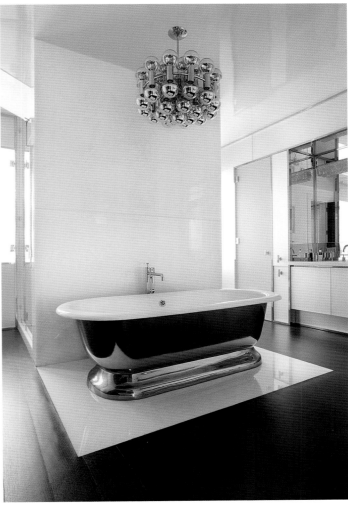

Left

In the master suite, the custom platform bed in Macassar ebony features a headboard of embroidered horsehair. The chandelier by Brutalist sculptor Paul Evans mixes puzzle pieces of nickel-plated steel in a finish that coordinates with the linen-and-metal rug. The photograph is by Douglas Gordon.

Above

In the master bath, a double-ended tub is clad in a polished iron that complements the hanging metallic light fixture. The tub is based on a design from the early twentieth century.

Above left

Installation artist Alice Aycock created the metallic sculpture at the base of a stairway. A family favorite, the sculpture fascinates with its energy, weightlessness, and playful spirit.

Above right

The owners' fondness for street art is reflected in the work of Mr. Brainwash, a pseudonym for Thierry Guetta, who uses iconic imagery to make often provocative statements.

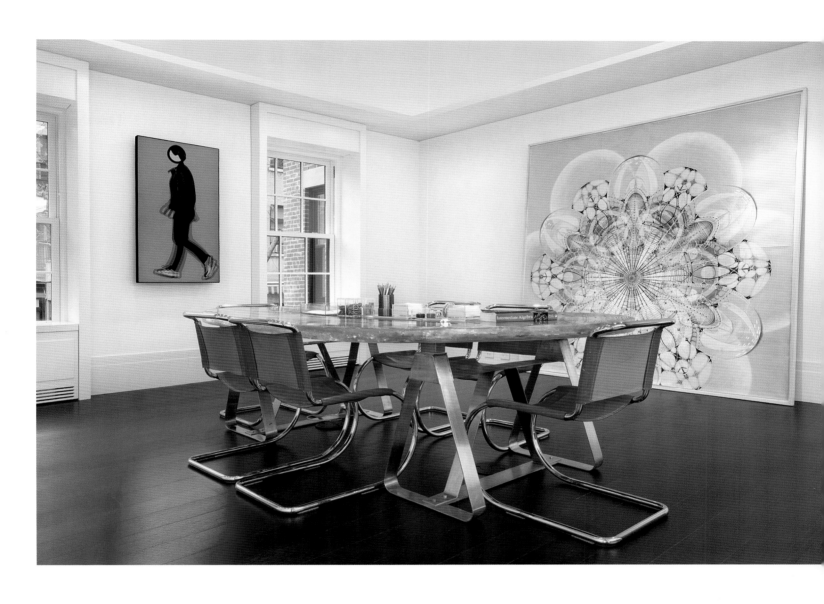

Above

In the playroom, the wall space is just large enough to accommodate one of Amy Myers's detailed large-scale drawings. Breuer-style chairs with distinctive orange backing contrast with the blue in the Julian Opie work, *Robbie Walking 3,* that hangs between the windows.

Overleaf

In the office, the predominantly blue carpet adds color and texture to the space. The vintage leather armchairs by Sigurd Ressel contrast with the clean lines of the custom white desk. A photograph by Luis Gispert and metal overhead lighting by C. Jeré bring additional color.

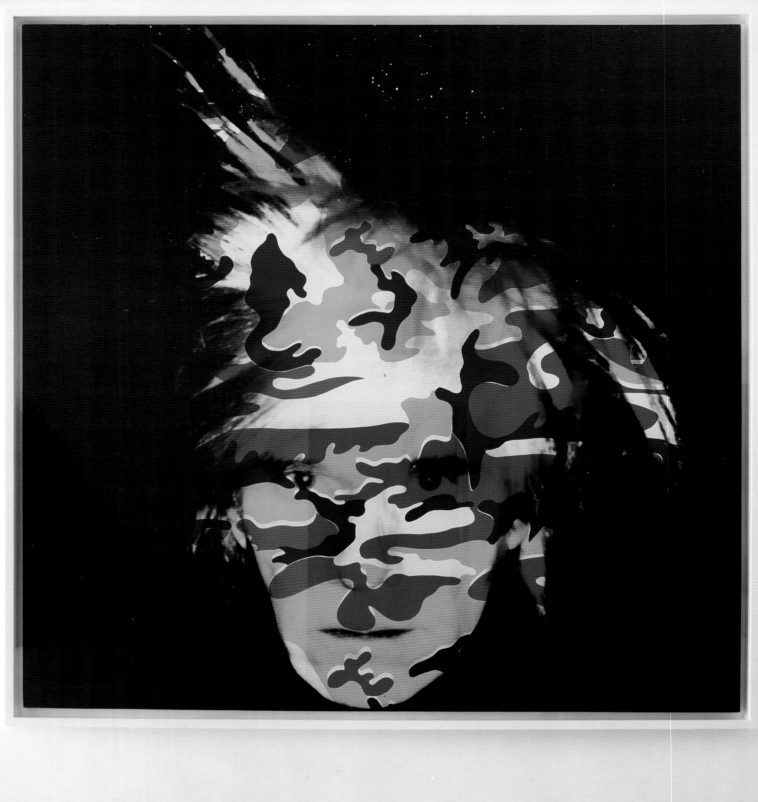

Breakers Oceanfront Retreat

The supreme art is the art of living.

—Claude Lalanne

From Park Avenue to Palm Beach, I've been privileged to follow many of my New York clients to their seaside retreats in Florida. One of my favorite projects was redecorating a four-bedroom penthouse in the historic Breakers hotel complex.

Listed on the U.S. National Register of Historic Places and distinguished by its Renaissance revival architecture style, the Breakers has been a fabled oceanfront getaway for more than a century. It now boasts a private enclave of luxury apartments within its confines, and my client was among the first to purchase one when they became available. Her apartment faces the beach and, perhaps surprisingly for an oceanfront resort, features dramatic spaces. Expansive walls and imposing floor-to-ceiling windows take in the view and drown the apartment in a warm, golden sunlight. "Like being at sea," is how my client and her daughter describe it—on a luxury liner of the highest order. "We feel like we're on a cruise."

Of course, the dimensions and scale of the rooms are ideal for the display of fine art, and we have been able to take full advantage of these dramatic spaces without having to deal with some of the architectural constraints of a more traditional residence. The color palette is still neutral— cool, soothing whites that reflect the Florida sunshine and highlight the vivid art.

The furnishings are streamlined and low in profile to maximize the views. The smooth limestone floor in the entrance hall contrasts with hand-polished Venetian plaster that gently sparkles on the walls. Even with all the whiteness and clean proportions, no one would ever describe the interior as austere. The combination of the views, the overall mix of custom furnishings, and the array of art is simply breathtaking.

Sublety and sophistication were the goals—not tried-and-true formulas. In fact, my client wouldn't even consider sisal for the carpeting. "So overdone," she noted. The white woven-leather rug that we chose may be hard to maintain, but it adds just the right touch of drama—and again illustrates the client's keen eye and willingness to try something new.

It's an ideal space for entertaining, whether in the formal conversation areas or on the more intimate terrace that faces the ocean. The white walls are broken up by yellow floor-to-ceiling drapery in the combined living and dining rooms. These cascading waterfalls of silk provide just the right pops of color in both rooms, adding luster to the sunlight that reflects off the ocean but never distracting from the art.

The four bedrooms are almost always occupied by friends and family over the winter months. Here, too, the color palette remains largely neutral, with more polished Venetian plaster, creamy silks, and lacquered furnishings. And here again, the private spaces feature works of art as imposing and thought-provoking as those in the more public settings.

The stories my client has shared with me about her art collection never cease to amaze. As far as I know, she is the only person for whom Andy Warhol created a portrait not once, but twice—and presented the second as a replacement for what was considered a less-than-successful first attempt. Now she has been immortalized like Marilyn, Liz, Elvis, and Mao.

The art arrangement usually includes about two dozen pieces from the hundreds my client has collected over the last fifty years. Many stay for the duration of the season, but others are swapped out when my client wants to change the mood or bring back an old favorite to keep her company. Not too long ago, she switched out a de Kooning canvas that was largely yellow in color for another that featured more reds and blues. It was absolutely the right choice. Fortunately my client has the good taste, sharp eye—and the collection to draw upon—to make such choices all the time.

So many stories and so many celebrated names: Georgia O'Keeffe, Mark Rothko, Jasper Johns—she befriended them all. And now their timeless works—and the lifetime of memories associated with them—fill the walls of her spacious home, creating a glorious space for entertainment and contemplation.

"My life wouldn't be as rich without this art," she says. "Many pieces are simply beautiful. Others are bold, jarring, and often unexpected—just like life."

Left
In the limestone-paved entrance hall, a low bench in tufted leather invites contemplation of *Black White* by Ellsworth Kelly and *Flags 1* by Jasper Johns. The hand-polished Venetian plaster illuminates the space with its marble-like sheen.

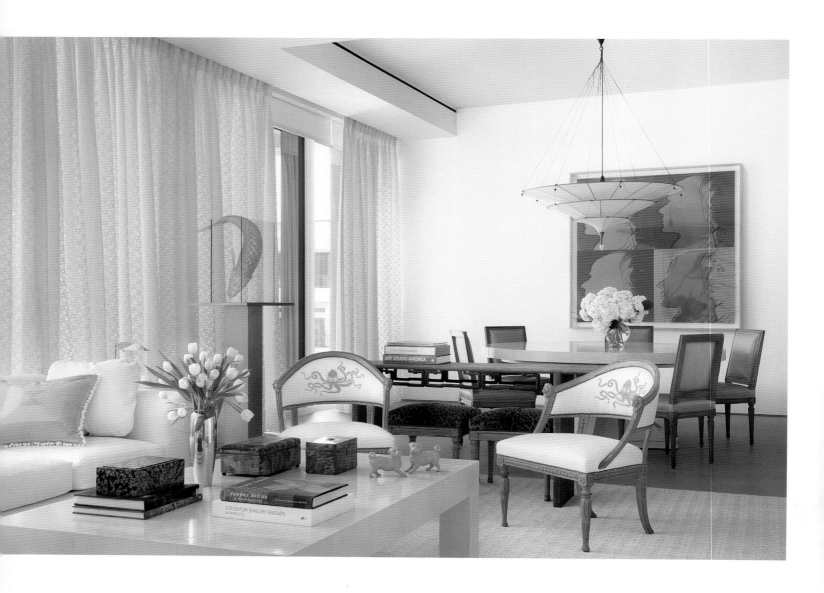

Above
Light reflects off the ocean through yellow sheers. John Meeks designed the subdued Parsons-style table and the whimsical octopus embroidery on the Swedish chairs.

Opposite
A silk Fortuny light fixture balances over a custom-made parchment table. The rectangular *The Shadow* by Andy Warhol contrasts with the round table and adds shades of red, pink, and black to the mix.

Overleaf
A late, untitled work by Willem de Kooning, with its swirling reds and blues, is the focus of the living area. Frank Gehry's Fish Lamp balances on a pedestal by the window. A pair of Swedish stools upholstered in an unexpected leopard-print velvet are tucked under a shagreen-covered altar table.

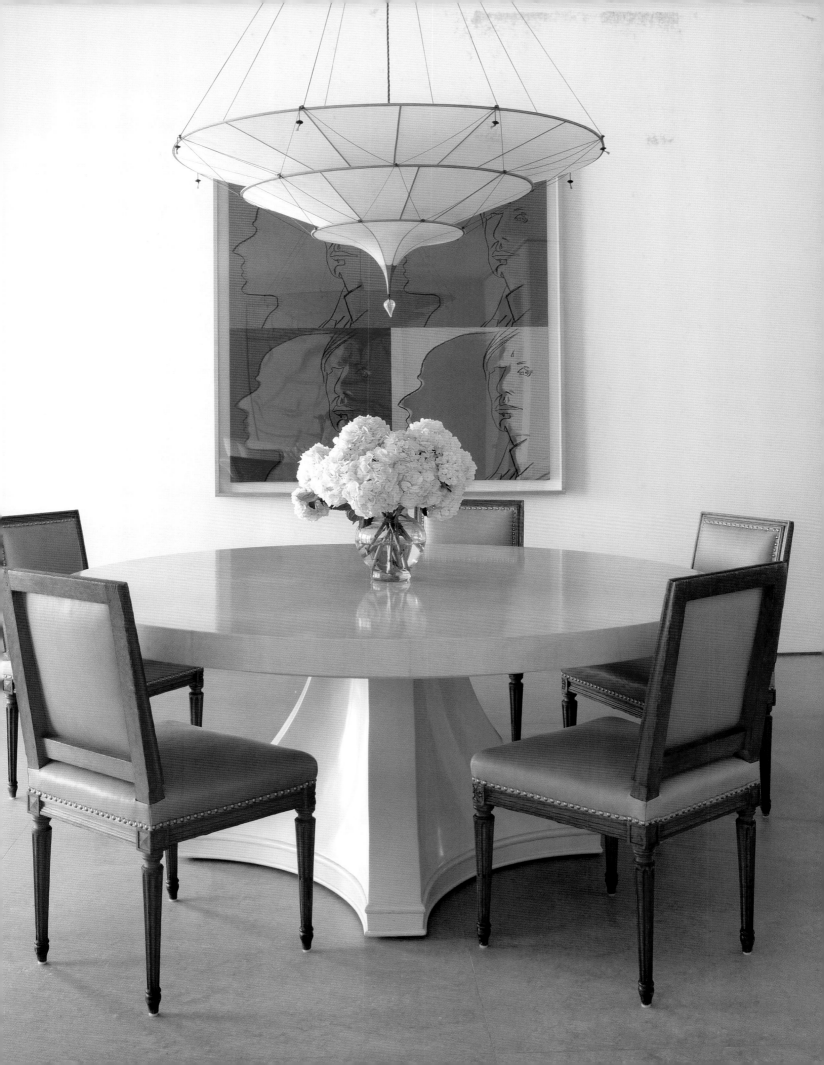

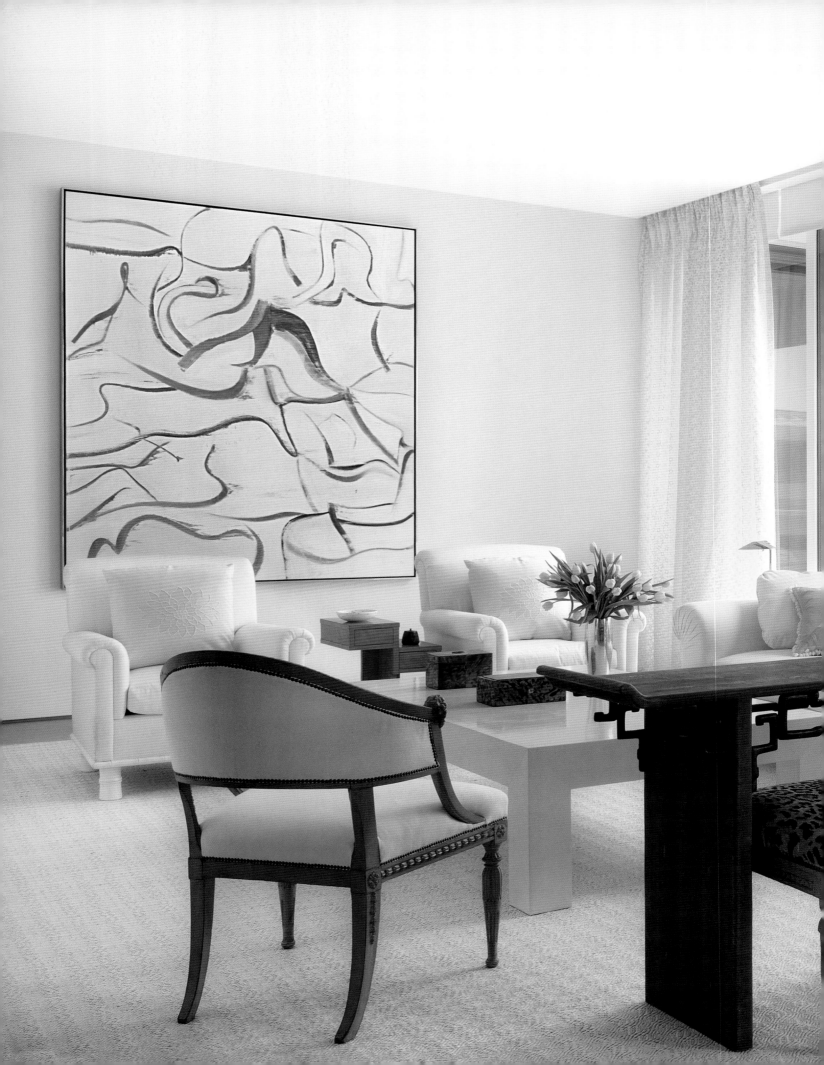

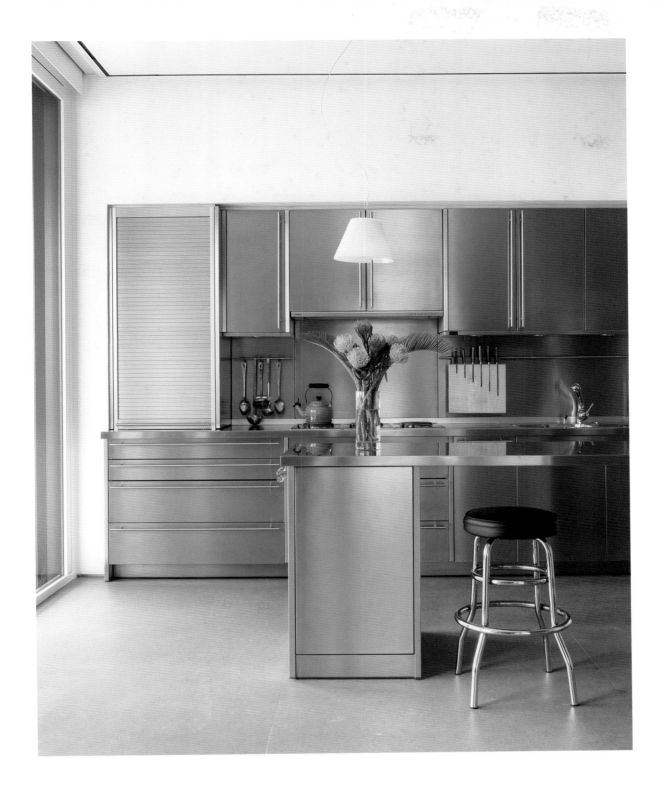

Opposite
An untitled work by Agnes Martin
hangs above a custom-made
lacquer-and-steel buffet.

Above
In the kitchen, a shapely vintage
stool holds its own amid the rectilinear
stainless-steel cabinetry.

Overleaf
In the soft, inviting master suite, the
four-poster bed and night tables were
custom made to blend in with the neutral
palette. Prints from the Cremaster
Cycle by Matthew Barney hang above
the low, streamlined wall table. *Candy
Cigarette,* a photograph by Sally Mann,
is displayed by the nightstand.

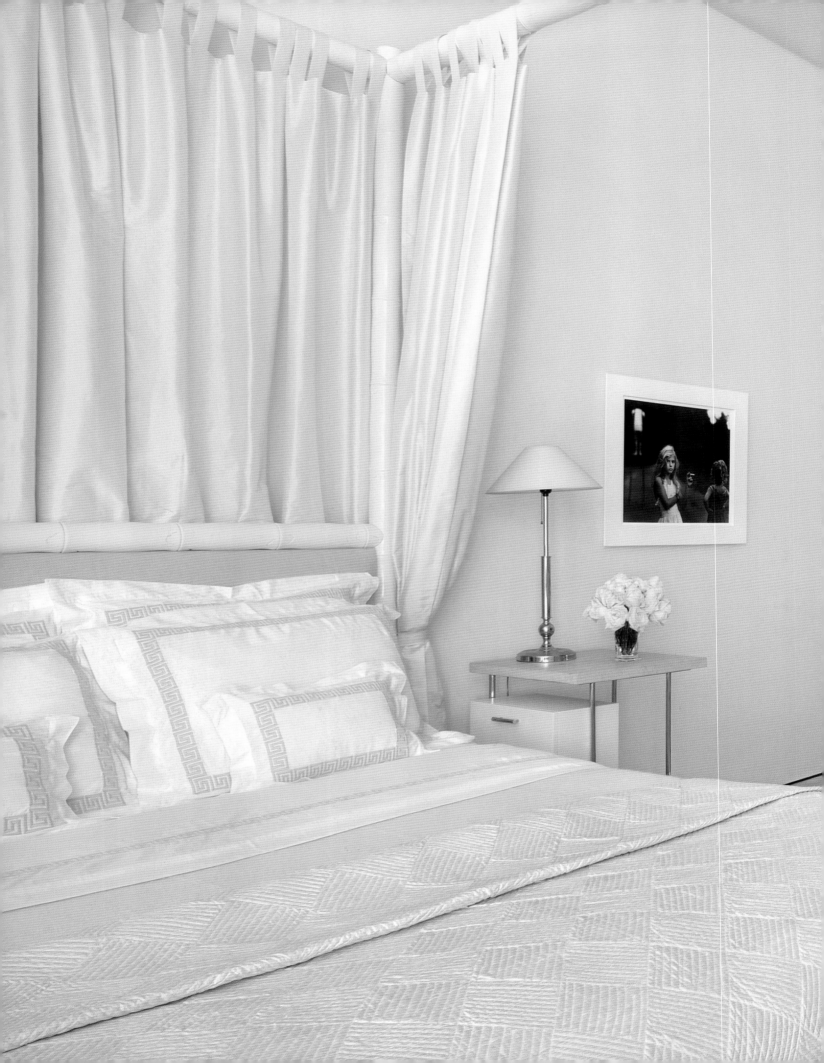

Right
Teak chairs offer expansive views of
the Atlantic Ocean. The original
terra-cotta tiles were glazed white to
bring the interior color scheme out-
side. Pygmy date palms were chosen
for their color and sculptural quality.

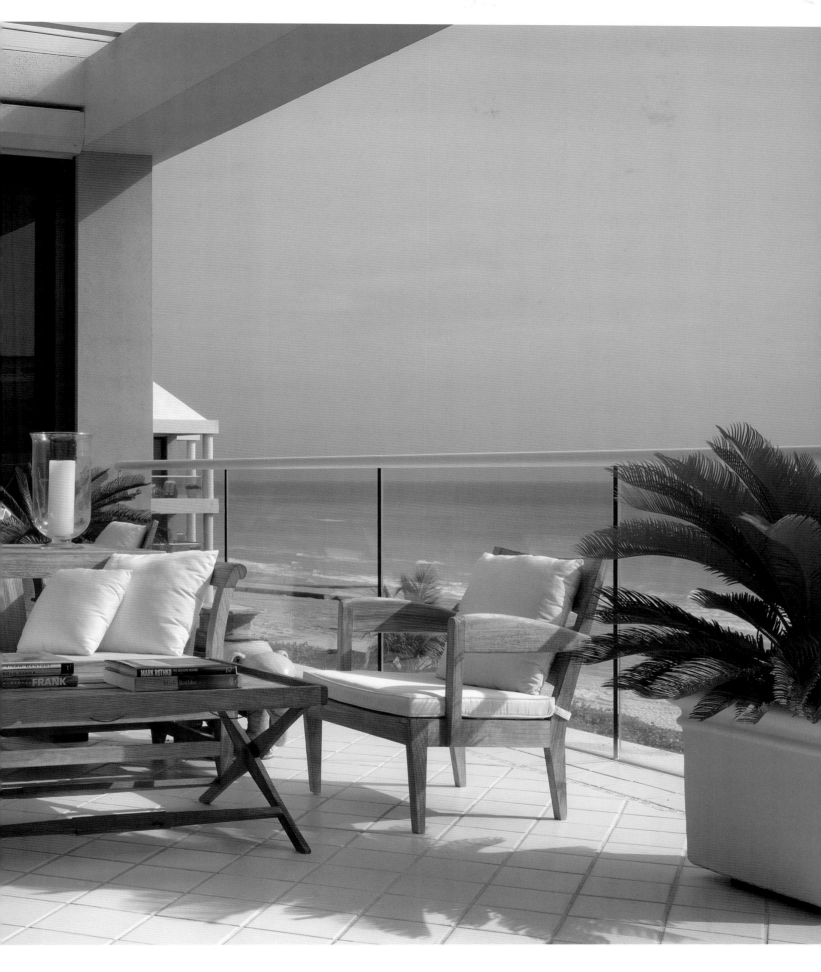

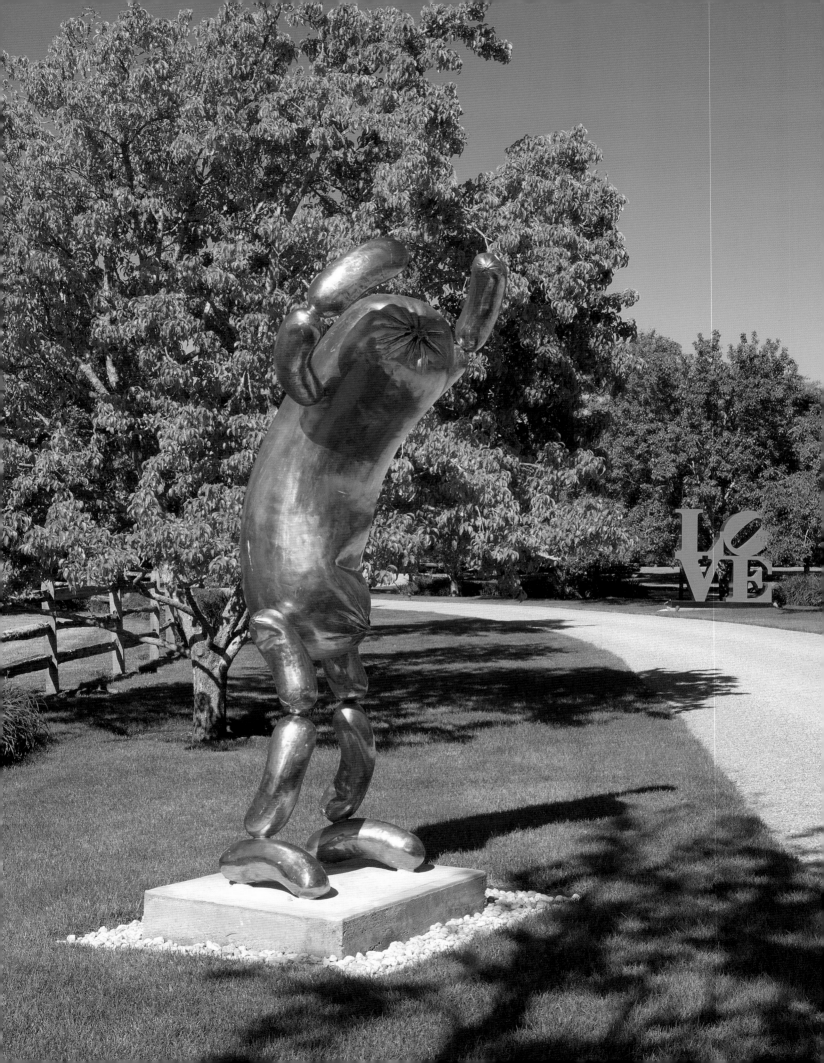

Inside and Out

This world is but a canvas to our imagination.

—Henry David Thoreau

The Hamptons, with its miles of pristine beaches and one magnificent house after another, has always held a special attraction for me. Recently I had the pleasure of working on a house in Water Mill, a beautiful lakefront estate just a short distance from the ocean. It's a special house in a very special and historic village, almost 375 years old, with its own still-functioning watermill and windmill.

To say the property is breathtaking would be an understatement. The 13,000-square-foot building stands on almost 13 acres, with a guest house, pool, tennis courts, and panoramic views. It's a family compound that is usually filled with the laughter and commotion of children, grandchildren, and friends.

The excitement begins on a long driveway, lined with a sheltering allée of trees, to the main house. Sculpture is strategically placed on the grounds, celebrating the imaginative spirit of the owners and creating a warm and inviting mood. There's no classical Greek statuary here; like the collection inside, it's all contemporary and cutting-edge—with a nod to Pop and surrealist art and their sense of adventure and fun. Robert Indiana's iconic *LOVE* sculpture welcomes visitors while giant red snails and other shiny, happy creatures prompt smiles and lend an air of playfulness.

"We think of the lawn as a large canvas," says the owner. "It's kind of a welcome mat. And we want to share our biggest and most entertaining pieces with as many people as possible."

Designing the grounds was clearly a labor of love for my clients, and that same spirit of dedication and adventure extends to the interior of the updated American shingle style house. Built in 2002 to designs by Mojo Stumer Architects, the house has a somewhat modern facade but features the gables and porches of the classic design. In a sense, it's a refinement—or perhaps relaxation—of the style, eliminating the fussiness and ornamentation of the nineteenth-century Queen Anne buildings that were once so prominent here.

Of course, a house of this sort—with its traditional horizontal spaces and mostly conventional ceiling heights—can pose a challenge for collectors of contemporary art. That's why we relied on streamlined, custom furnishings that have low profiles and blend in with the neutral backgrounds.

And there is simply so much to remember. A sculpture of a Roman goddess may seem like a nod to the classical school, but not when it's *Statue of Venus Obliterated by Infinity Nets* by Yayoi Kusama in orange against a matching backdrop. Kehinde Wiley's portrait over the living room fireplace fills the room with vibrant color while Ryan McGinness's kaleidoscopic image in the hallway is riveting. In their own ways, the pieces may be cutting edge, but they still carry on the traditions of great art while carving out their own space within it.

The cream walls and highly polished hardwood floors provide the perfect backdrop for these and other works, like the Color Field paintings of Morris Louis, the Roy Lichtenstein in the gallery, and the enormous Kenneth Noland canvas in the master suite. There aren't a lot of antiques or relics of the past here either, and even the ceiling light fixtures are largely inconspicuous. Once again, the open sight lines and low-slung chairs and furnishings direct the eye where the owners want it to go—to the colorful, imaginative, and thought-provoking works that line the walls and fill the open spaces.

"Originally, we came out here to relax. But the collection has grown so much and the pieces are so creative and captivating that our imaginations take flight," the owners say. "It's exhilarating and fun, and the family wouldn't have it any other way."

Opposite Large works by Erwin Wurm (left) and Robert Indiana set a cheerful mood along the driveway.

Above and opposite
Large-scale sculptures of childhood
toys by Yoram Wolberger animate
the approach to the house. A horse
sculpture by Deborah Butterfield
appears very much at home along
the lawn.

Overleaf
Festive figures by Barry Flanagan
(center) and Tom Otterness welcome
arriving guests.

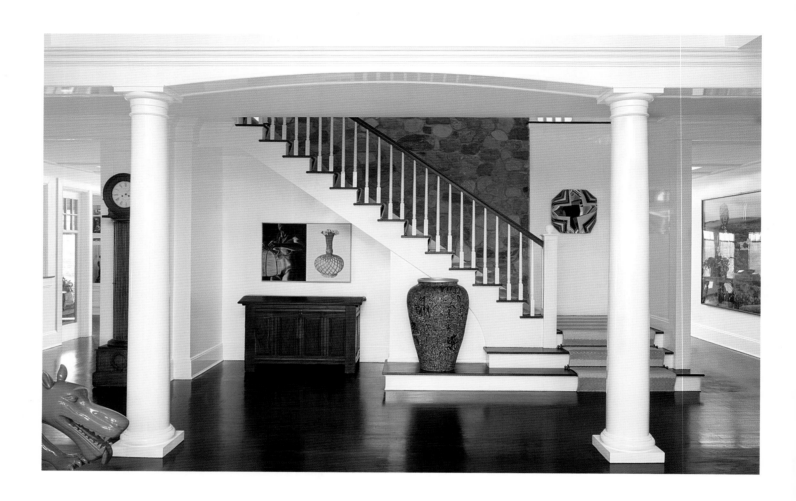

Above
A gallery space was created in the entrance hall within the framework of the traditional American architecture. A sculpture by Zhou Chunya and contemporary diptych by David Salle are juxtaposed with a tallcase clock and massive Chinese vase.

Opposite
Statue of Venus Obliterated by Infinity Nets by Yayoi Kusama occupies a space where, in the past, a classical nude might have stood.

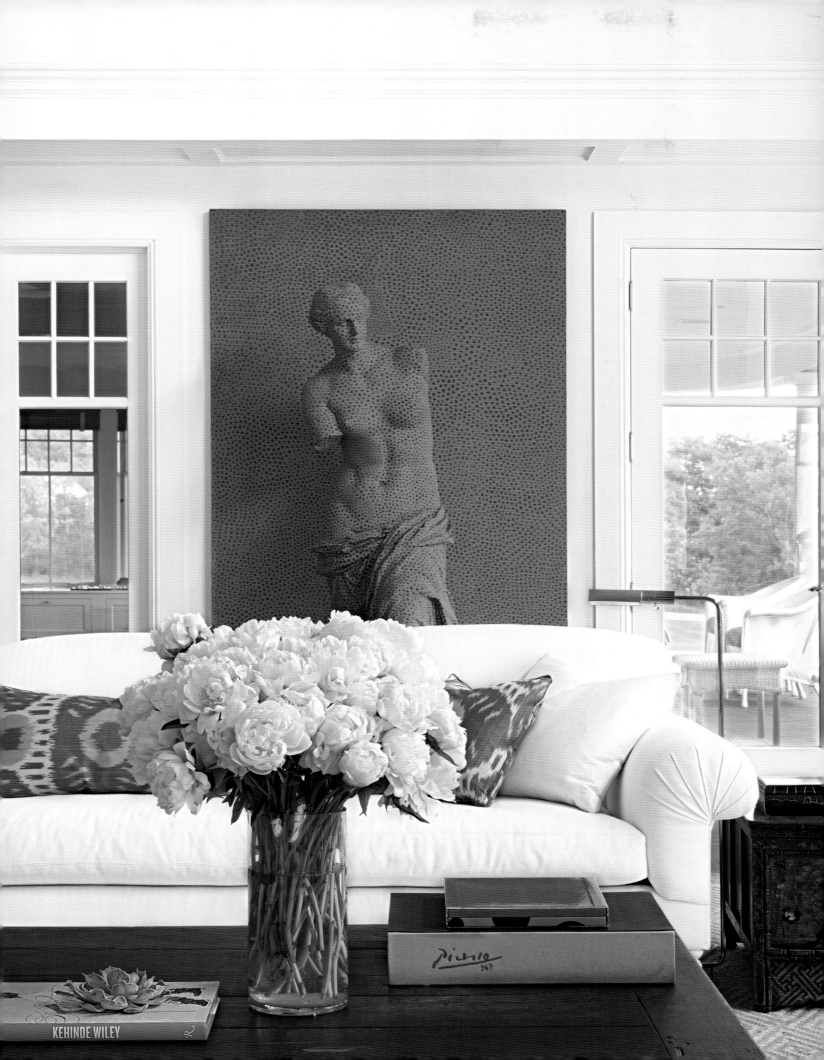

KEHINDE WILEY

Picasso
347

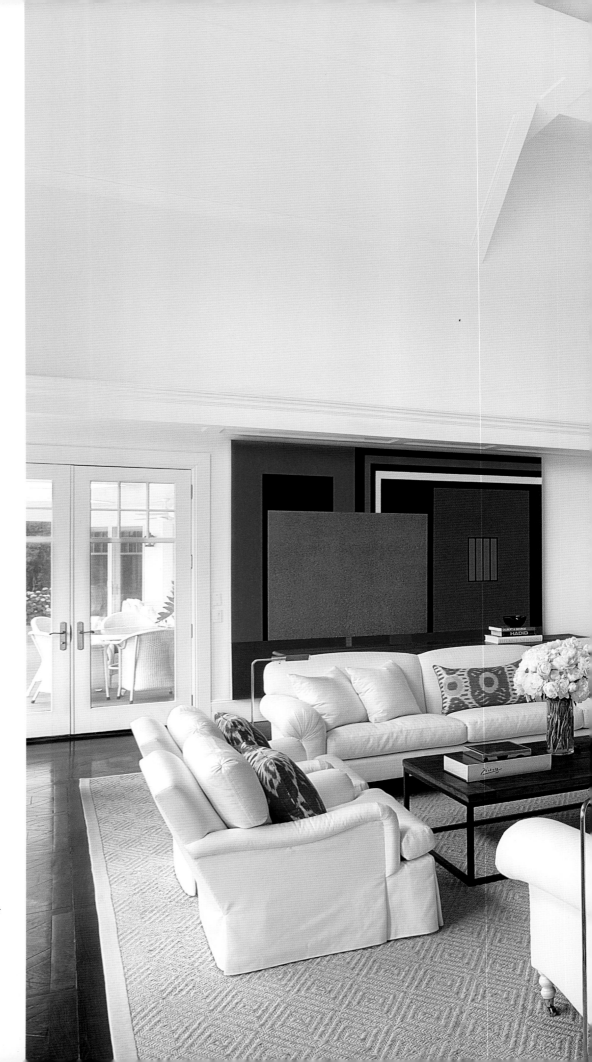

Right
A double portrait by Kehinde Wiley and a large geometric canvas by Peter Halley bring color and drama to the monochromatic living room. In a nod to tradition, classic chandeliers in silver cast a warm and inviting light.

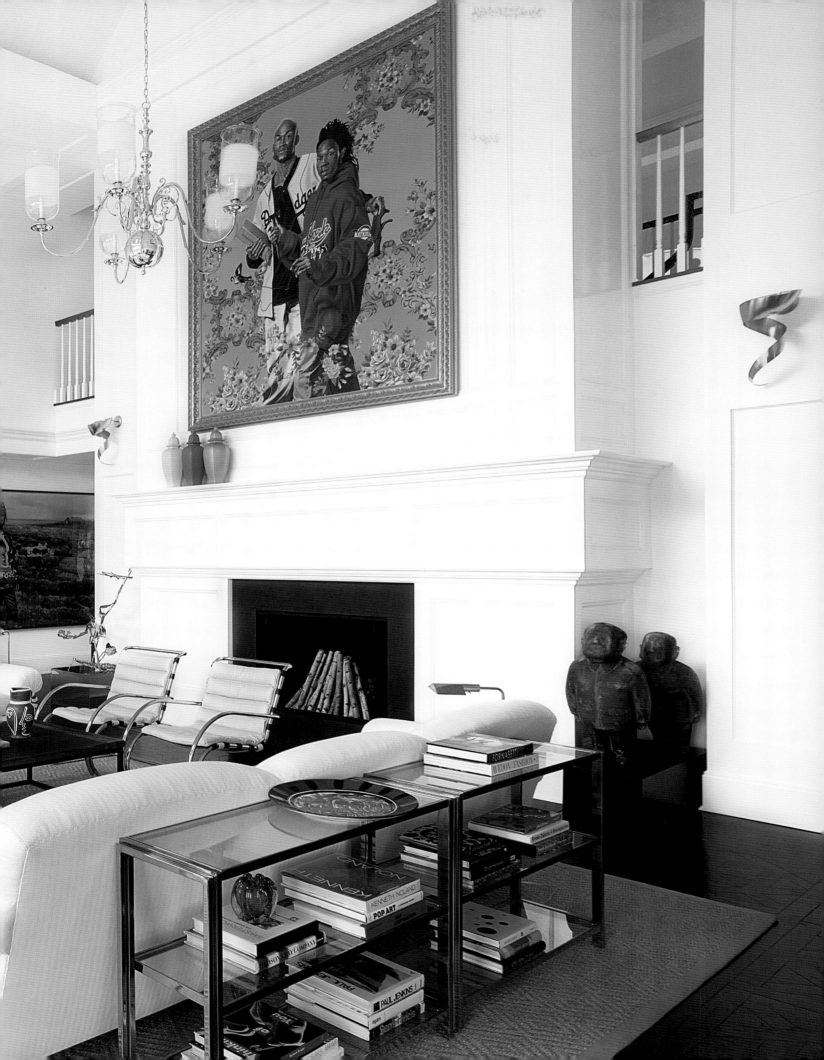

Above
A drawing by Richard Serra hangs above a classic settee.

Right
The white lacquered gallery space is wide and long enough to accommodate a changing display of paintings and sculpture.

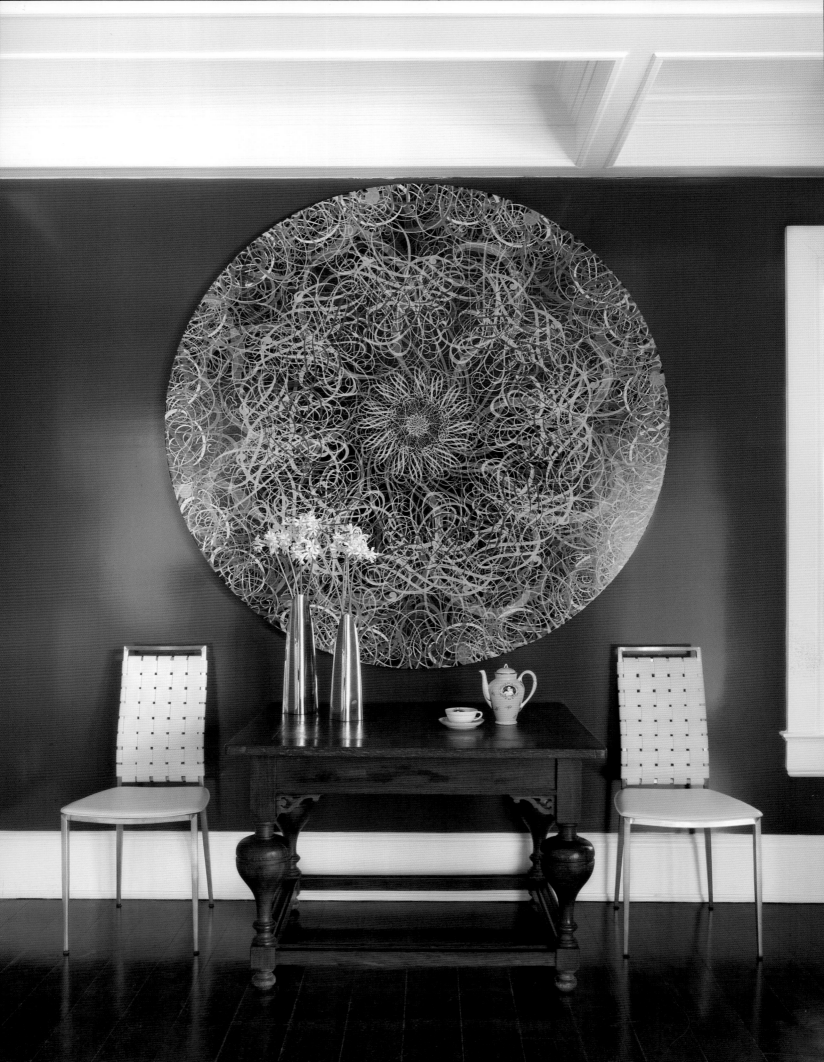

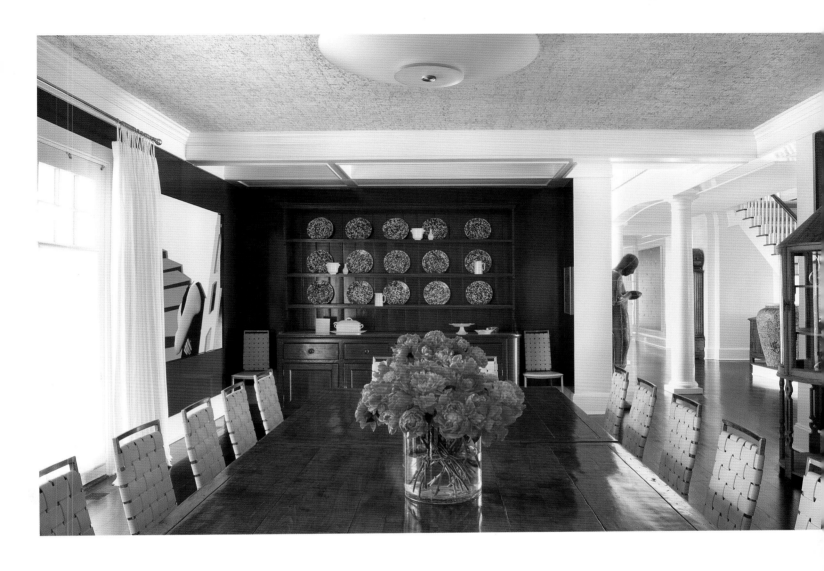

Opposite and above
A figure by Anthony Gormley stands as a silent sentinel outside the dining room. A painting from Ryan McGinness's Black Hole series fills the wall between the windows. The teapot and cup and saucer are from the "Madame de Pompadour" service by Cindy Sherman.

Above
A rustic farm table and wood-framed clock contrast with the sleek white chairs and large globes of the ceiling light fixture.

Opposite
A postmodern, conceptual work by Barbara Kruger hangs in a light-filled corner of the study.

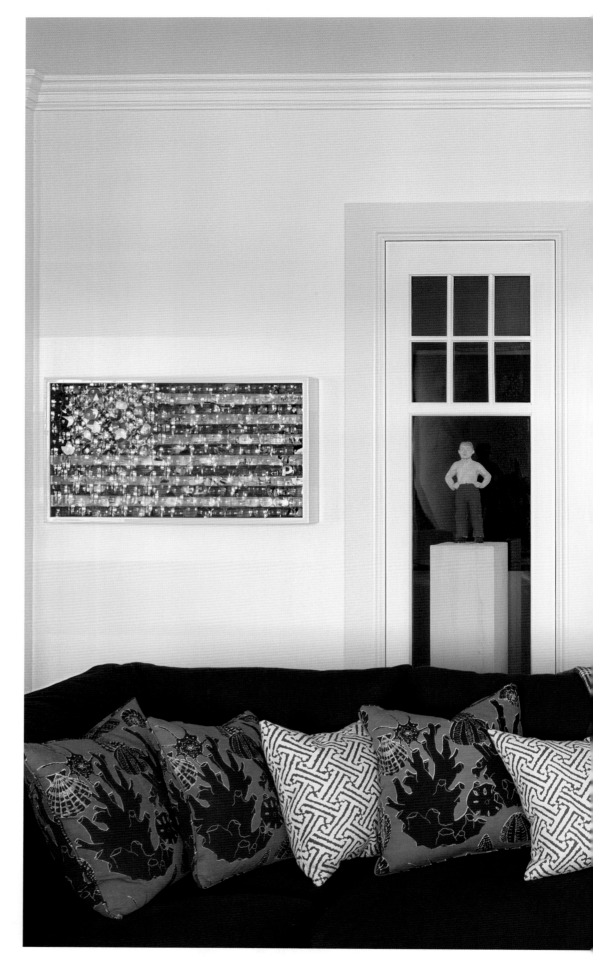

Right

The range of blues in the custom sofa and throw pillows echo the palette of *House of Cards Blue* by Larry Rivers. The flag wall hanging is by mixed-media artist David Datuna, and the sculpture of metallic cans is by Subodh Gupta.

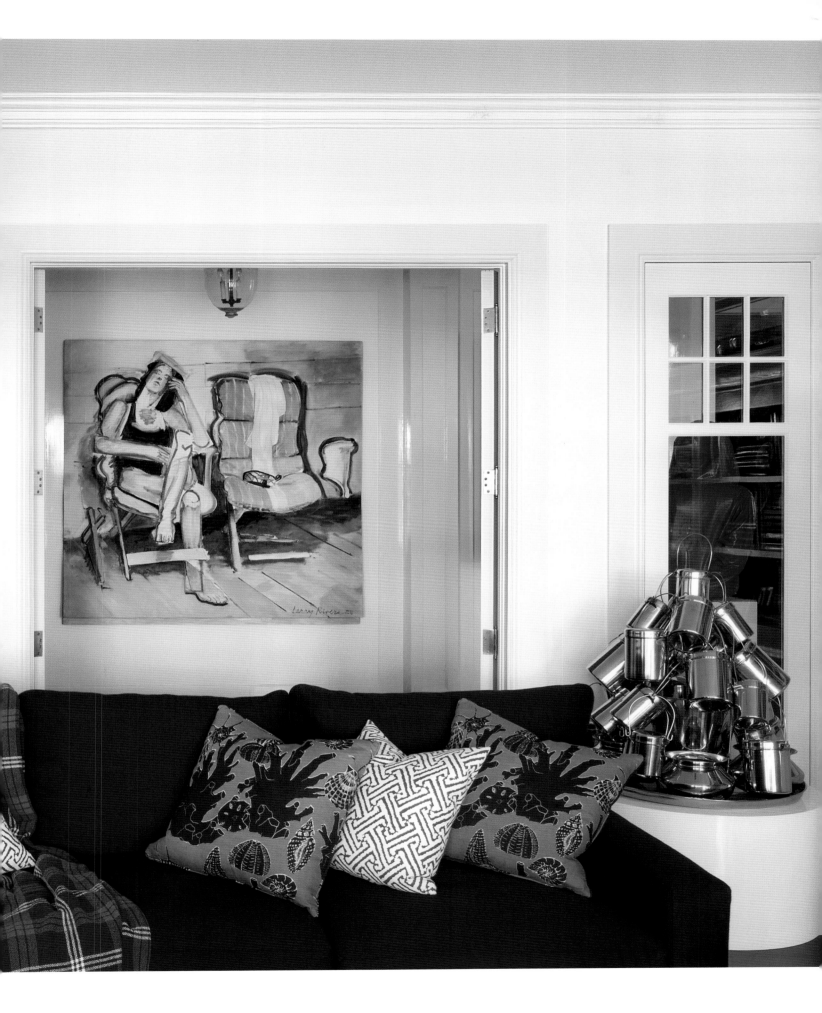

Above
In the second-floor hallway, a vibrant sculpture by Karl Appel and a "ready-made" arrangement by Haim Steinbach bring color and shape to the cool open space.

Opposite
In the master suite, a work by Kenneth Noland fills the space with vibrant shades of purple, pink, gold, and blue. Furnishings are kept low to the floor, and the color scheme is neutral.

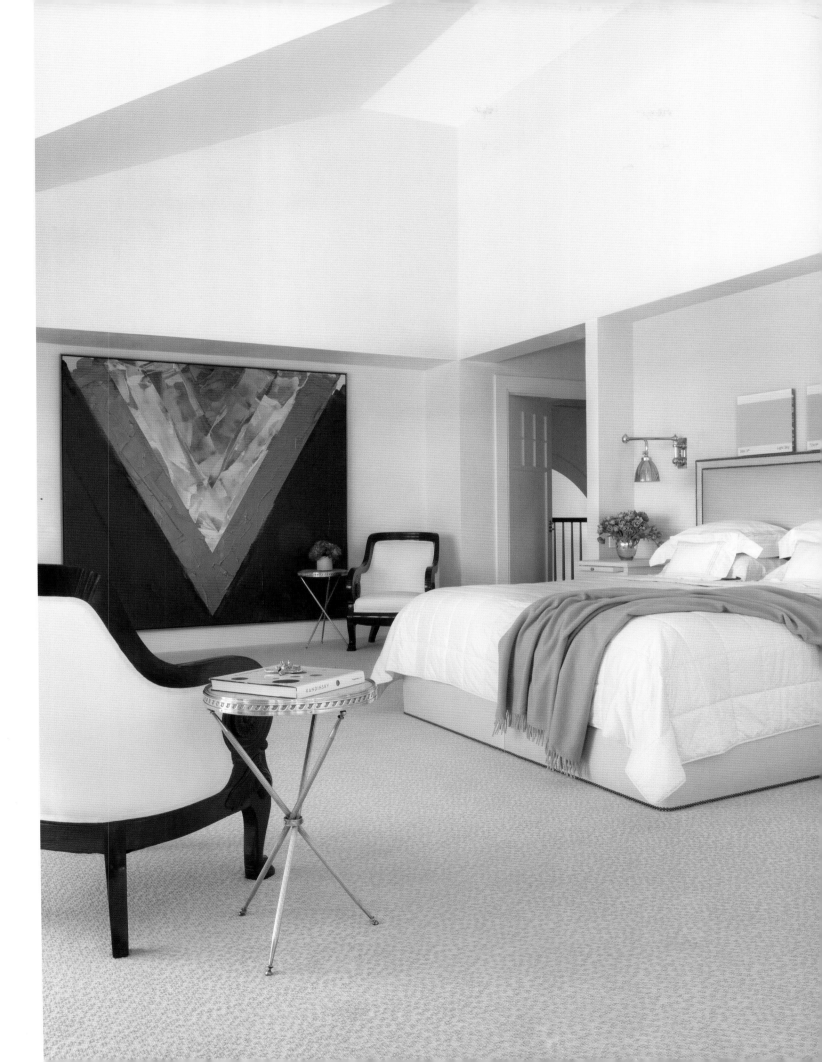

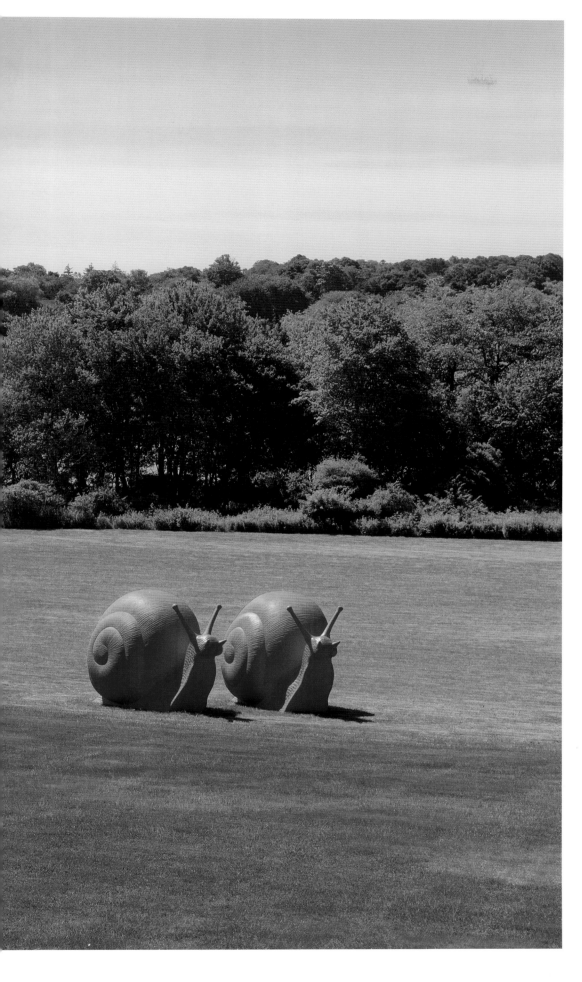

Left
Giant red snails by the Cracking Art Group bask in the sunlight on the lawn leading to Mill Pond.

Park Avenue Combination

Art enables us to find ourselves and lose ourselves at the same time.

—Thomas Merton

Along with Rosario Candela, the architect who did the most to transform the Upper East Side into a bastion for fine living was J. E. R. Carpenter. The magnificent buildings he created along Fifth and Park Avenues typically feature spacious apartments with high ceilings and generous entrance halls. Their grand proportions allow them to serve not only as art galleries but also as "pivot points," providing multiple views and easy access to the main public rooms.

I've had the pleasure of decorating several Carpenter apartments. But the most rewarding project was a complete redesign of two adjacent residences in a classic building. When combined, the new space encompassed six bedrooms, offered exposures on all four sides, and provided more than 70 feet of frontage on Park Avenue.

My clients, who already lived nearby in a classic prewar co-op, had built a contemporary art collection worthy of any museum, with works by virtually all the major artists. Jean Dubuffet, David Hockney, Robert Rauschenberg, Damien Hirst, and Richard Prince are just a few of the painters represented, while the list of sculptors includes Louise Nevelson, Fernando Botero, Bruce Nauman, and Roy Lichtenstein, among others. The couple loved the expanding array of modern masterpieces, and they loved the home where they had raised their family. But, ultimately, they realized they needed more space to do justice to the collection and to allow friends and family to enjoy it as well.

When the two apartments came on the market—one owned by a former U.S. Treasury Secretary and the other by the estate of *Vogue* editor Diana Vreeland—the couple acted quickly to acquire the twin units and proceeded with the renovation. The challenge was to take two well-designed apartments and merge them harmoniously into a single unit. Patience was essential, but the anticipation of having a new home—and museum-quality gallery—was great.

It took months and months of work—in fact, almost a year-and-a-half of demolition and reconstruction—to rearrange the rooms and align the new reception and public spaces together on one side with the more private rooms and workspaces on the other.

Carpenter's signature entrance hall remains a key feature. But now, more than 50 feet long, it is truly magnificent. Its striking proportions are made all the more dramatic with bronze door surrounds and bold crown moldings at the ceiling. For such a long corridor and so many important works of art, lighting was a priority. The row of crystal chandeliers adds a subtle touch of luxury while bathing the space with an inviting glow.

Furnishings share the space with the art throughout the apartment in lighter tones that never cry out for attention. Apricot silk-velvet and beaded wall coverings in the dining room engage the eye but don't distract from the art. The colors, which might at first appear unusual, were chosen to coordinate with the client's antique china. The dining room was, in fact, so large that we had to cluster three chandeliers together to maintain an appropriate scale. John Meeks designed many of the pieces, including the pair of club chairs in the living room with Japanese obi ties. That's always been our goal: to feature custom-made furnishings to complement the one-of-a-kind art. And here again, when oriental carpets were chosen, we focused on a soft, subdued color scheme that does not disrupt the visual harmony.

Perhaps the most appealing aspect of the project was the clients' light-hearted approach to life and collecting. When I first met them, I knew they had a good sense of humor—they always laughed at most of my jokes anyway—but I wondered if their blue-chip collection would lean toward the formal or heavy-handed. So it was a delight to discover a painting of a dancing cake in the kitchen, a muscular Mapplethorpe in the gym, and a reclining nude over the bed. These touches remind you that these collectors are real people and this place is a real family home.

My clients put it best: "Many of these pieces make us think about the artist's point of view. But others just make us smile and feel good about life. They're meditative. They're amusing. We'll probably keep collecting as long as possible. Along with family and good works for the community, it's really what our lives are all about."

Opposite Works by Deborah Butterfield and James Turrell create a note of mystery.

163

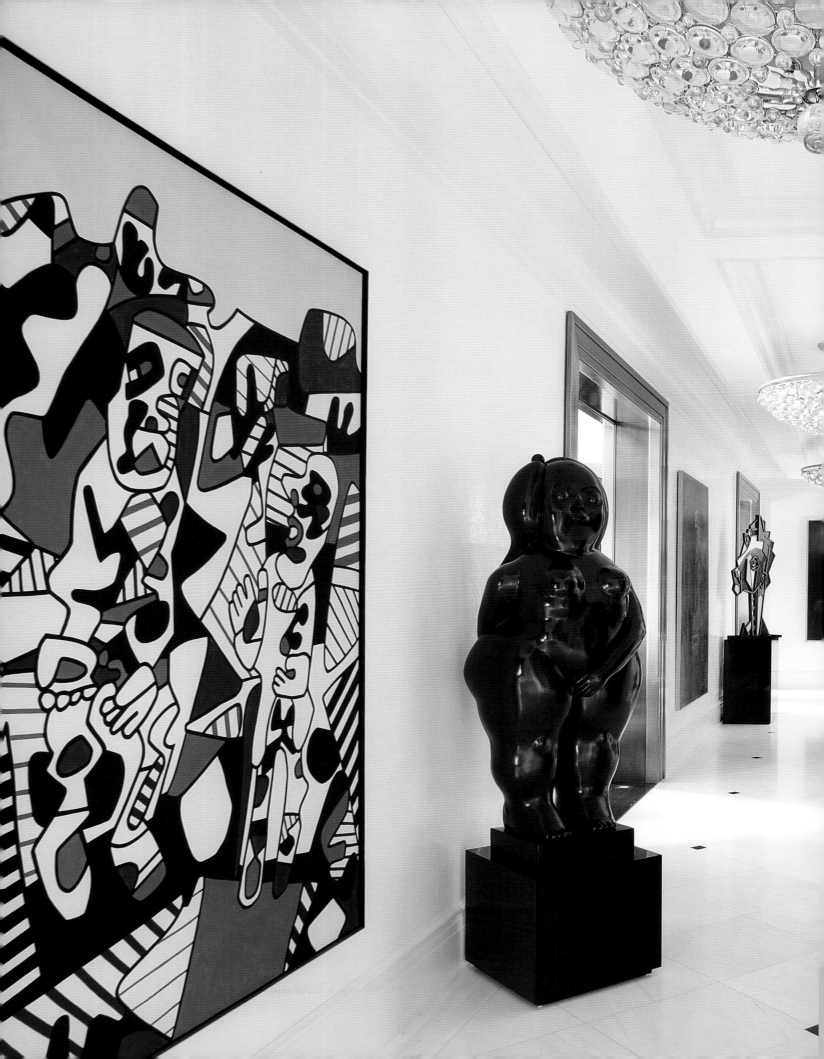

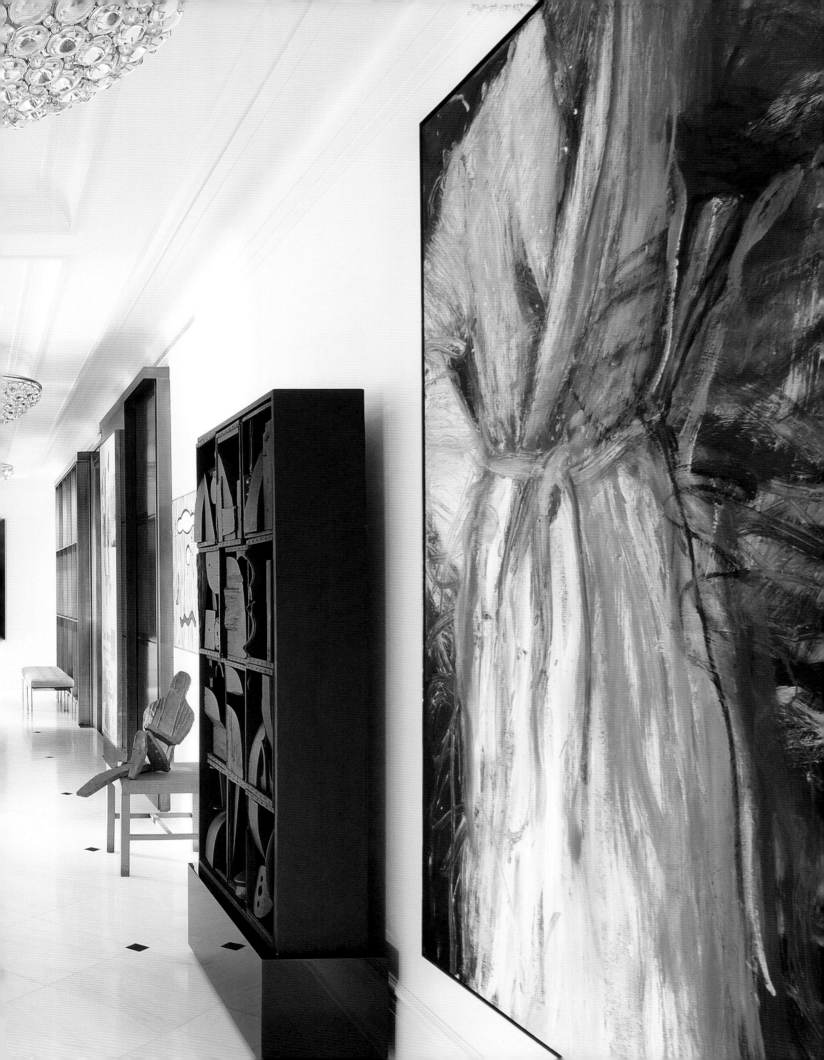

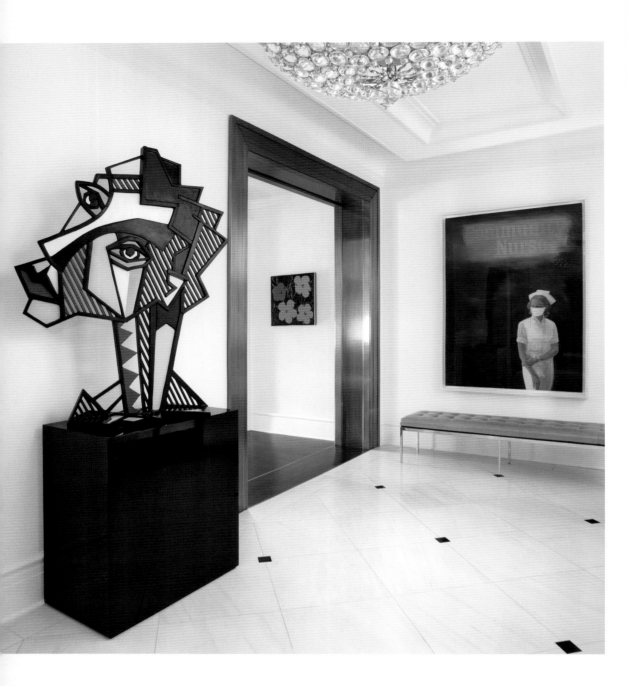

Preceding pages and above
In the monumental gallery, a line of crystal chandeliers mounted in high-gloss tray ceilings reflect light around the cast-bronze door surrounds.

Major works by Jean Dubuffet, Richard Prince, and Jim Dine share space with sculptures by Fernando Botero, Roy Lichtenstein, Bruce Nauman, and Louise Nevelson.

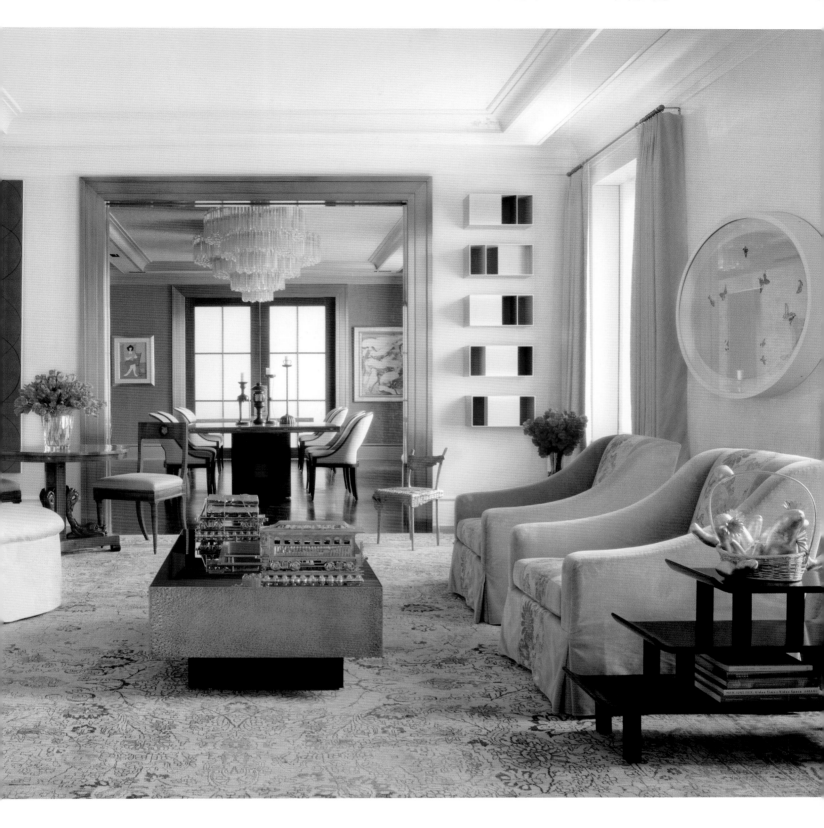

Above

The low profiles of the silk-covered furnishings defer to works by Alex Katz, Robert Mangold, Donald Judd, and Damien Hirst in the living room.

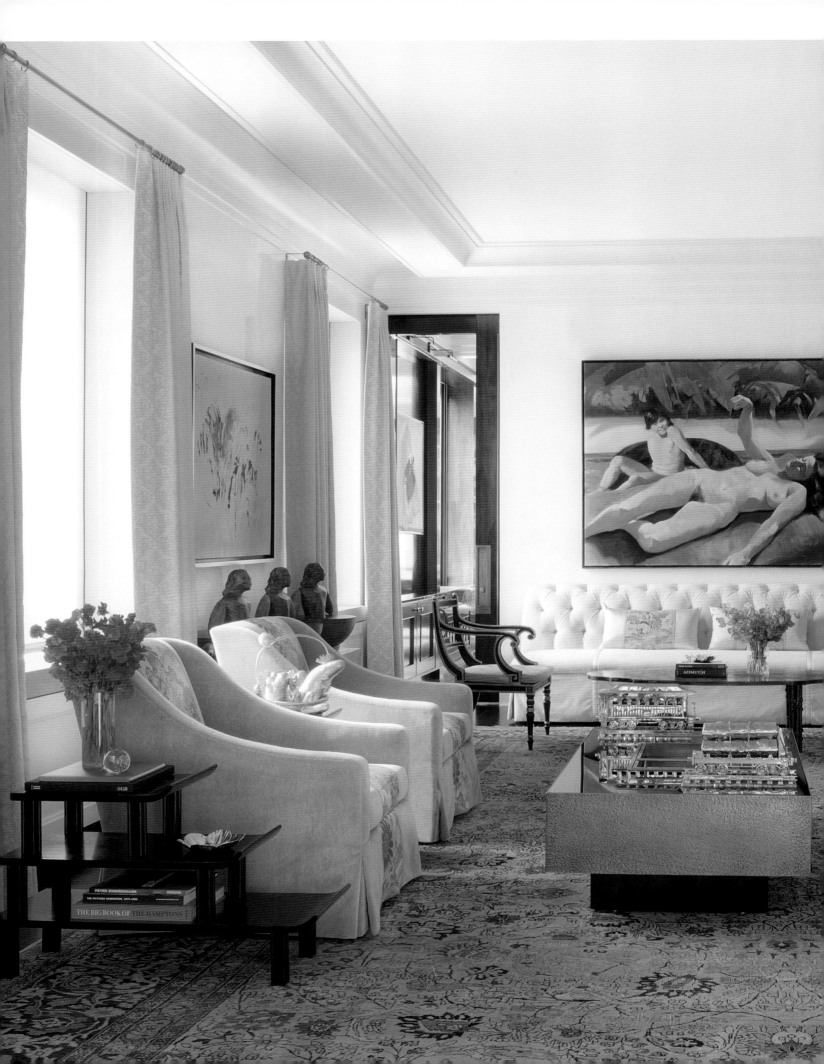

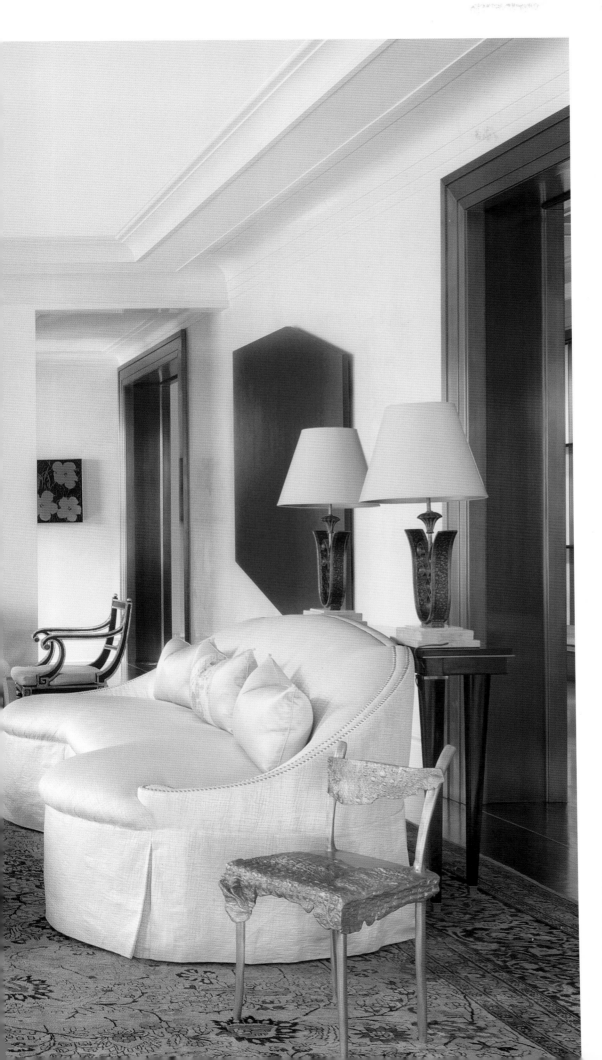

Left
The rug introduces subtle blue tones to the setting where attention gravitates naturally to works by Cy Twombly, Eric Fischl, and Ellsworth Kelly on the walls. A bronze chair by Claude Lalanne adds a sculptural element.

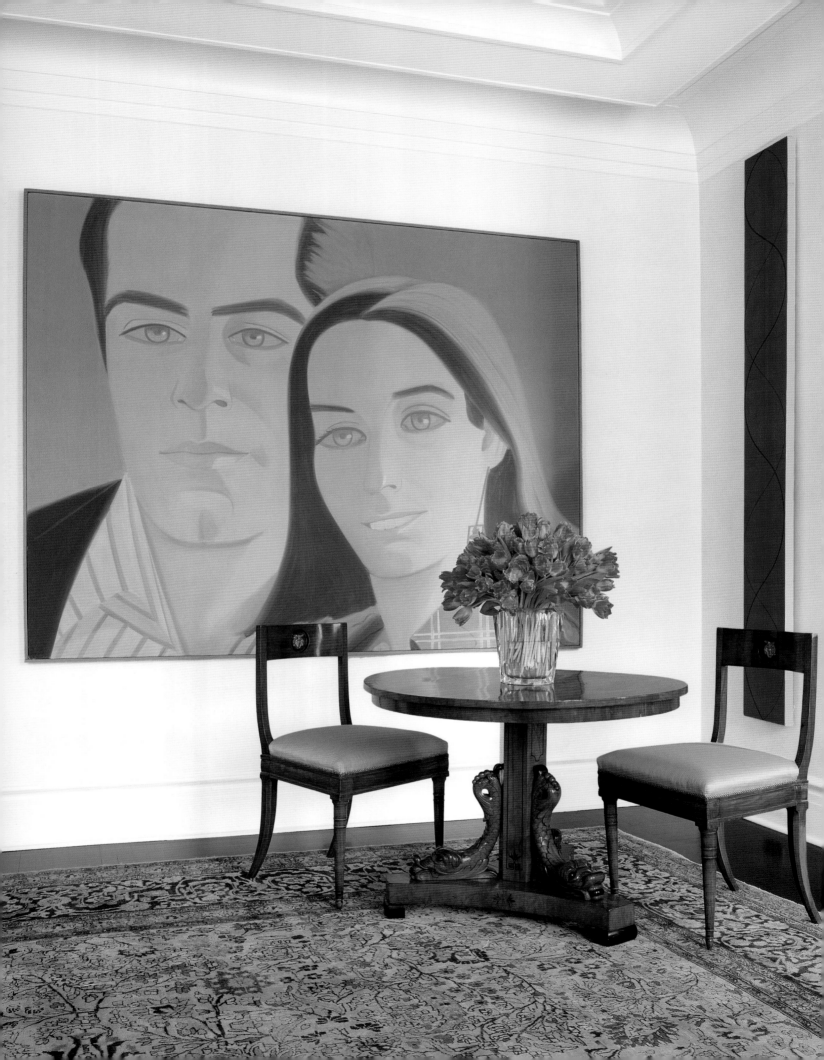

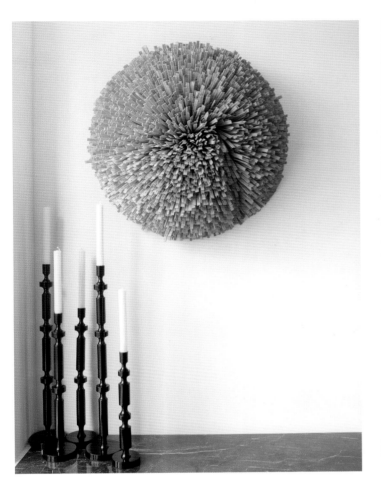

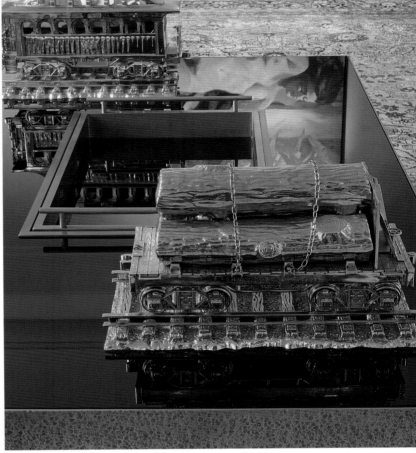

Opposite
A Biedermeier table pairs with
neoclassical chairs in a corner
in front of paintings by Alex Katz
and Robert Mangold.

Above left
The wall construction by Frederico
Uribe weaves chopsticks in a circular
form that contrasts with the vertical
lines of the candlesticks.

Above right
Cars from the *Jim Beam-J.B. Turner
Train* sculpture by Jeff Koons sit on
a bronze coffee table by Philip and
Kelvin LaVerne.

Above
A Buccellati silver leaf dish and a patinated and enameled bronze table by LaVerne provide subtle sparkle.

Opposite
A trio of sculptures by Juan Muñoz are displayed below a Cy Twombly canvas in the living room.

Overleaf
In the office, the paneling is high-gloss walnut with bronze inlaid details. A cherished Art Deco desk was restored and mixes comfortably with the midcentury coffee table and more recent leather chairs. The skull is by Damien Hirst.

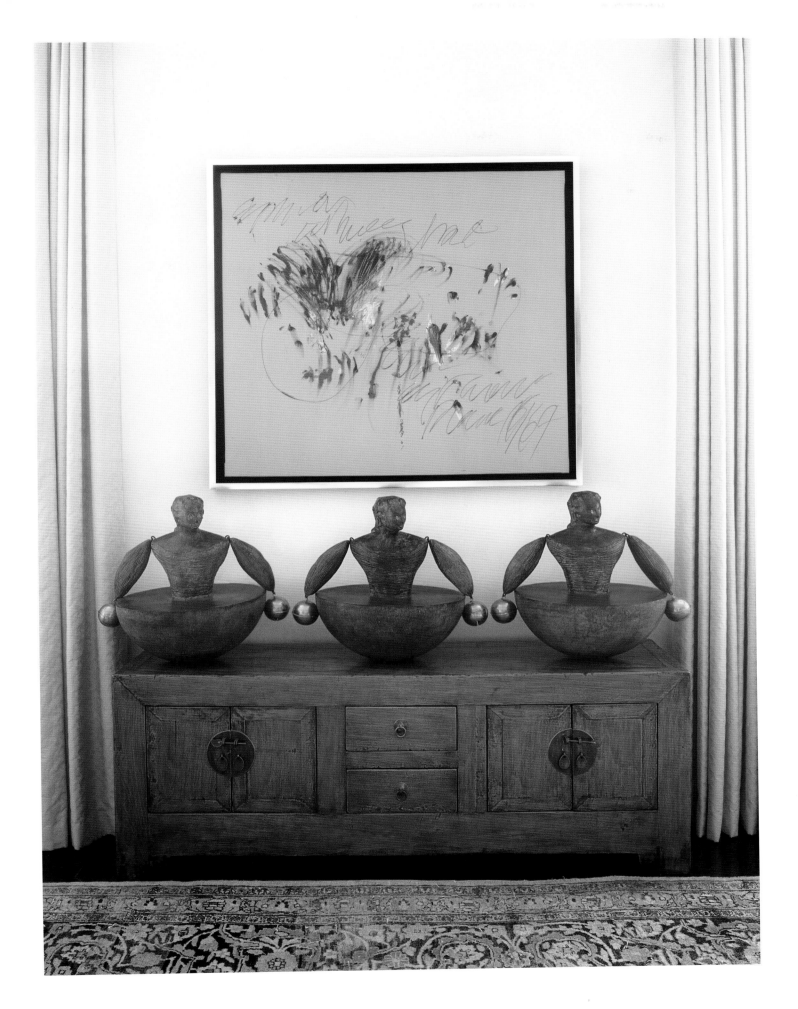

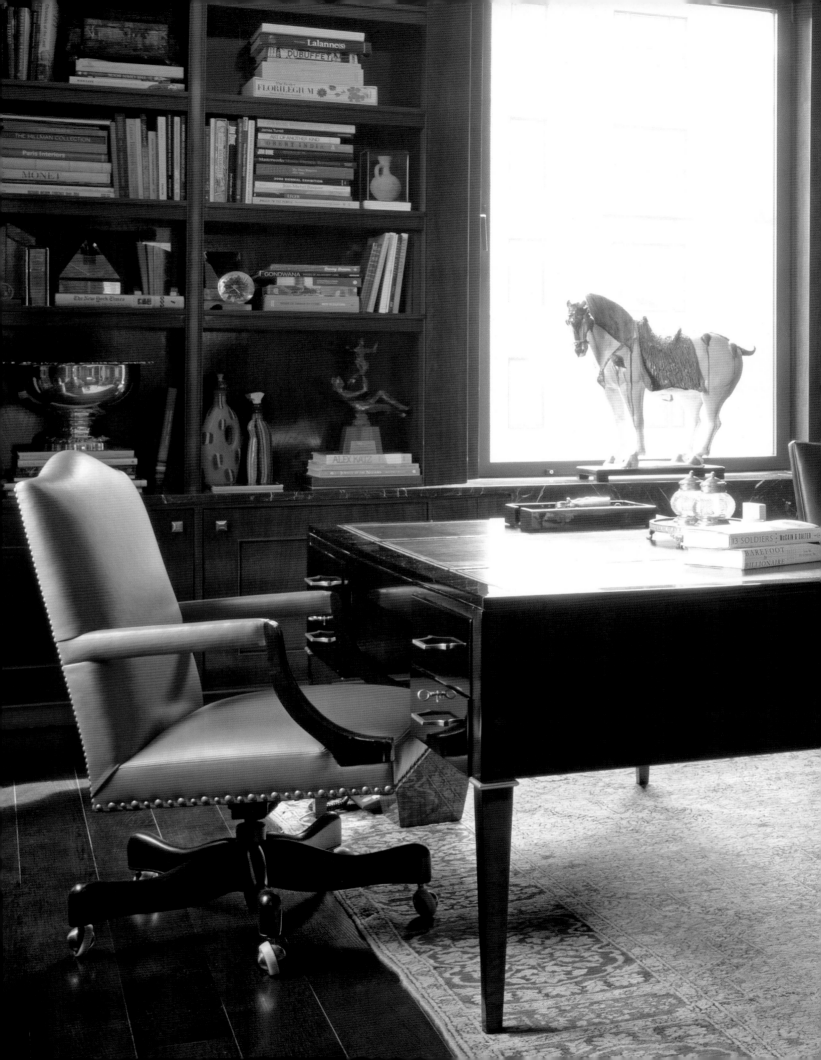

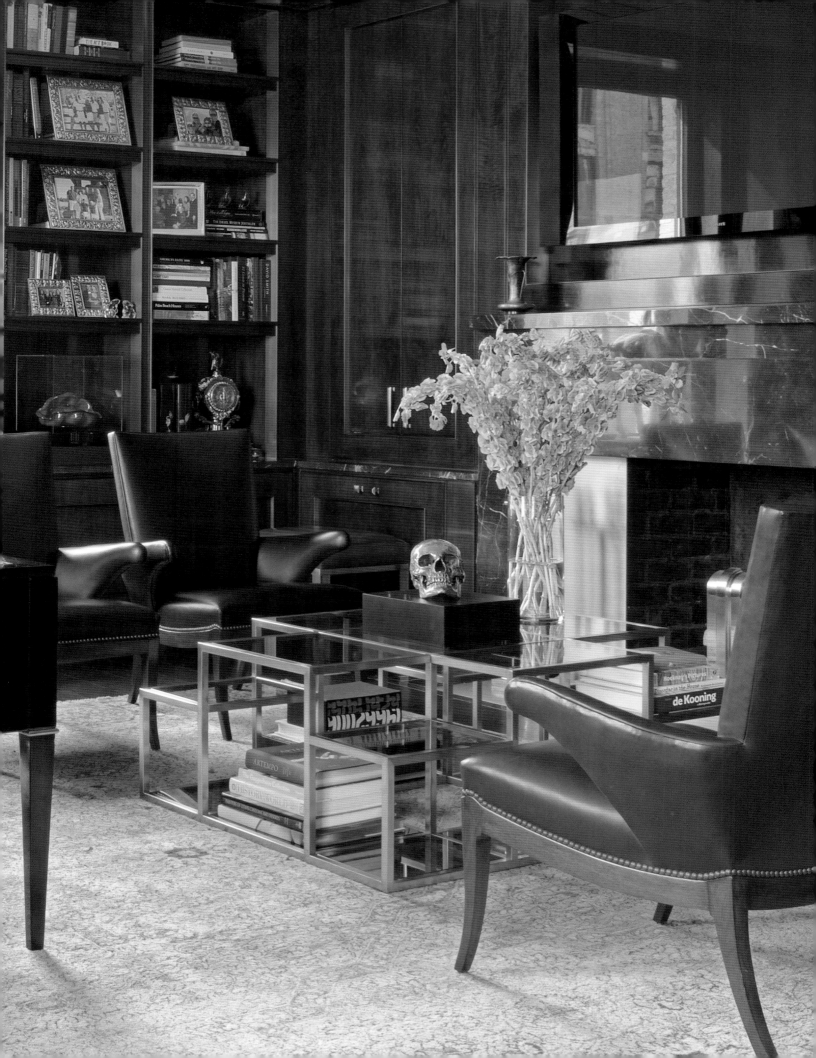

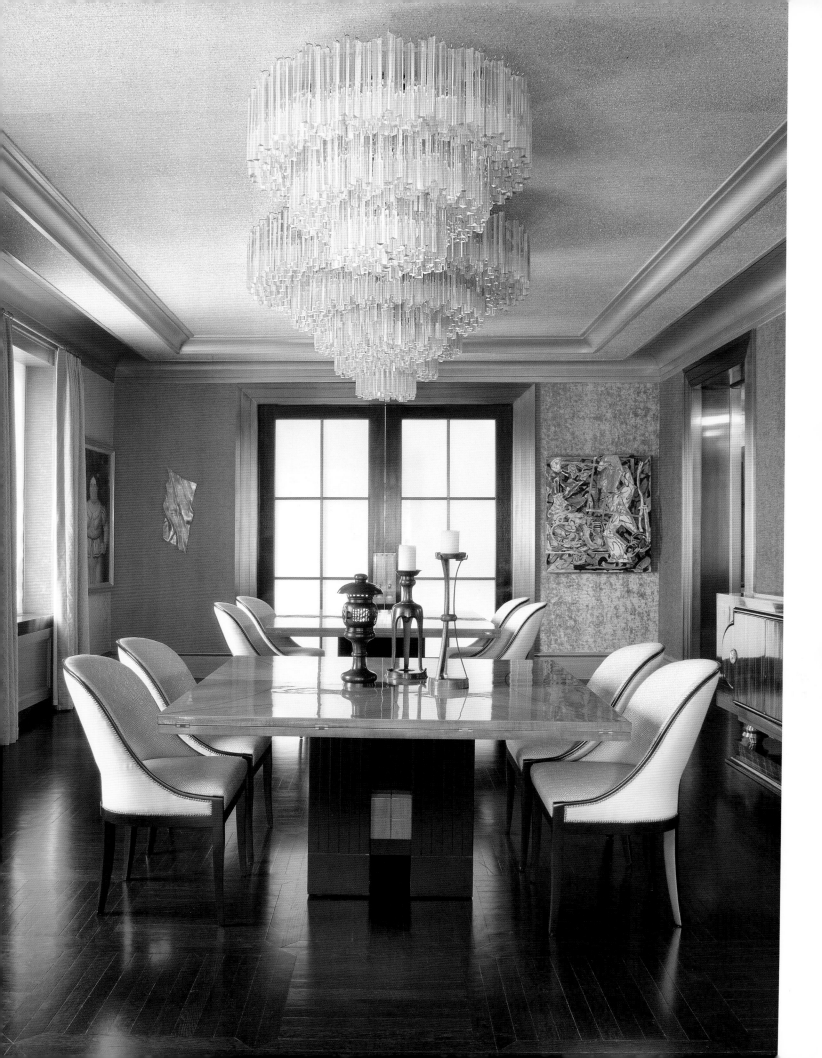

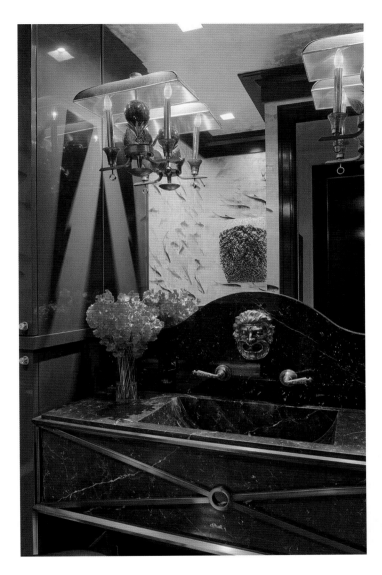

Opposite

In the dining room, the walls are upholstered in velvet and the tray ceiling features a crystal-beaded wallcovering to reflect the light from three custom crystal chandeliers.

Above

In the marble master bath, a wall sculpture by multimedia artist Paola Pivi adds depth and texture. The delicate strands of beads appear to float like coral surrounded by sea creatures.

Left
Pop Art is celebrated in the family room where works by James Rosenquist, Jeff Koons, and Andy Warhol share space beneath a mobile by Alexander Calder.

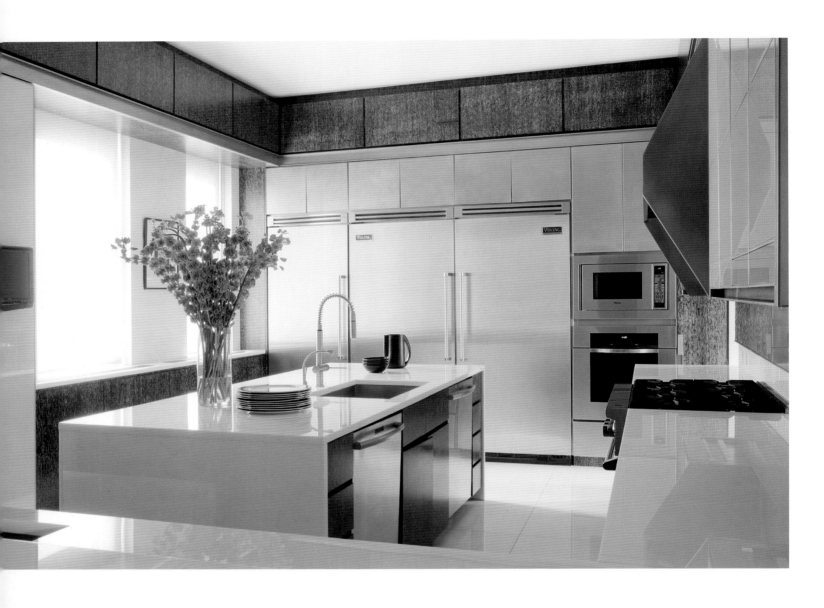

Above

The streamlined, stainless-steel
kitchen is a study in modernity.
The smooth, reflective countertops
contrast with the rougher white
oak millwork with a cerused finish.

Opposite

In a dining area, chairs in the style
of Josef Hoffmann were chosen to
blend with the custom table and black
lacquered cabinets. *Drift* by Farhad
Moshiri shines with bright color.

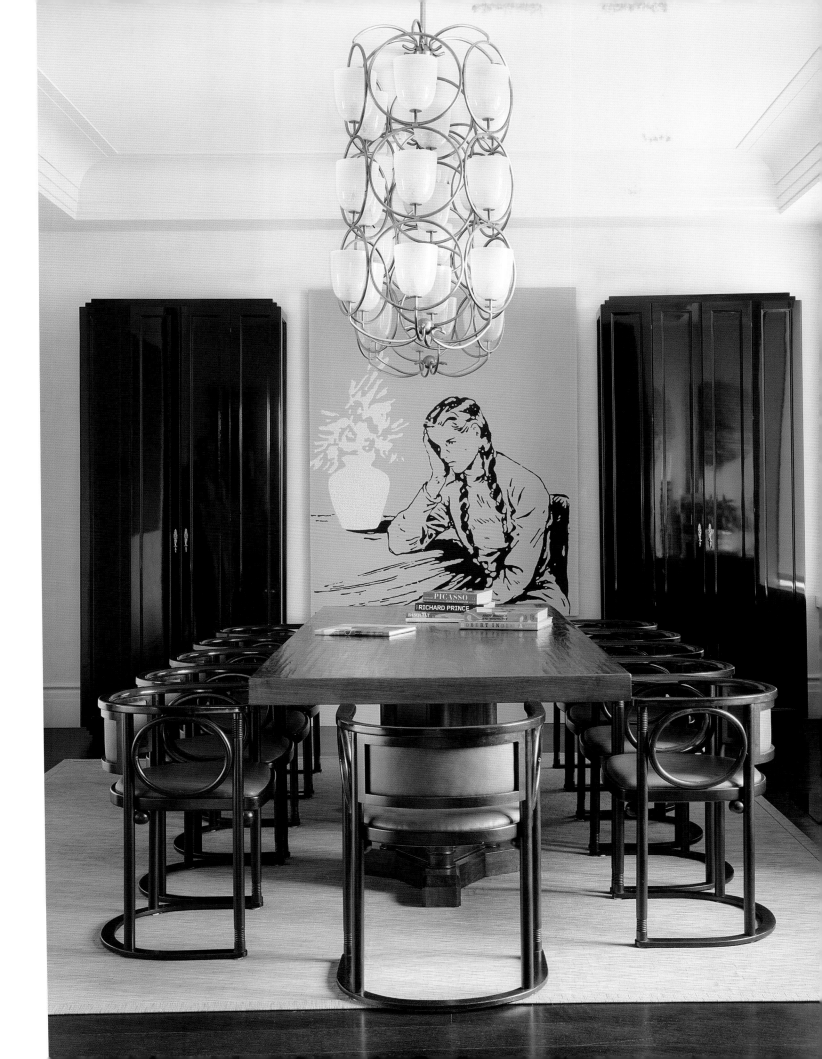

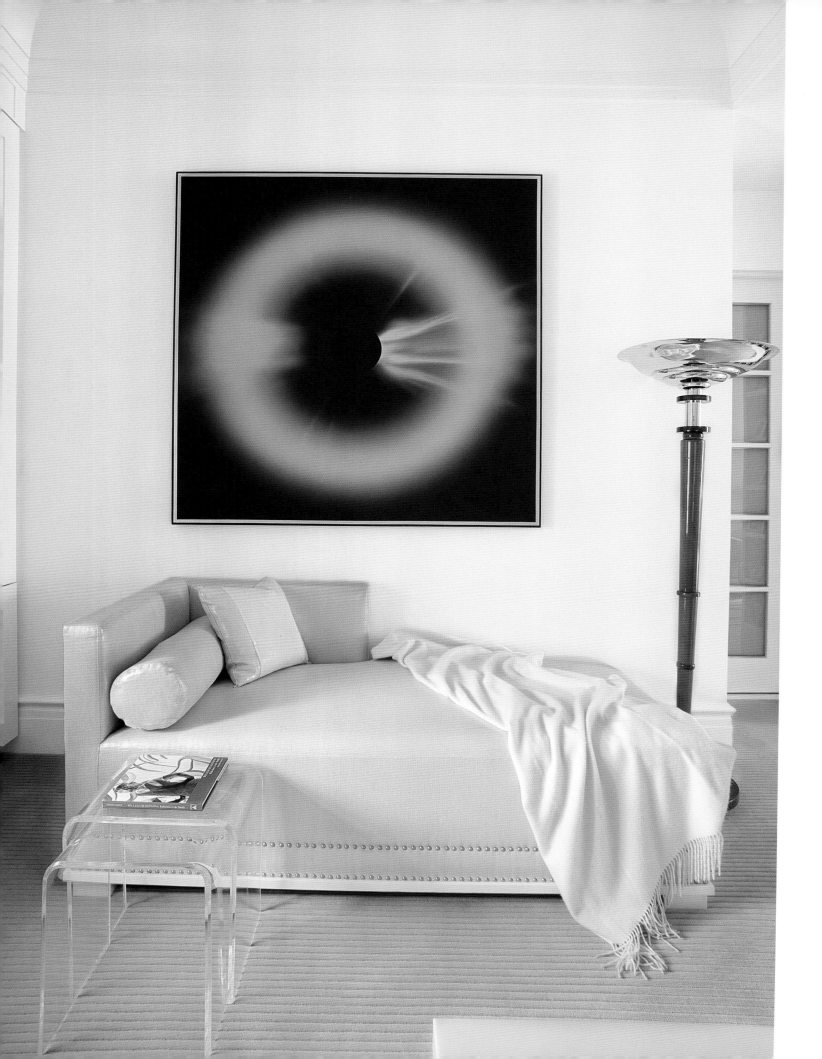

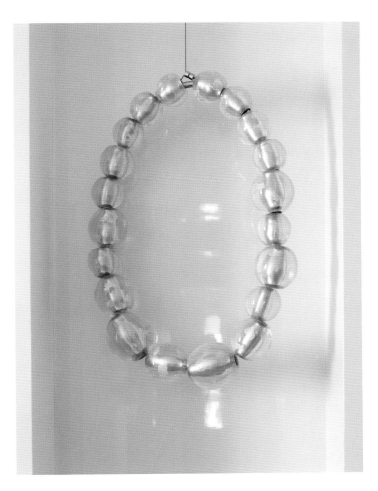

Opposite
In a quiet corner of the master
bedroom, an Art Deco torchère
and comfortable chaise are
juxtaposed with a vivid painting
by Jack Goldstein.

Above
A favorite necklace by Giancarlo
Ottanelli of Florence is displayed
in a small niche. The sculpture
by William Woodrow is a study in
intricate detail.

Above

The borders on the guestroom
linens mirror the narrow frame
on *Self-Portrait White Marilyn*
by Yasumasa Morimura.

Opposite

A wall sculpture by Tom Wesselmann
brings a pop of color—and playful
erotica—to the master suite. John Meeks
designed the bed and nightstands in
a nod to the apartment's 1930s roots.
The metallic duffle is a more recent
Pop Art work by Sylvie Fleury.

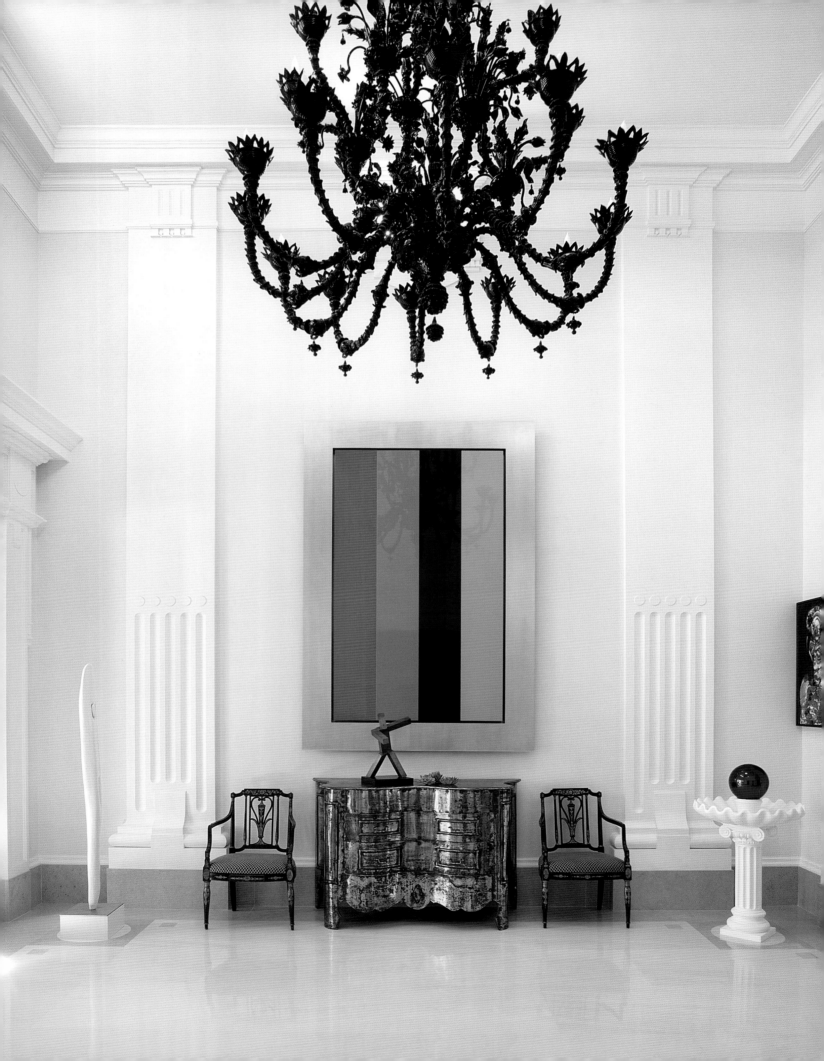

Lake Worth Adventure

A work of art is above all an adventure of the mind.

—Eugene Ionesco

Lake Worth is lined with houses with a rich architectural history and a unique charm of their own. Venetian-inspired palazzos share the waterfront with classic Georgians, Italianates, Spanish haciendas, and modernist contemporaries in a mix of styles that is both elegant and timeless.

One of my earliest projects along Lake Worth was a commission from a New York real estate developer and his wife. The two were longstanding Palm Beach residents, but as their family and their art collection continued to grow, they decided it was time to build the "home of their dreams" amid the tropical foliage.

"We're planning an adventure," they told me. "And we want you to help with it."

The house had been designed, but I joined the team before construction began, which gave us the opportunity to suggest certain refinements. We worked closely with the architects and, of course, with the clients to make sure the interiors met their particular needs and would serve as the appropriate backdrop for their art collection.

Drawing on the architecture of the area, my clients created a house that blends classicized elements with Mediterranean revival traditions. Columns, a loggia, and formal gardens provide balance and symmetry. The array of mature palms and other tropical plants afford shade and create the impression that the structure has been in place for years.

It's a classic home, and the interiors certainly respect tradition. Our early start gave us the chance to suggest expansive walls for large-scale paintings and a generous gallery to display sculpture and smaller works. We advocated eliminating certain details, like additional columns and excessive moldings, to reduce visual clutter. And we played a key role in selecting the finishes of the stone and woodwork throughout the house. Our goal in virtually all cases was to tone things down, to keep the color palette of the walls and furnishings quiet so the art could project in full glory.

And what a great sound it makes! A colorful Picasso turns up the volume over the library fireplace, standing out against the subdued background of carefully waxed wood. In the pool room, a blue-and-white painting by Gary Simmons harmonizes with the ottoman, sofa, and chairs we designed ourselves. A Joan Mitchell painting in the dining room is a symphony of vibrant colors while John Meeks–designed chairs in shagreen bring a counterpoint of classic style.

And then there's the massive pink-and-yellow circle—*No. 296* by Swiss artist Ugo Rondinone—that strikes a unique chord of its own at the end of the long gallery. I'm still spellbound by it every time I visit. It's a daring mix overall—a bit adventurous in some respects, but exactly what the clients were looking for.

The designer Karl Lagerfeld hit the nail on the head when he said: "Trendy is the last stage before tacky." My years with Ralph Lauren taught me that same simple lesson, and my clients were in complete agreement.

That's why we custom-designed and built many of the upholstered pieces and tables throughout the house—and that's why I believe their classic shapes and the neutral walls in the background befit the traditional lines of the home so well. Our approach to most of the furnishings is to create "couture" pieces as unique and timeless as the art that surrounds them.

Fortuny light fixtures in the master bedroom and entryway cast a distinctive glow. The white-lacquered wood and mother-of-pearl headboard remains one of our favorite custom designs, enhanced by the light that streams in over Lake Worth. These details, along with the oversized clamshell basin in the powder room, add a touch of whimsy and remind you that this is Florida after all. Color choices throughout keep things cool and understated.

The overall look is bold but classic, glamorous but refined, cool—and a little sexy.

Of course, my clients and their family and friends come here to relax. But they've chosen art that is stimulating and exciting. "It's our little corner of the world," they enthuse. "But it's something of a visual adventure as we move from room to room."

Opposite A blown-glass chandelier painted in a startling dark eggplant complements the equally surprising bombé chest in stainless steel. A painting by Christian Eckart hangs above.

187

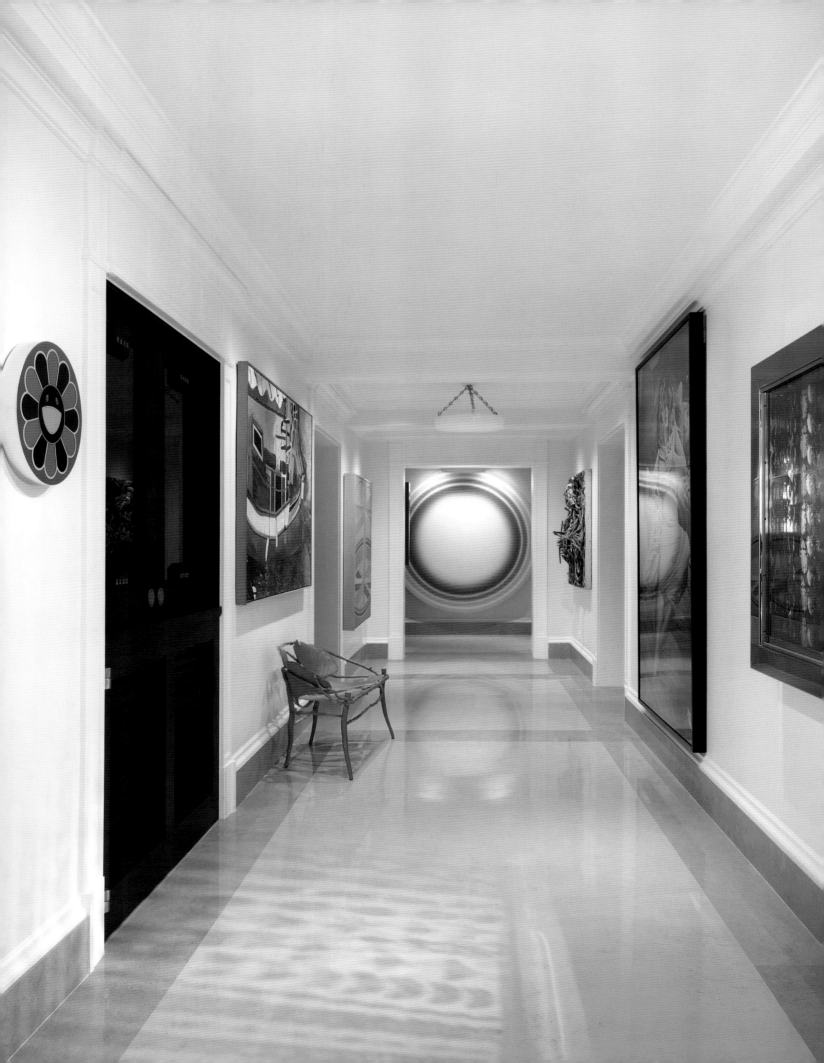

Opposite and above
The high ceiling in the gallery makes
room for both oversized canvases
and a range of smaller works, including
one of Damien Hirst's Entomology
Cabinets.

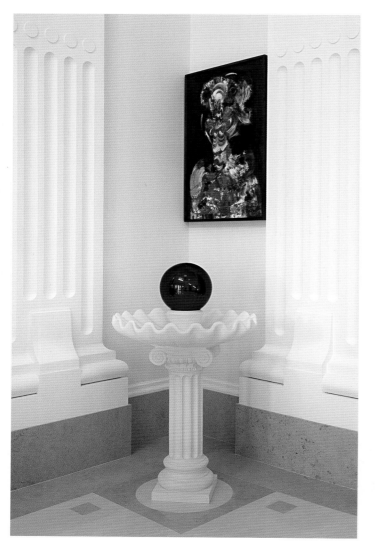

Above
Corners in the entrance hall accommodate sculptures by Jeff Koons and Anne Chu.

Opposite and overleaf
A tone-on-tone color scheme of whites, dove grays, and creams is carried throughout the sophisticated public rooms. Paintings by Anish Kapoor and Sam Francis bring vivid blues and splashes of red to a corner of the living room. Works by Damien Hirst, Brian Donnelly (professionally known as KAWS), and Jean Dubuffet surround the sofa, armchairs, and table designed by the Aman & Meeks team. Italian stools upholstered in horsehair provide another low seating option. The bronze sculpture is by Jean Arp.

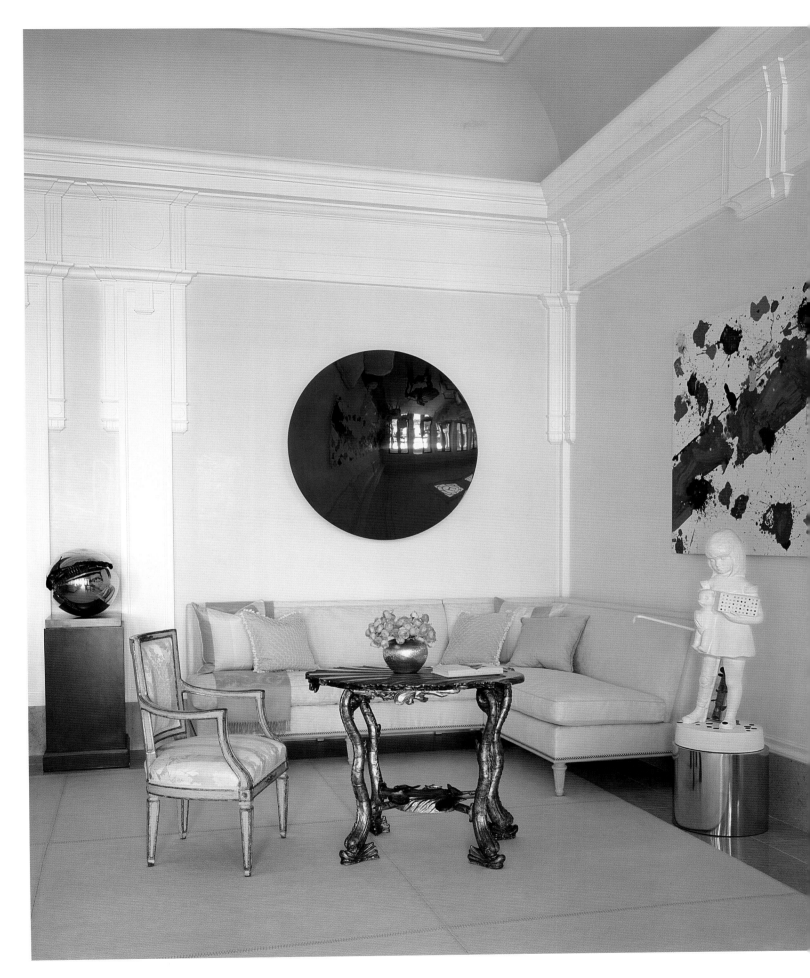

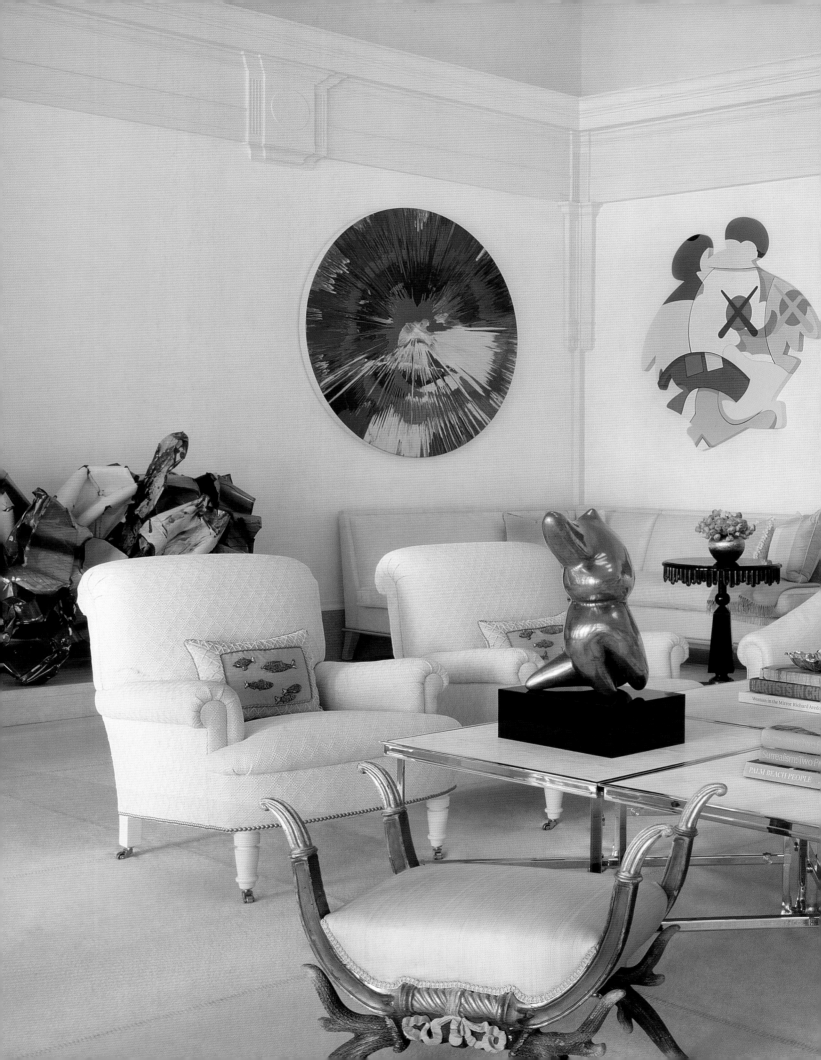

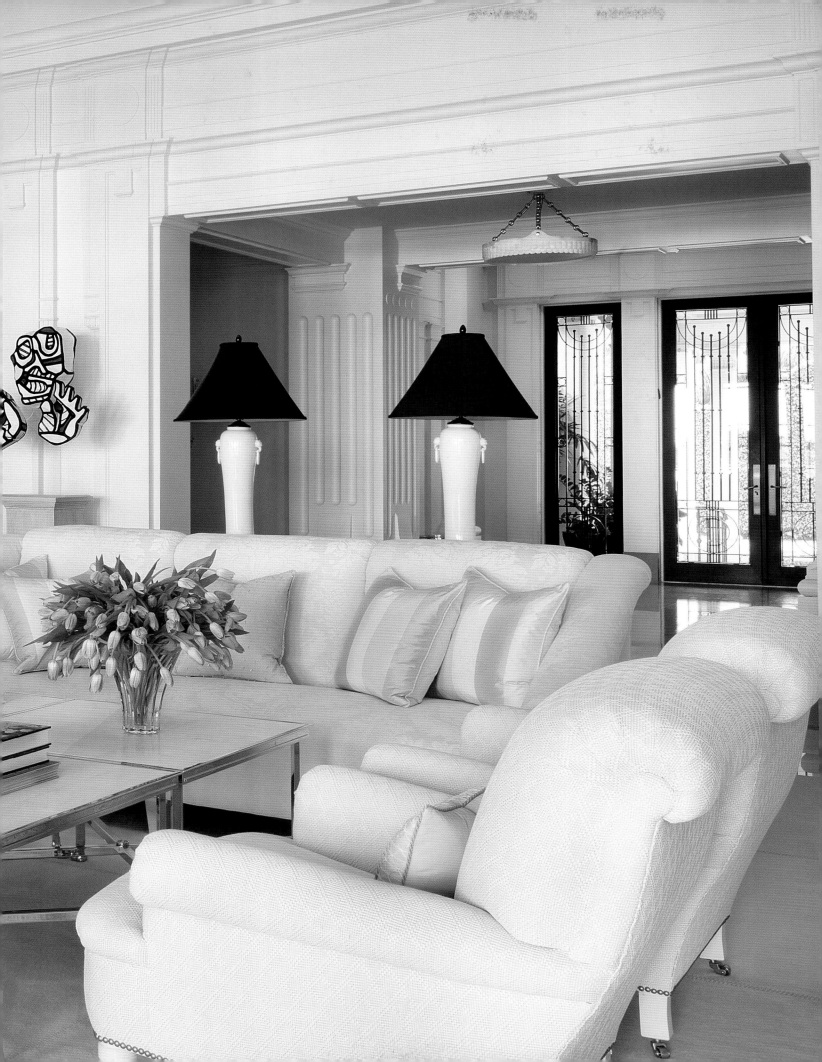

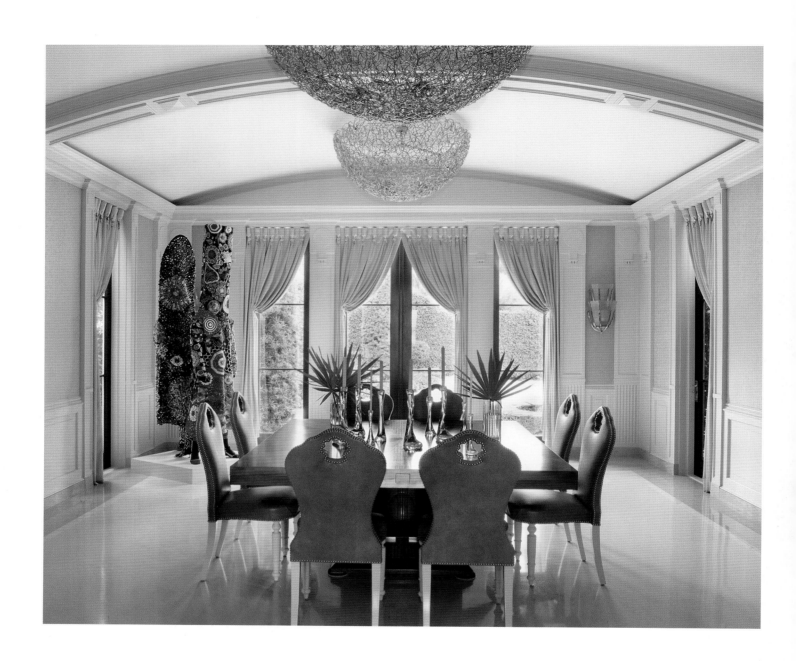

Above and opposite
In the dining room, the palette is kept
cool with custom-made keyhole chairs
in a celadon linen. The painting is
by Richard Prince and the pair of
enormous *Soundsuits* in the corner
are the work of sculptor and perfor-
mance artist Nick Cave.

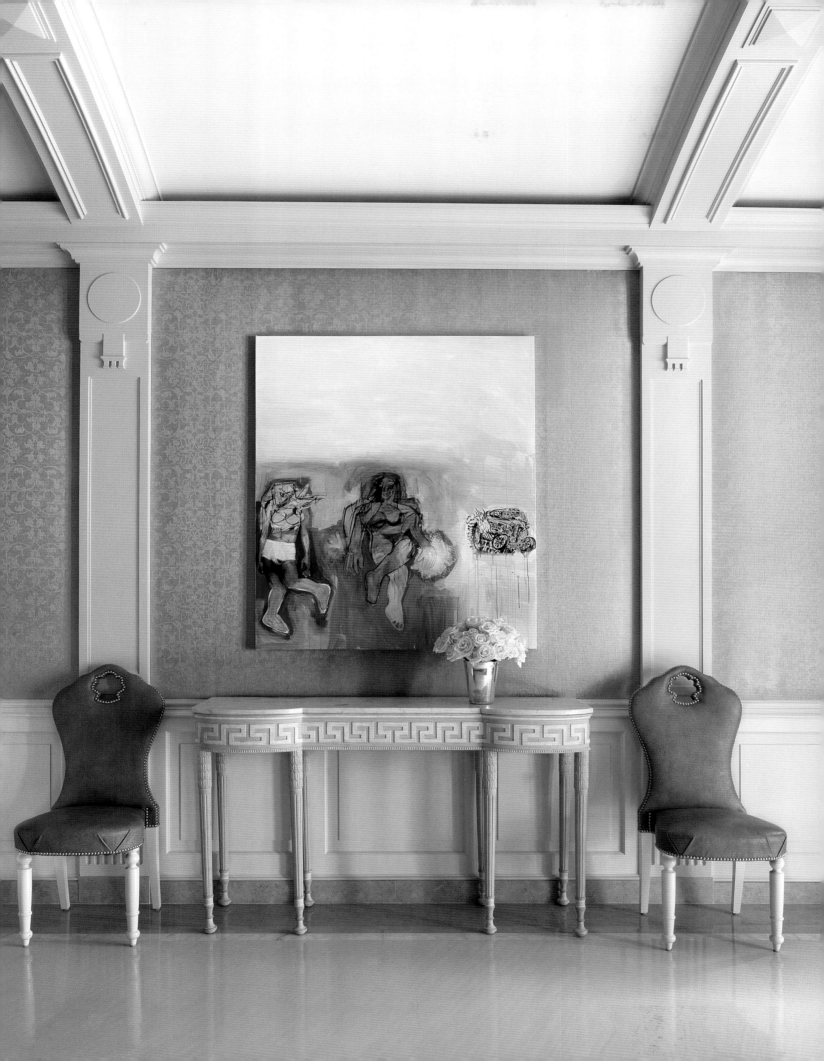

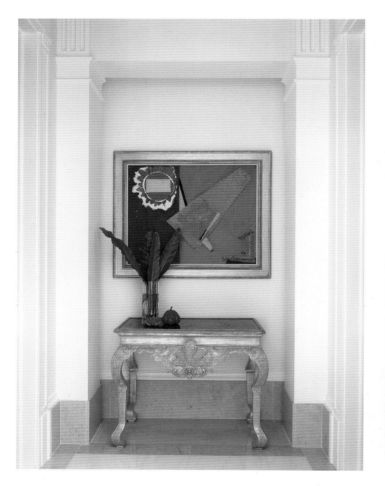

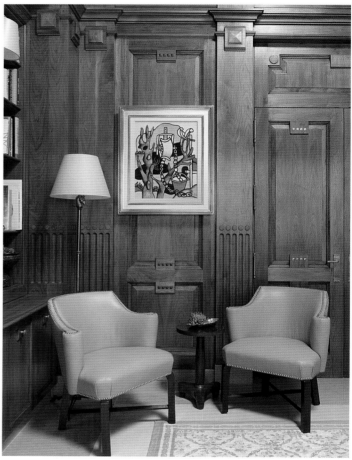

Above left
In a small nook, bold colors combine in a painting by Hans Hofmann that hangs above a giltwood table.

Above right and opposite
In the library, traditional paneling combines with postmodern detailing. Works by Léger and Picasso stand out against the polished wood. Andirons in the form of hands reach out from the hearth while a sculpture by Joan Miró sits on the coffee table. In a nod to the Florida setting, the bronze sconces feature a dolphin motif.

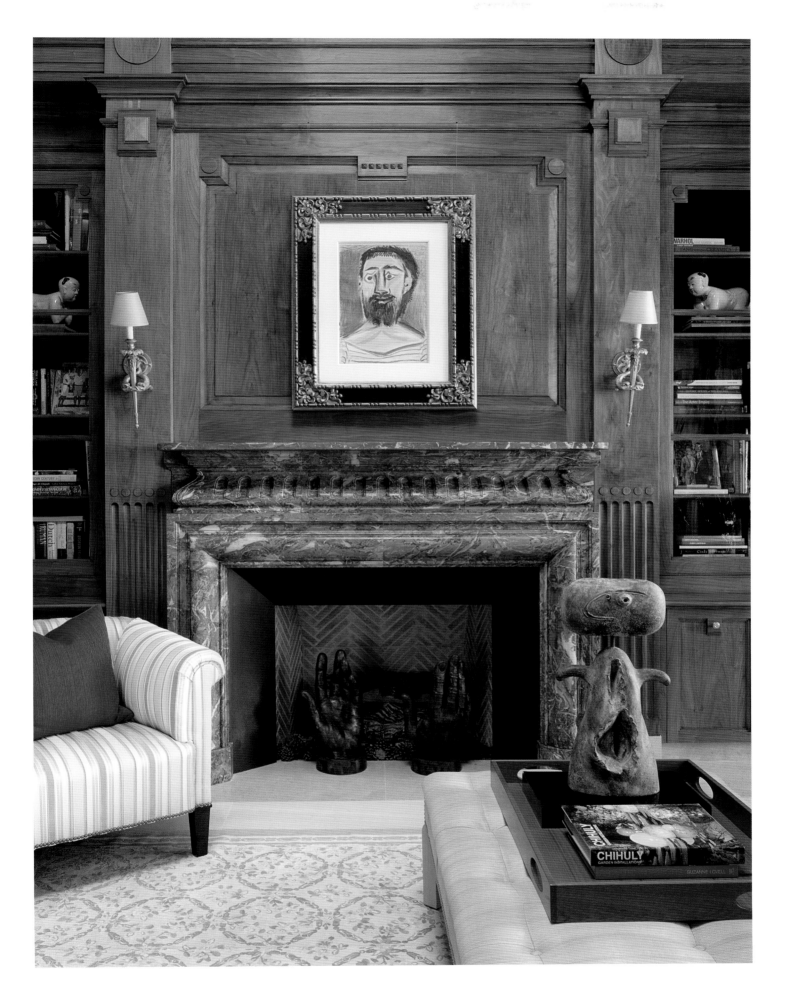

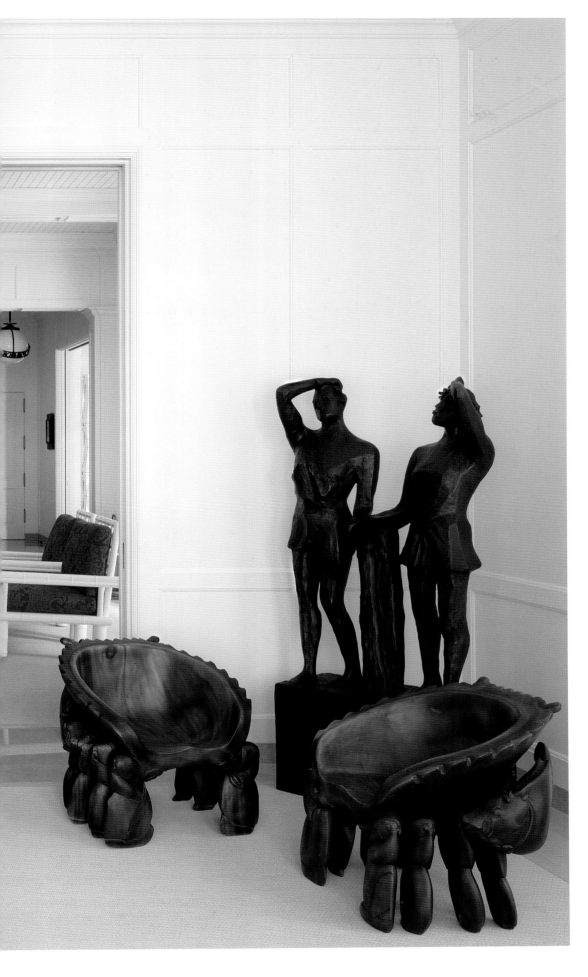

Left
Works by hyper-realistic sculptor
Carole Feuerman and word sculptor
Nancy Dwyer create a sense of
motion while a more traditional pairing
by Sandro Chia anchors the corner
space. The crab-like seats are
carved mahogany.

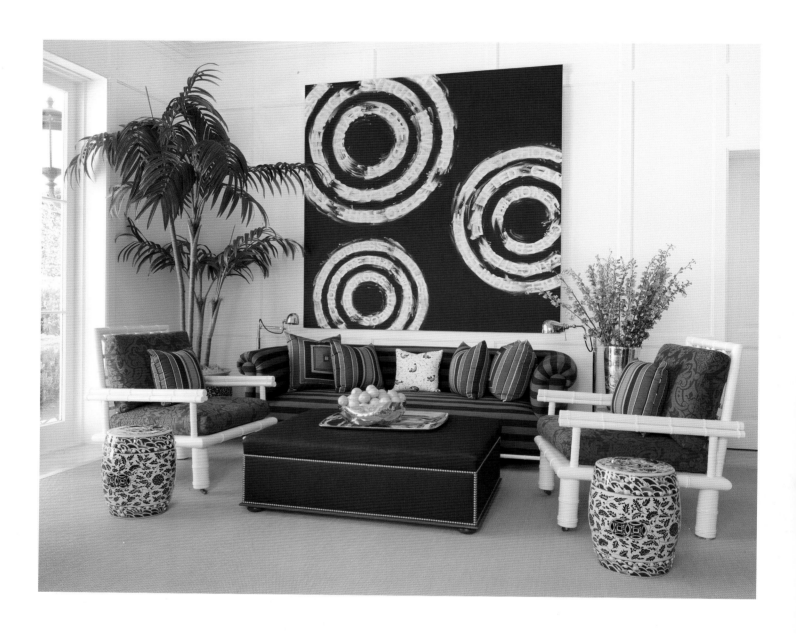

Above
A more casual approach was taken
in the pool room where the blues and
whites of a Gary Simmons canvas
are echoed in the custom-made sofa,
chairs, and ottoman.

Opposite
The blue color scheme continues in
another casual nook where a Buddha
head conveys a sense of serenity.

Overleaf
The owners' taste for contemporary
Japanese art is reflected in the dining
room. The chairs were designed by
John Meeks, with each sporting a
special embroidery of a sea creature.

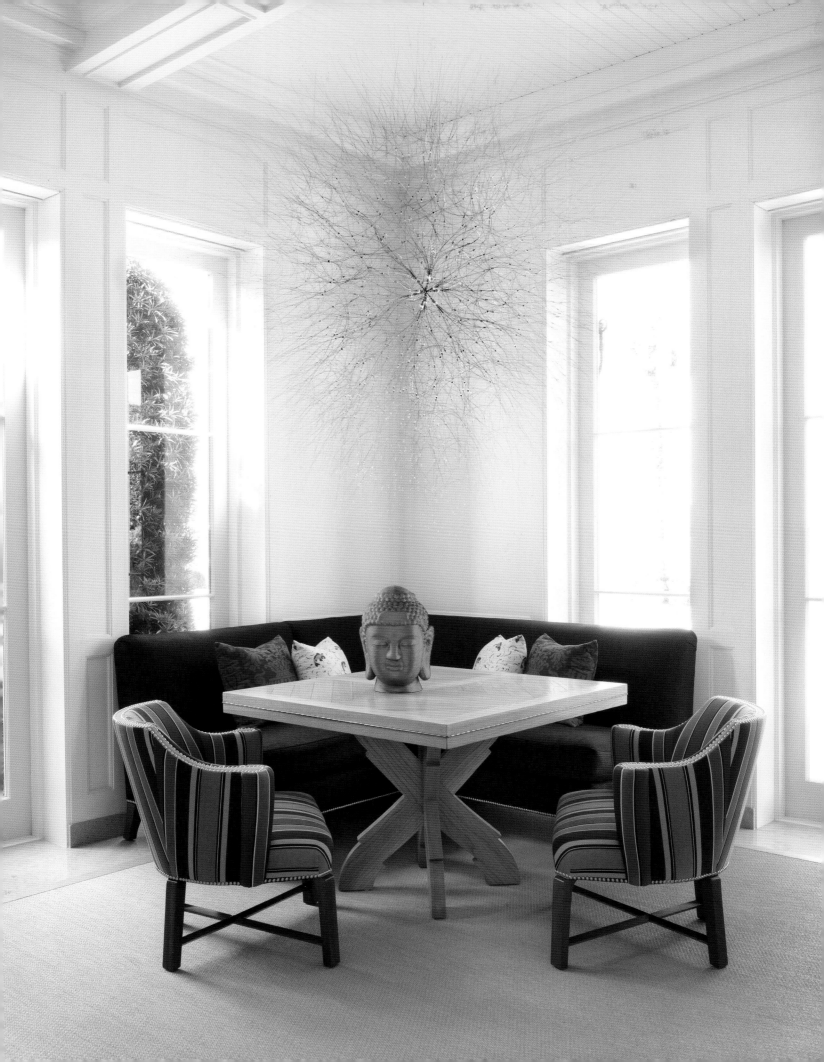

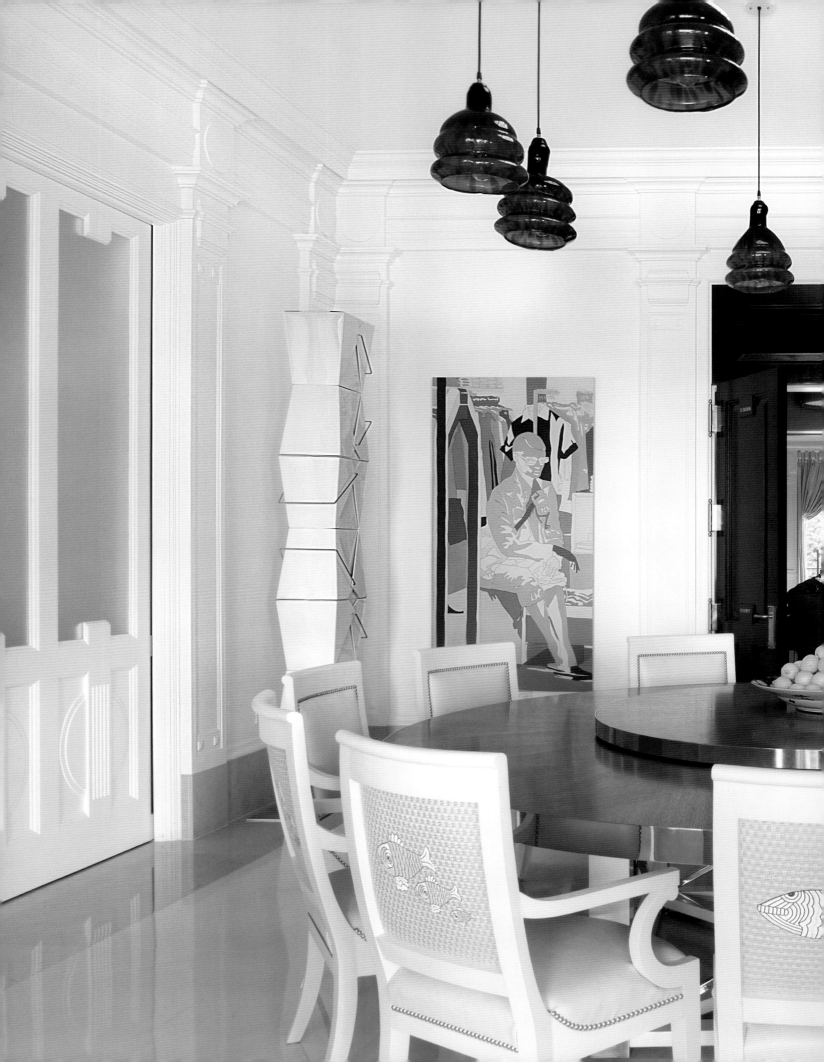

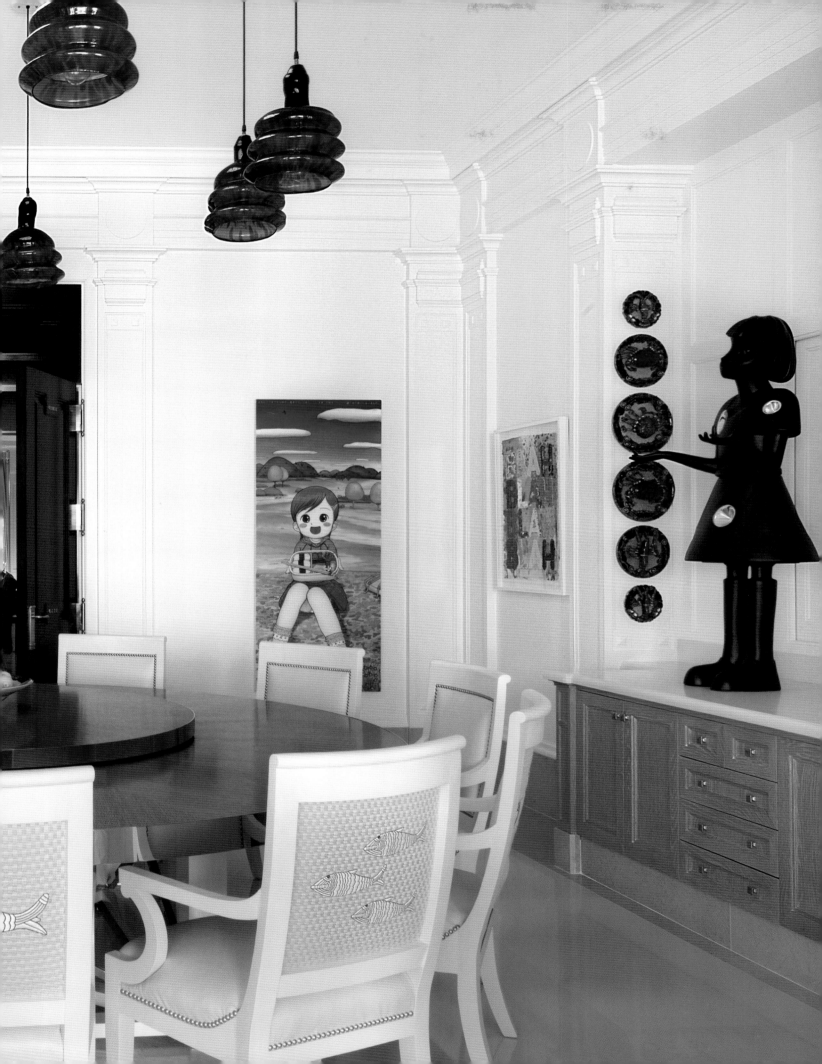

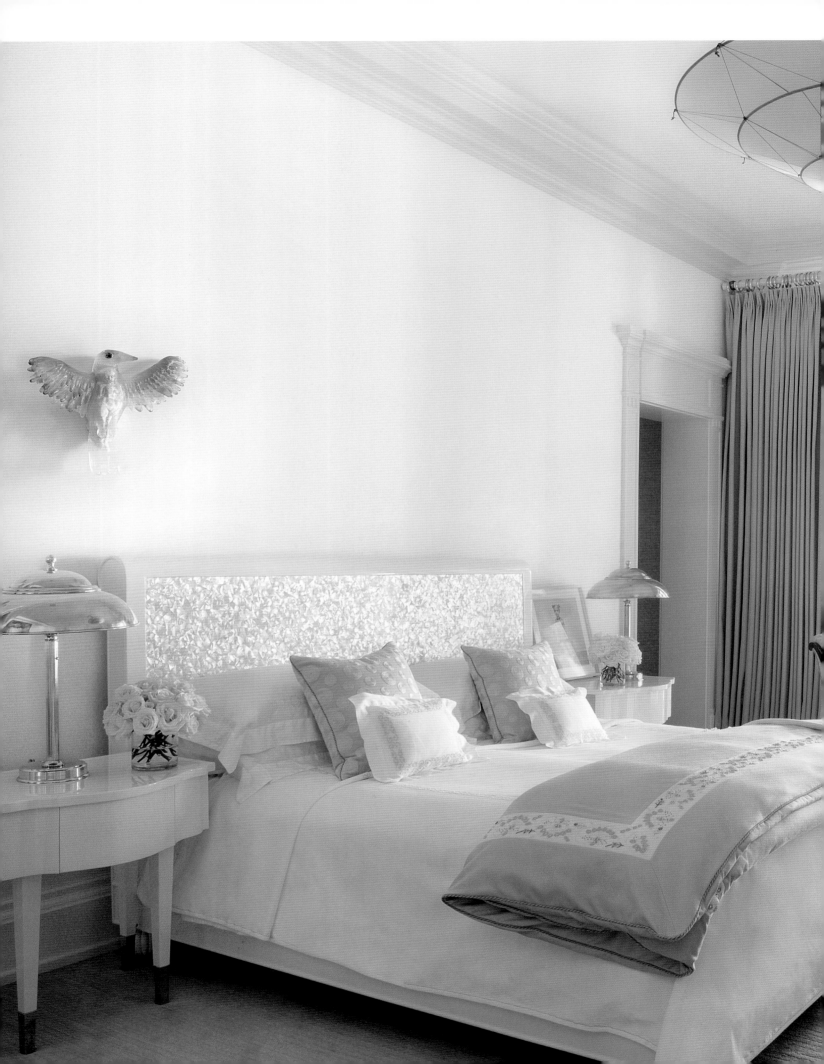

Left
French doors and a Fortuny chandelier drench the master suite in a warm and inviting light that reflects off the mother-of-pearl headboard. John Meeks designed the bed and side tables.

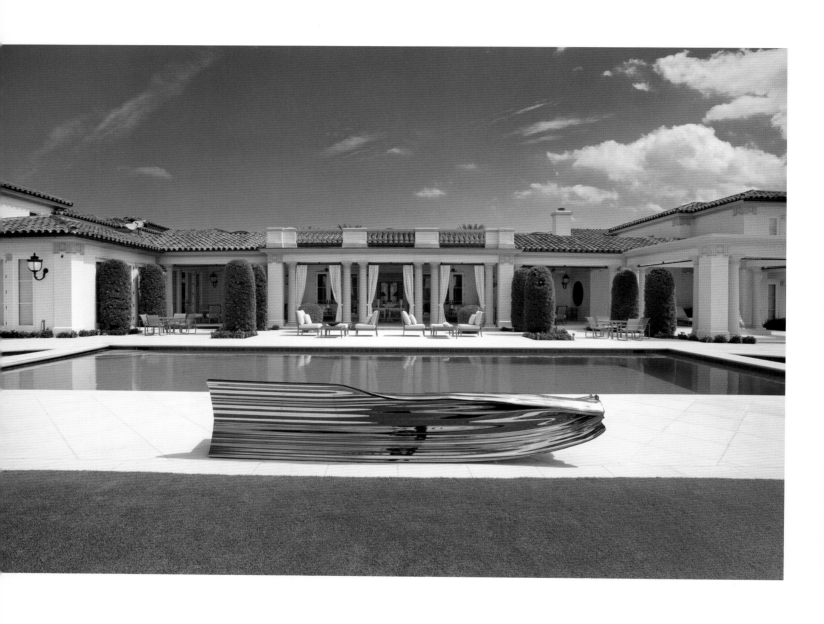

Above and opposite
The pool terrace is a setting for
outdoor sculpture.

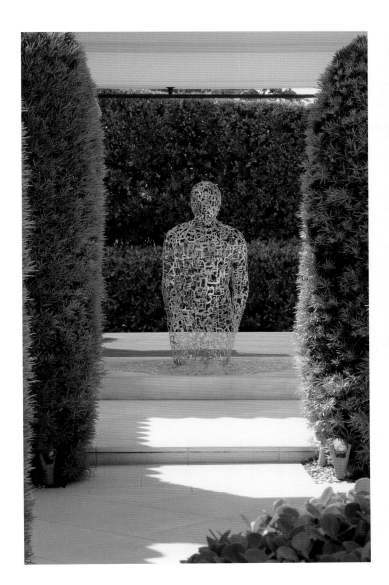

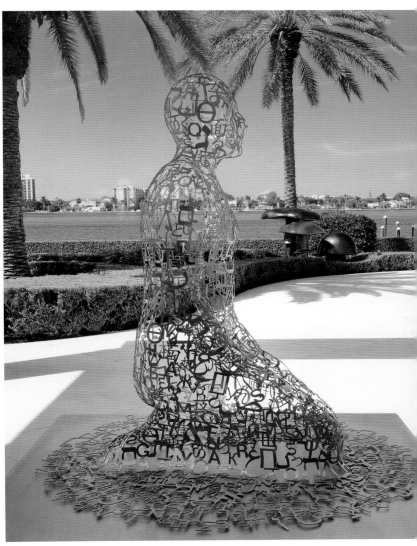

Above
A man in contemplation by Jaume
Plensa kneels in silhouette with
Lake Worth and West Palm Beach
in the background.

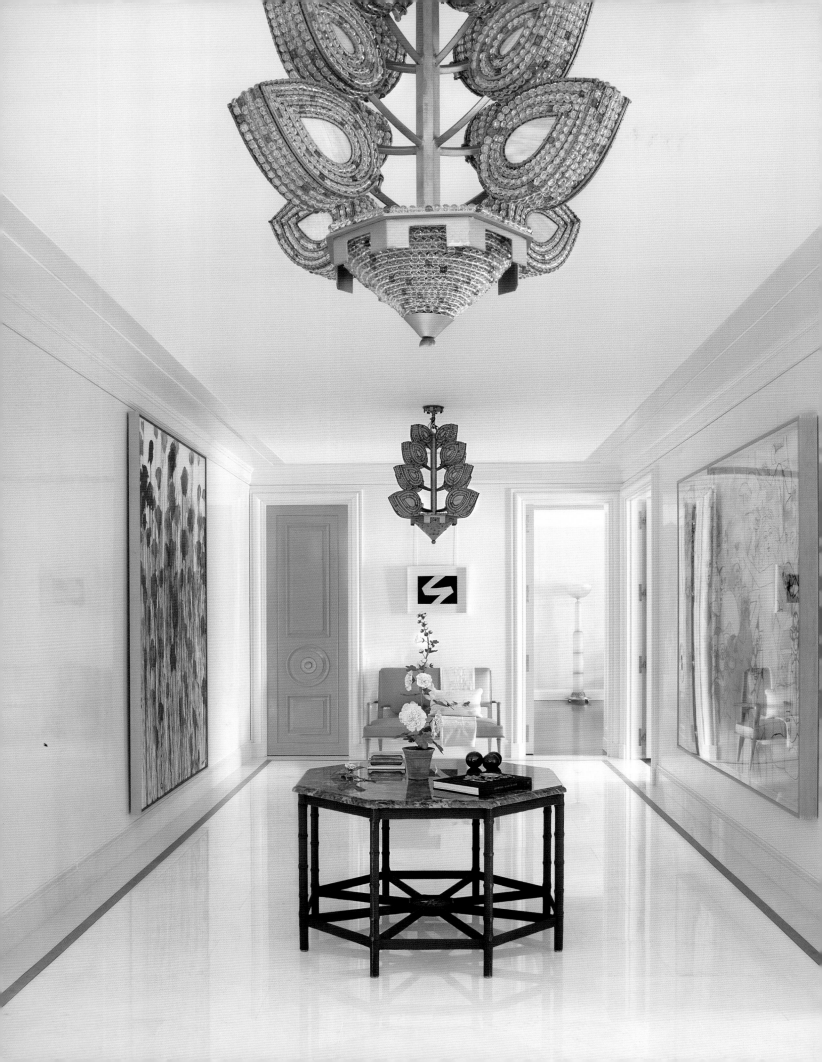

Contemporary and Classic

Maybe art is like true love; maybe it never dies. That's my hope, anyway.

—Damien Hirst

Perhaps an affinity for Damien Hirst's work is what drew me to my latest clients, a young New York couple who discovered their love of art—and each other—on a date at the Metropolitan Museum of Art. Once married, they started their collection with one of Hirst's butterfly paintings —among my favorites of his works—and they have gone on to acquire pieces by major artists like Frank Stella, Willem de Kooning, and Gerhard Richter as well as younger talents like Jenny Saville, Will Cotton, Kehinde Wiley, and John Currin, who share a bit of Hirst's flair for controversy.

Ironically, the setting for these provocative works couldn't be more traditional: a classic Park Avenue duplex residence that the *New York Times* aptly described as "one of the architectural gems to emerge from the exacting toolbox of the prolific Rosario Candela in the late 1920s." Acquired in 2014, the magnificent apartment boasts fourteen rooms, five bedrooms, six bathrooms, three fire-places and 80 feet of Park Avenue frontage.

My clients' goals were straightforward and clear: they wanted a Candela apartment in a Candela building. To accomplish their vision, we embarked on a top-to-bottom restoration—to bring the residence back to its original grandeur and create an inviting atmosphere for the clients to entertain friends and enjoy their art collection.

The clients knew that our "transitional" style would work best here since the architecture was traditional and their collection was just the opposite. They were not afraid to make some sweeping changes, like converting staff quarters on the second floor into a large office, but they insisted on maintaining Candela's original floor plan in the more public spaces.

Wooden floors in a chevron pattern were restored throughout the apartment while marble in the foyer adds a note of timeless elegance. Mantels were updated for a more contemporary look, but they maintain the scale of the Candela originals. Venetian plaster was used to accentuate the light in the living room and master bedroom while parchment panels in the dining room

keep the mood subdued and quiet, ideal for conversation by candlelight.

In another nod to tradition, we were inspired by the brass-trimmed, red-lacquered library that Albert Hadley had created for Brooke Astor. Our client's space pays homage to this iconic design with a more relaxed peacock-blue color treatment that we chose over the ten coats of red paint that were apparently used to create Mrs. Astor's library.

The clients were true collaborators, working closely to select a largely monochromatic color scheme for the walls and a neutral palette for the furnishings. Wisely, they recognized the importance of all the details, such as the Greek key pattern in the foyer and the delicate pearl-like moldings that create a jewel-box effect in the gallery.

I especially love the broad vistas and almost minimalist furnishings that give the art so much room to breathe. A Frank Stella dominates the expansive dining room, where twin tables can be combined to accommodate as many as twenty-eight guests or replaced by one for more intimate gatherings. Paintings by Brice Marden bring dramatic impact to the living room while a Will Cotton confection adds froth and whimsy to the master suite.

And then there's Maude, or, more accurately, *Bea Arthur Naked*, which hangs in the library. The controversial nude by John Currin created a media firestorm when it was sold at auction in 2013 and now takes center stage over the fireplace in all its glory. The peacock-blue walls and bronze trim may seem inconsistent with the apartment's otherwise neutral color palette, but the flat back-drop actually makes the art stand out even more. An organic light fixture by Claude Lalanne provides just the right illumination.

My young clients admit that many of their art choices are provocative and cutting-edge. But they feel that Rosario Candela would be delighted by the restoration and pleased that the art collection fits in so comfortably. "We feel at home here," they say. "And our art feels right at home, too."

Opposite In the gallery, an octagonal table by Jacques Adnet is wrapped in gray leather and topped with pink and gray marble. Light is reflected from the custom bronze chandeliers with their rows of crystal beads and amber accents.

209

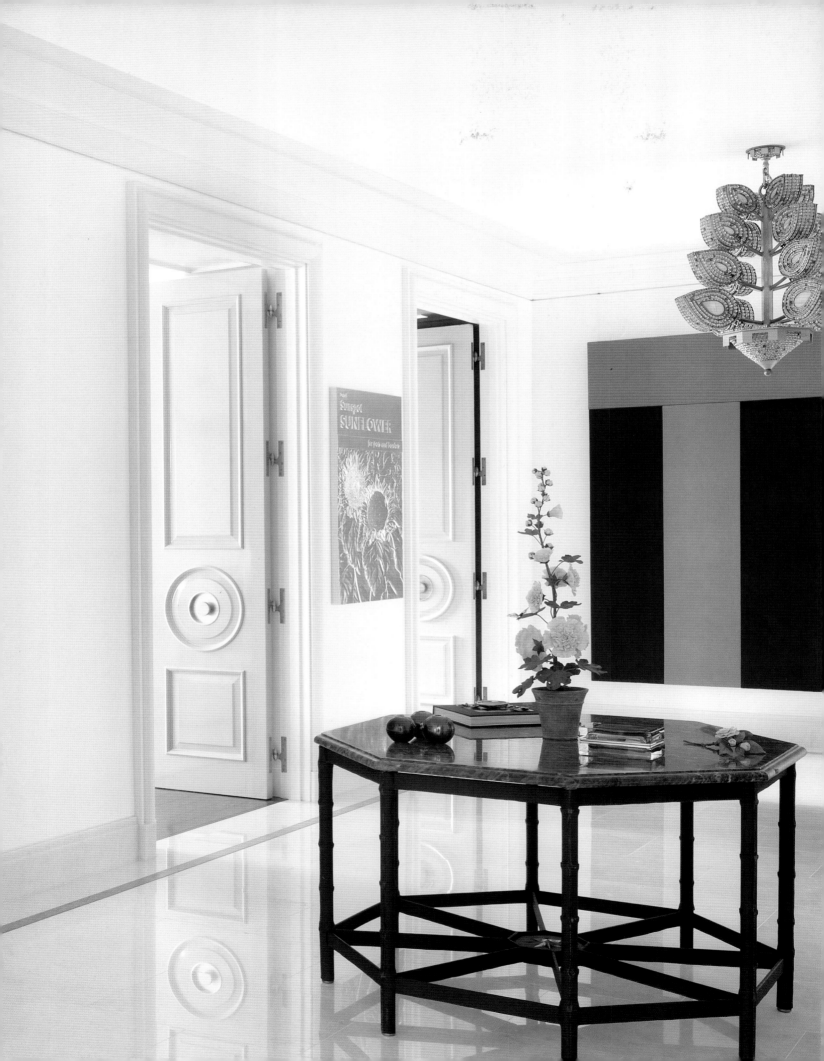

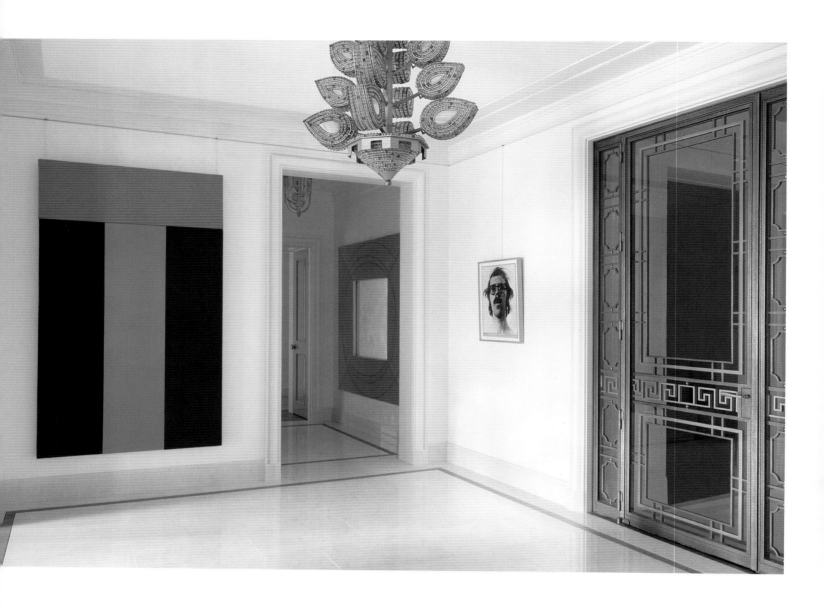

Preceding pages
White-and-cream marble flooring
and Venetian plaster on the walls bring
light to *The Enchanted Island* by
George Condo. The generous space
opens to the principal rooms in keep-
ing with Rosario Candela's original
floor plan.

Above
Small details like the key pattern
in the foyer door and the delicate
pearl-like moldings recall the
apartment's classic origins. Works
by Brice Marden, Robert Mangold,
and Chuck Close line the walls.

Opposite
The half-circle shapes in the settee
by André Arbus are echoed in the
round carvings on the large lacquered
doors. Hanging from a picture rail
above is a work by Ellsworth Kelly.

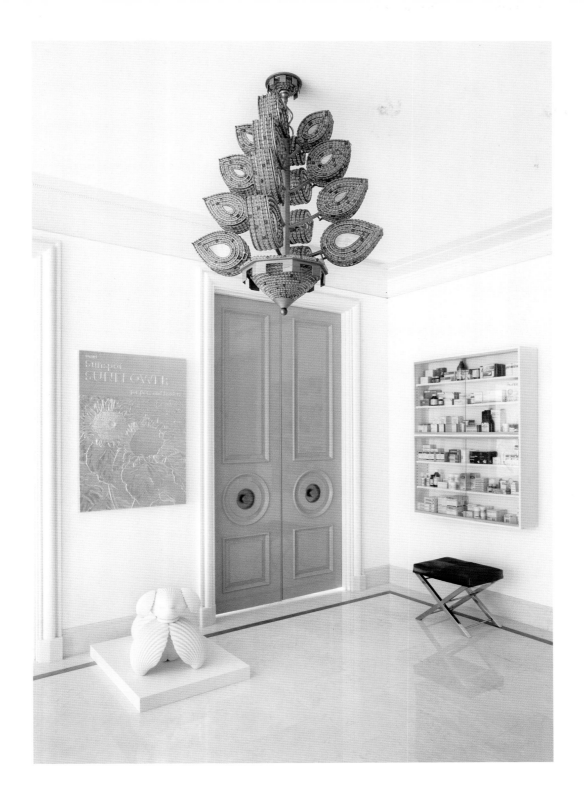

Opposite

The tonal range of the walls, floor, and furniture in the gallery allows the pink in the Philip Guston painting to pop. The curving lines in the surreal crocodile console by Claude Lalanne are echoed by the Gustavian armchairs upholstered in white mink. The side table is by Achille Salvagni.

Above

Another view of the gallery reveals an aluminum relief by Charles Ray, a sculpture by Katharina Fritsch, and one of Damien Hirst's Medicine Cabinets.

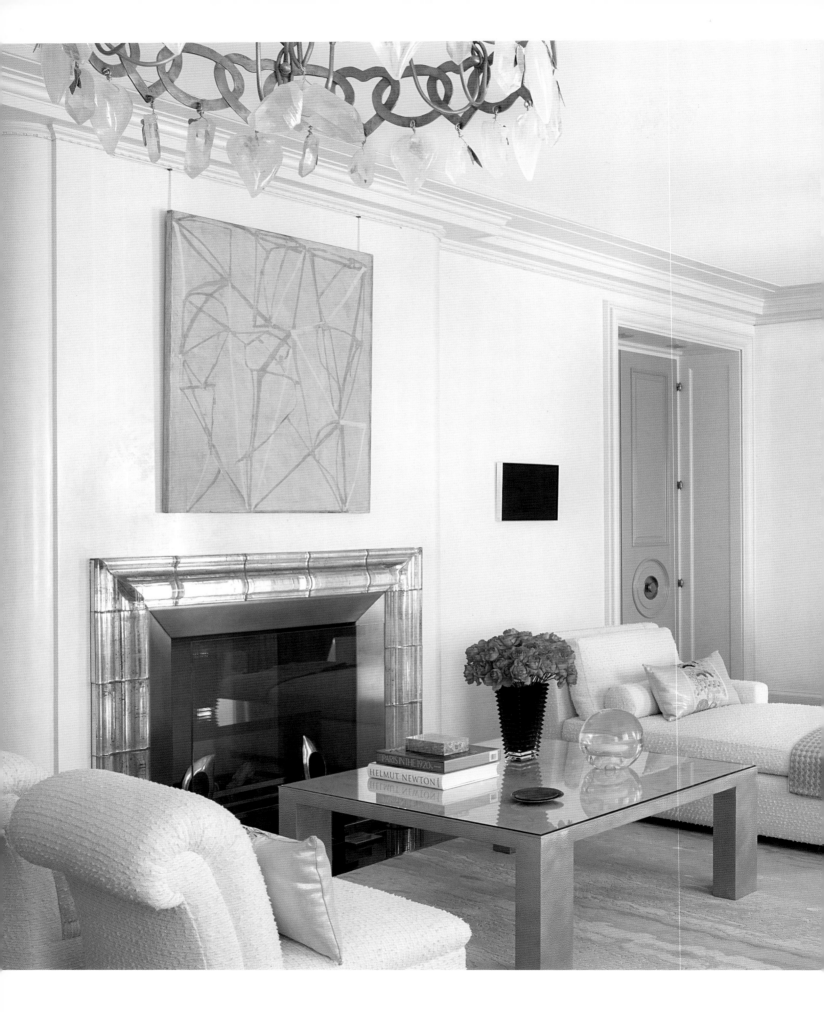

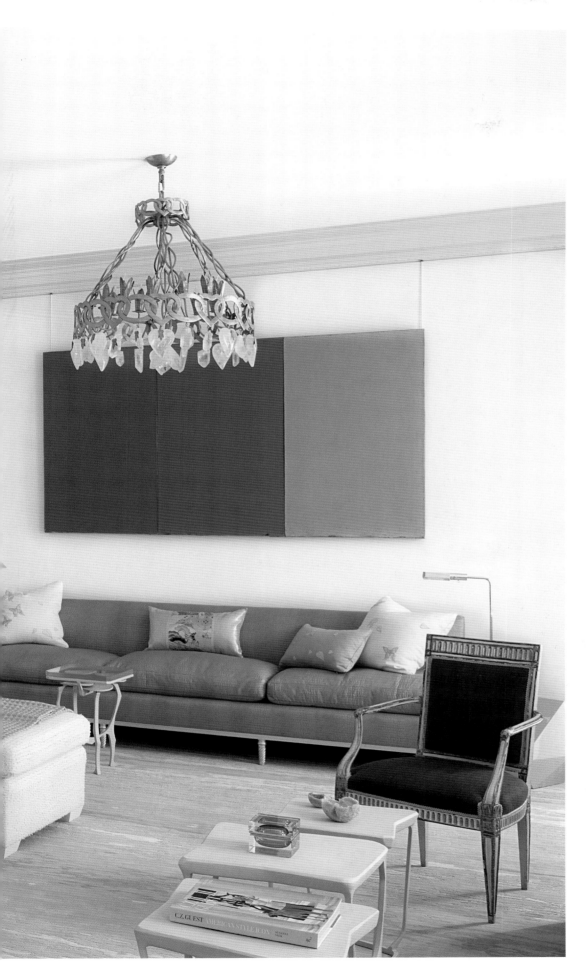

The low silhouettes of the furnishings
and monochromatic paint choices
in the living room allow paintings by
Brice Marden to command attention.
The mantel in poured-mercury glass
with a stainless-steel surround main-
tains the scale of the Candela original.
A white bouclé fabric with metallic
accents covers the slipper chairs.
Heart-shaped crystals adorn the pair
of bronze chandeliers.

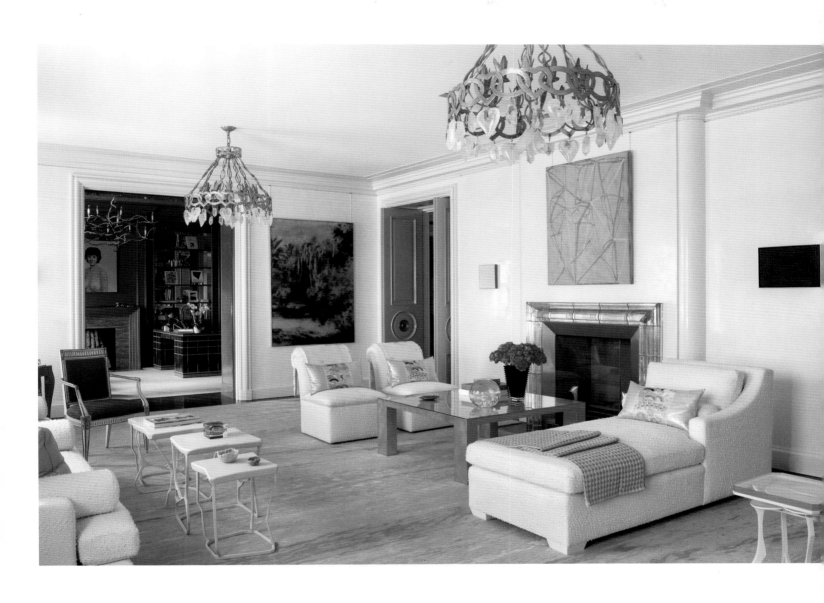

Opposite
John Meeks designed the frog and lily pad embroidery on the pillow as well as the gingko leaves on the white-on-white throw.

Above
Another view of the living room showcases a painting by Gerhard Richter. The custom coffee table in hammered bronze features a top in gesso and mother-of-pearl.

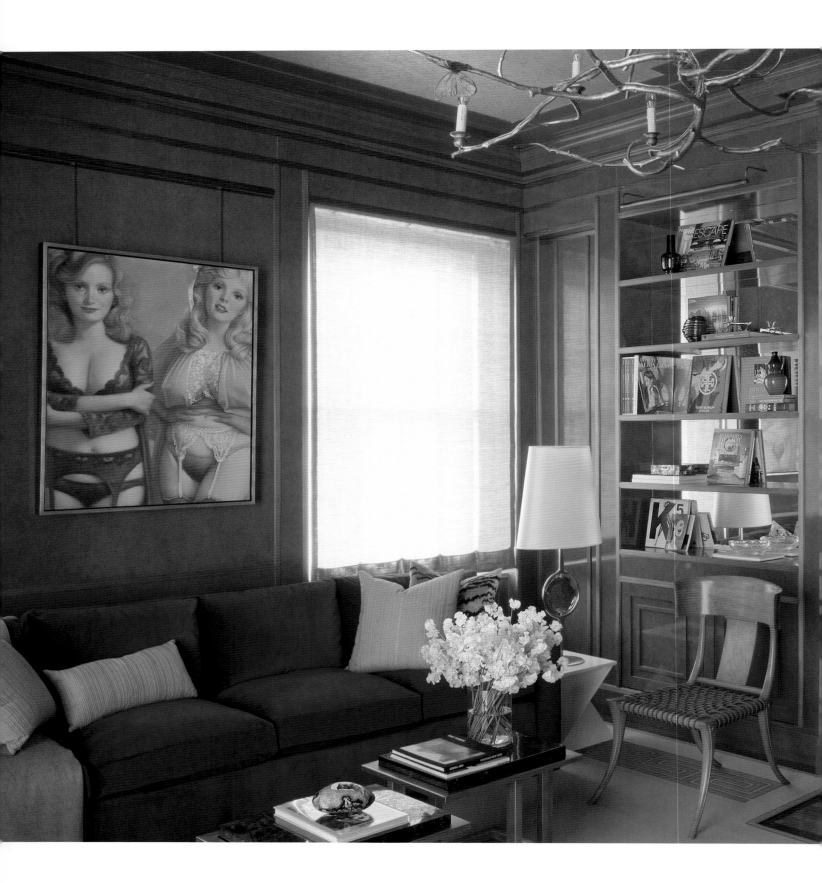

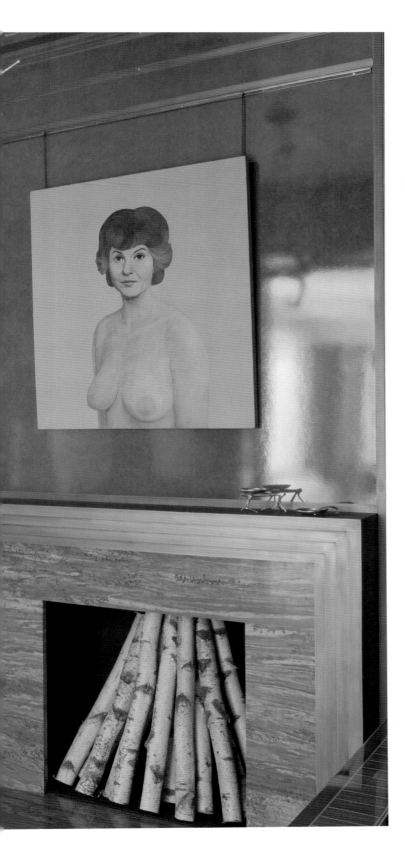

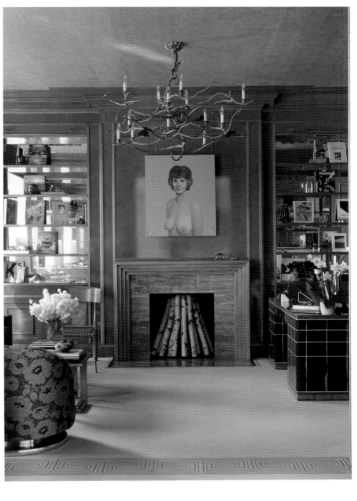

Left and above
The library was inspired by the work of Albert Hadley for Brooke Astor's iconic apartment. Peacock-blue substitutes for red paint and combines with brass trim to highlight the much-discussed *Bea Arthur Naked* portrait by John Currin. *Lynette and Janette,* also by Currin, hangs between the windows. An organic chandelier by Claude Lalanne provides illumination.

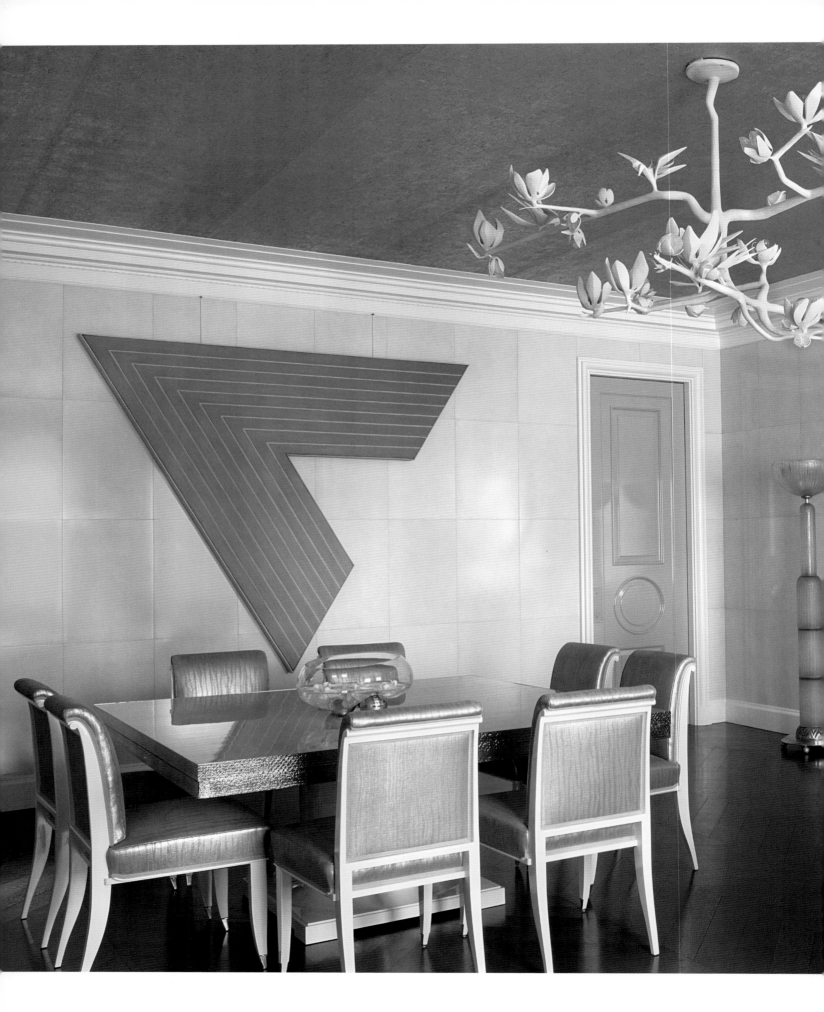

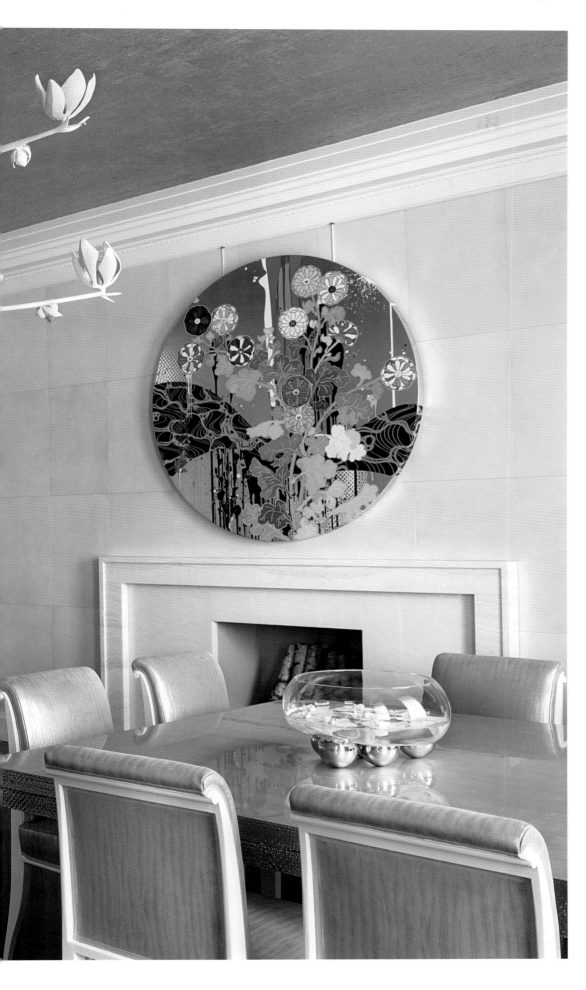

Left
A Lalanne ceiling light was also chosen for the dining room where parchment panels cover the walls for a pearl-like effect. A metallic leather fabric covers the chairs and complements the silver-leaf top and nickel trim on the custom tables. The darker gray on the ceiling draws the eye to works by Frank Stella and Takashi Murakami.

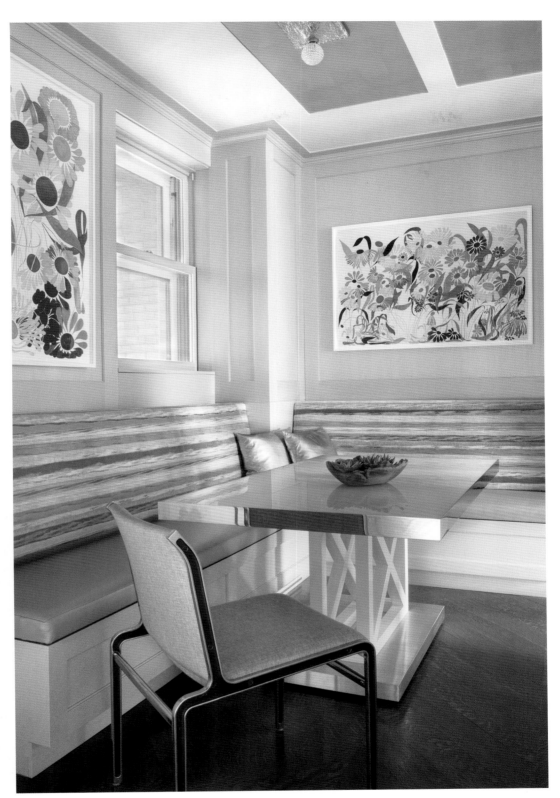

Left and above
In the kitchen, the palette is light gray
with a cool blue-green combination
for the cabinetry that complements
the Japanese ash door. A metallic
sheer horsehide covers the custom
banquettes in the breakfast nook.

225 Contemporary and Classic

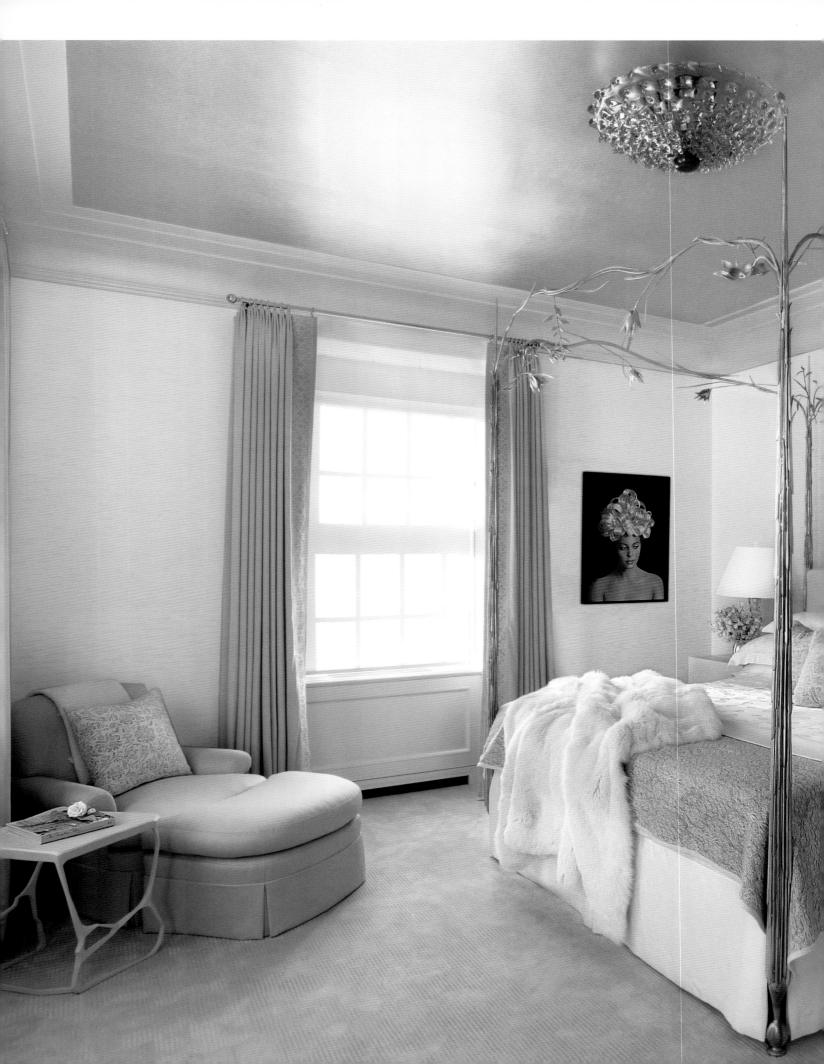

Left

A silver-leaf tea paper covers the
ceiling in the master suite for a look
that is soft and serene. The head-
board on the whimsical four-poster
bed is covered in a celadon horsehair,
and the color scheme continues in
the draperies and furnishings. Hanging
by the window is *Ribbon Candy
Portrait* by Will Cotton.

Contributors

JAMES AMAN

Jim Aman opened his firm, now Aman & Meeks, in 1995. He is recognized as one of America's leading interior designers with an enviable roster of clients that includes some of the country's leading entrepreneurs, philanthropists, and patrons of the arts. His work has been regularly featured in *Architectural Digest, Elle Décor, Town and Country, House Beautiful, Florida Design, Quest,* and NBC's "Open House NYC," and he has been a contributor to the annual Kips Bay Decorator Show House and the Palm Beach Jewelry, Art, and Antiques Show.

A graduate of the Pratt Institute in New York, Jim began his design career working for Ralph Lauren and helped to establish the "visual environment" for the legendary designer's retail shops and boutiques in department stores worldwide. He was a member of the creative team that transformed the majestic Rhinelander Mansion on Madison Avenue into the flagship store of the Polo Ralph Lauren empire.

He went on to serve as the creative director of Wathne, Ltd., a Polo licensee and purveyor of luxury leather goods and fine clothing, where he was responsible for the design of stores in New York, Los Angeles, and Japan, directing all aspects of the brand's creative presence. With this experience—and a growing list of friends and clients who turned to him for design projects—Jim decided to launch his own business.

Although he does not acknowledge a signature style, Jim believes his clients are drawn to his ability to blend traditional and contemporary elements in a transitional context that creates an elegant backdrop for their art collections.

"It's about creating the perfect environment for the art," he explains, "and it's important that the fabrics, furnishings, and design details stand on their own to create a sense of timeless beauty, comfort, and sophistication." He applies the same artistic principles of light, color, texture, and scale that characterize the world's best art in the selection of fabrics, fixtures, and bespoke furnishings that surround and enhance the collections.

Active on the New York and Florida social scenes, Jim has been an ardent supporter of various causes, including the Hope for Depression Research Foundation and the Fisher Landau Center for Art in Long Island City, New York.

When not visiting with family in the Palm Beach area, Jim and his life and work partner, John Meeks, divide their time between their apartment on Manhattan's Upper East Side and their lakeside retreat.

MARK STEPHEN ARCHER

Mark Stephen Archer is a long-time friend of Jim Aman, having met him when they were both starting their careers in New York City. He fondly remembers spending time with Jim in the Northern New Jersey/New York area and visiting with his family in New Jersey and in Telluride, Colorado.

Mark holds a bachelor's degree from Seton Hall and a master's in journalism from Pennsylvania State University. After a brief stint in journalism and freelance writing and a much longer, award-winning career on Madison Avenue, Mark took a giant leap off the corporate ladder for the wilds of western Michigan, where he divides his time between an architecturally signifi-cant house in Grand Rapids ("The Furniture City") and a summer cottage on Lake Michigan in Glenn ("The Pancake Town").

He has written for many publications and produced numerous television commercials and video programs. When not collaborating with the owner of a local advertising agency, he enjoys traveling and spending time in Saint-Jean-Cap-Ferrat and Villefranche-sur-Mer in the south of France.

KAREN FUCHS

Karen Fuchs is an award-winning photographer who has been shooting internationally for the past twenty-four years. Her work has appeared on numerous magazine covers, in features, and in major advertising campaigns.

Her passion, sense of style, and ability to connect deeply with her subjects are reflected in the vibrant and bold imagery she creates. In recent years, in addition to commissioned work, Karen has started focusing more on personal projects, keeping her love for her art strong. This work has been exhibited interna-tionally at Hamiltons and M&C Saatchi in London and galleries in France, Spain, and the United States. Having lived in four coun-tries on three continents, Karen has been based in the New York City area for the past seventeen years.

JOHN MEEKS

John Meeks has been creating luxurious interiors for residential and commercial spaces for nearly twenty years. He began his career in the fashion industry in the mid 1980s with a couture label that caught the eye of luxury stores including Henri Bendel and Martha, Inc.

With a passion for architecture and interior design, John began to create window and promotional displays for those stores and ultimately joined Jim's interior design firm in 1997. His intuitive design vision, hands-on approach, and sophisticated aesthetic combine to create unique spaces for each of his clients.

A descendant of the legendary family of cabinetmakers J. & J. W. Meeks, John carries on the tradition of bespoke furniture de-sign and will be launching a furniture line in the near future. He is a graduate of the Museum School of the Massachusetts College of Art in Boston.

Acknowledgments

To my work and life partner, John Meeks, whose creative designs are featured throughout this book, I am extremely grateful for your love and support.

To my parents, Marcia and James, who have always encouraged me to pursue my dreams, I am so appreciative of your unconditional love. You created a warm, nurturing environment for me as a child, and you continue to make me feel good about myself and my work.

To my sisters, Meredith and Laura, who have always been in my corner and remain my very best friends. An extra-special note of thanks to Meredith, who manages the office and always goes the extra mile to make sure the business runs smoothly and the clients are happy. I'll never know how you keep up with all the late hours and last-minute changes. But you always do it with a beautiful smile and an enviable amount of grace.

Speaking of clients, I am forever grateful to the people who have invited me into their homes and allowed me to help create environments for their families and for their art. My thanks to: Michelle and Lawrence Beyer, Candia Fisher, Emily Fisher Landau, Christine and Richard Mack, Phyllis and William Mack, and Lisa and Steven Tananbaum. A very special thank you to Emily Fisher Landau, who was so kind in the development of this book, and to Candia Fisher, who joined me on many of the photo shoots and was always available with helpful insights. Her passion for life and art remains an inspiration.

I also wish to salute the principals at the architectural firms who have collaborated with me on many projects: Leroy Street Studio, Vail Associates, and Mojo Stumer Studios. Thanks, too, to St. Charles of New York. In the publishing world, Margaret Russell and Michael Boodro have also been very helpful for many years, and I greatly appreciate their confidence and support.

To Karen Fuchs, my deepest thanks for your sharp eye and ability to create brilliant images. Your artistry never fails to amaze, and I am so glad that you were a key player on our team.

And finally, when words fail me, I've always been able to turn to my lifetime friend Mark Archer whose writing talent, business acumen, and vision helped make this book a reality. Thank you for your patience, your attention to detail, your sense of humor, and, most of all, your friendship for almost forty years.

Library of Congress
Control Number: 2016936159

ISBN 978158093-4145

Design by Jena Sher

The Monacelli Press
236 West 27th Street
New York, New York 10001

Printed in China